Magdalena Abakanowicz

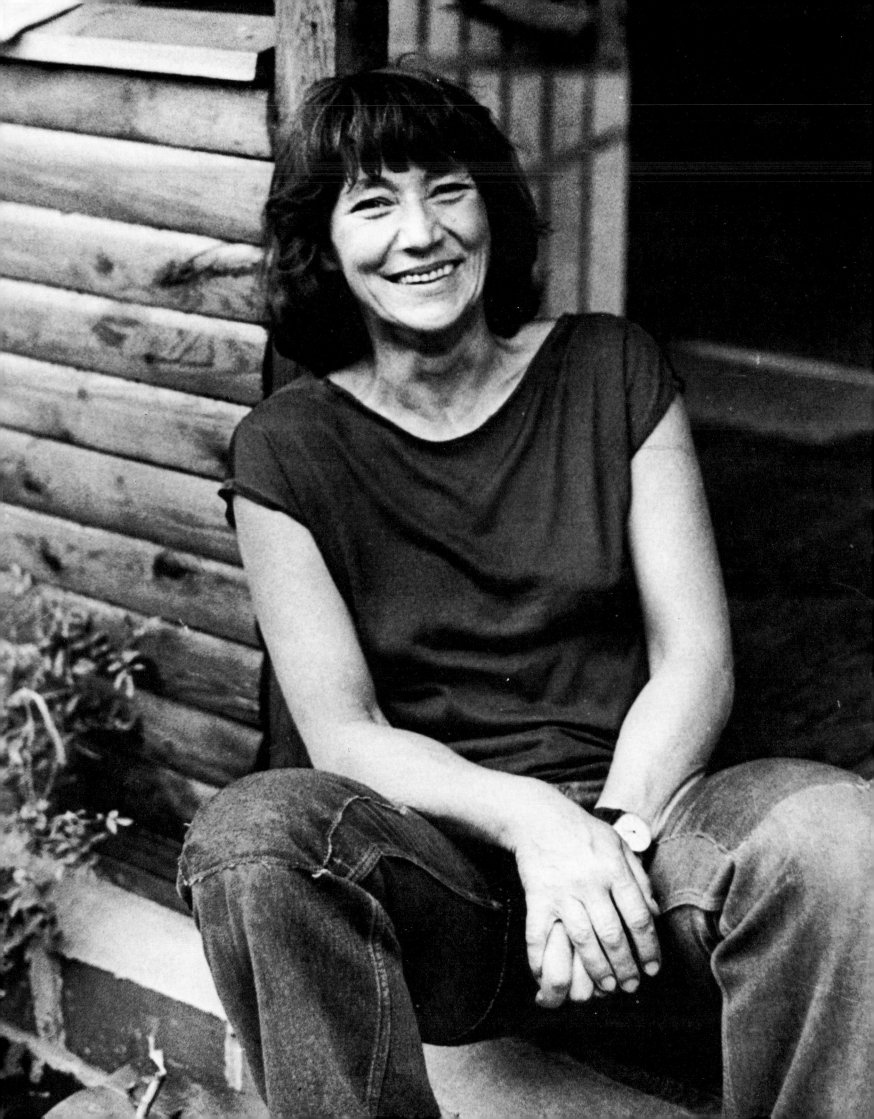

Magdalena

Abakanowicz

Museum of Contemporary Art, Chicago

Abbeville Press, Publishers, New York

Published on the occasion of the exhibition "Magdalena Abakanowicz," organized by the Museum of Contemporary Art, Chicago

Exhibition Tour

Museum of Contemporary Art, Chicago, and the Chicago Public Library Cultural Center
November 6, 1982–January 2, 1983

Musée d'Art Contemporain, Montreal
February 10–March 27, 1983

Portland Art Museum and Portland Center for the Visual Arts, Oregon
February 28–April 22, 1984

Dallas Museum of Fine Arts, Texas
June 21–August 19, 1984

Frederick S. Wight Art Gallery of the University of California, Los Angeles
September 23–November 11, 1984

Library of Congress Cataloging in Publication Data
Abakanowicz, Magdalena.
 Magdalena Abakanowicz: Museum of Contemporary Art, Chicago.

 Exhibition held at Museum of Contemporary Art, Chicago, and The Chicago Public Library Cultural Center, Nov. 6, 1982 through Jan. 2, 1983, and other museums.
 Bibliography: p. 172
 1. Abakanowicz, Magdalena—Exhibitions. I. Museum of Contemporary Art (Chicago, Ill.). II. Title.
N7255.P63A232 1982 709'.2'4 82–11511

ISBN 0–89659–323–1

Major funding for the exhibition and this accompanying book has been provided by the National Endowment for the Arts, a federal agency. The Chicago showing was made possible in part by the Illinois Arts Council, a state agency.

Cover illustration: *Backs* 1976-82 (cat. no. 71)
Photo: © 1982 by Dirk Bakker, Detroit, Michigan.

Frontispiece: Magdalena Abakanowicz 1981

Designed by Michael Glass Design, Chicago, Illinois.

This book is printed on Royal Coat by Toppan Printing Co., Ltd., Japan.

The type is Sabon and was set at Dumar Typesetting, Inc., Dayton, Ohio.

First edition

Table of Contents

Preface

BY JOHN HALLMARK NEFF

Magdalena Abakanowicz is considered by many critics and artists alike to be the foremost artist working with fiber in the world today. That she is now considered a leading sculptor, as well, indicates how far she has come since her innovative, imposing woven *Abakans* of the 1960s led the way for a decade of experimentation by many artists with fiber as a medium for expression or as a medium for the making of art. Her work proved to have the strength to break with the venerable tradition of tapestry going back to the Middle Ages, and to transform radically our expectations of woven objects from being craft to being fine art.

Although still known primarily in weaving circles, Abakanowicz, nevertheless, had critical recognition and encouragement for her achievements since almost the beginning of her career. As early as 1968 in the catalogue for her exhibition at the Helmhaus, Zurich, organizer Erika Billeter proclaimed that:

> *the name of Magdalena Abakanowicz has become a symbol of the contemporary art of weaving. She has most determinedly contributed to the liberation of weaving from its role of decoration and wall ornament and to freeing it from its long-lasting dependence on painting. What Abakanowicz has begun is not a revival in tapestry-making, but a revolution!*

Nearly fifty one-person exhibitions of Abakanowicz's work have been presented in many of the most important European museums; a major exhibition also circulated in Australia during 1976. But of particular interest is the recent trend in Europe to consider her work within the broader context of international developments in sculpture, such as the "ROSC '80" exhibition in Dublin; "Soft-Art" organized by the Kunsthaus Zürich in 1980; and "Kunst wird Material" shown this year at the Nationalgalerie, Berlin. Whether at the Venice Biennale in 1980 as the featured artist at the Polish Pavilion or this year at the major showing at the Musée d'Art Moderne de la Ville de Paris, Abakanowicz as a sculptor who just happens to use fiber and wood in preference to clay or to steel has found a new audience in the art world.

The occasion of this first comprehensive retrospective of Magdalena Abakanowicz's work of the last two decades thus marks an important point in the career of the artist, who is now in her fifty-second year. Mary Jane Jacob, Curator at the Museum of Contemporary Art, initiated the exhibition while at The Detroit Institute of Arts. We would like to acknowledge the role of this institution in supporting this project through its early stages. We would also like to thank Ms. Jacob for bringing this extraordinary exhibition to Chicago. Throughout the years of preparation, she has maintained her commitment to the high standards she set for the exhibition, its tour, and this publication.

With the exception of an important exhibition of *Abakans* organized in 1971 by Eudorah Moore for the Pasadena Art Museum, this present exhibition is the first opportunity for a North American public to see Abakanowicz's work in its full range and magnitude. Previously she has been seen in the context of group exhibitions of Polish weaving or contemporary fiber art. One function of the Museum of Contemporary Art has been to question, to test current definitions of art in terms of the objects which are made in our time and to present those exceptions which lead to new rules. "Magdalena Abakanowicz" is an exhibition that challenges such definitions. This exhibition offers us not only a new perspective on the work of Abakanowicz, but on fiber work generally, which has suffered from still-operative hierarchical distinctions between art and craft. Claire Zeisler's 1980 exhibition at The Art Institute of Chicago was one of the very few exhibitions in the United States dealing critically with the contributions of the leaders in this field. In the case of Zeisler, the exhibition was historical and dealt with her entire career to date. In a similar way, this exhibition of Magdalena Abakanowicz presents the full range of her work as contemporary sculpture, while also reconsidering recent work in fiber as a significant aspect of the unusually diverse art world of the 1980s.

The exhibition also continues the Museum of Contemporary Art's plan to represent the work of artists from Europe and elsewhere whose contributions warrant serious and, in some cases, repeated coverage, such as the recent exhibitions of contemporary art from the Netherlands and a major retrospective of work by the late Yves Klein. These exhibitions are an important way to serve an interested public as well as artists in Chicago. For this reason, we are particularly pleased to be presenting this exhibition of Magdalena Abakanowicz in cooperation with The Chicago Public Library Cultural Center. The *Abakans* will be installed at the Cultural Center, with the cycles from the *Alterations* at the Museum of Contemporary Art. After the Chicago opening, the exhibition will travel to other museums in the United States, Canada, and Japan. This accompanying book should add considerably to our understanding of an extraordinary woman whose art, as a direct extension of her experience and circumstances, is a powerful, yet vulnerable vision of our times.

Acknowledgments

During my first trip in February 1979 to the artist's studio in Warsaw, I was able to experience firsthand the visual strength of Magdalena Abakanowicz's art. It was an energizing experience to meet with Magdalena, who spoke less about the objects she made than about her interests, feelings, and thoughts. Only a short time before, I had been introduced to her work as one of the many readily available examples of the burgeoning contemporary fiber field. Yet Abakanowicz's art, even in reproductions, had seemed unique.

Plans for "Magdalena Abakanowicz" were begun in 1979 under the auspices of The Detroit Institute of Arts with the support of several committed individuals, namely: Madalyn Rosen, who first introduced me to this rich area of study; Gary Knodel; Susan F. Rossen; and most importantly, Dr. Frederick J. Cummings, Director of The Detroit Institute of Arts, who from the beginning viewed this exhibition as one of the major contemporary shows of our time. Others who have long devoted themselves to this field played an essential role through their contributions to the area of fiber art and the special interest they have had in seeing this project come to fruition. Among them are Alice Pauli, Ann and Jacques Baruch, Mildred Constantine, and Eudorah Moore, to whom we would like to express our deepest gratitude.

The publication of this book has been brought about through the efforts of many individuals. Magdalena Abakanowicz has contributed a special, autobiographical statement, "Portrait x 20," published here for the first time. This prose poem in 20 sections transcends prescribed art historical texts and, while dealing generously and openly with personal experiences, speaks beyond the artist's own situation—as does all her other art. A sincere note of appreciation is due to Jasia Reichardt who, having organized one of Abakanowicz's most important exhibitions at the Whitechapel Art Gallery in London in 1975, was well-qualified as the contributor of the extensive, illuminating essay that follows on the artist's art and life. Ms. Reichardt would like to thank Stefan Themerson and Nicholas Wadley for reading and commenting on her essay; Celina Wieniewska for translating Polish texts; and Irena Gabor-Jadczak for facilitating her contact with Poland. Although the photographs used here come from many sources, many of the most important have been supplied by Artur Starewicz, who for the last few years has documented Abakanowicz's objects and installations; his photographs also provide important background information within the exhibition itself. For his tireless efforts in this regard, and assistance with facilitating the installation of works, we are most grateful. In addition to providing constant personal support, Jan Kosmowski, the artist's husband, has also been an

invaluable reference source, particularly in compiling the detailed bibliography in this book. We are grateful to Nancy Grubb at Abbeville Press for her support and assistance with this project. Finally, we would like to express our deepest thanks to Michael Glass, designer, and Terry Ann R. Neff, editor, whose important contributions have made possible the publication of this extraordinary book on the occasion of this exhibition.

The Museum of Contemporary Art's key role as organizer of this traveling exhibition and coordinator of this publication would not have been possible without the guidance and interest in the art of Magdalena Abakanowicz of John Hallmark Neff, Director; Helyn D. Goldenberg, President, and the Museum's Board of Trustees; and William J. Hokin, Chairman, and the other members of the Exhibition Committee. For the Chicago showing, there has been a new and welcome collaboration between the Museum of Contemporary Art and the Chicago Public Library Cultural Center. We would like to extend our sincere gratitude to the following for their involvement and for enabling us to present a more complete showing than would otherwise have been possible in this city: Marie Cummings, Executive Director, and Janet Carl Smith, Director of Programs, Chicago Council on Fine Arts; Amanda S. Rudd, Commissioner, Mary Ghikas, Assistant Commissioner, and Arthur Morgan, Director of Maintenance and Security, The Chicago Public Library; and Janet R. Bean, Director, and Gregory G. Knight, Coordinator of Exhibitions, The Chicago Public Library Cultural Center. The efforts of many other individuals at both institutions have been instrumental in this project and to them we owe our sincere thanks: Lynne Warren, Jean Marshall, and Regan Heiserman of the Museum's Curatorial staff; and departmental assistants for this project, Mitzi Sabato, Katie Jarman, Dorothy Rudzki, and Jeffrey Edelstein; Phil Berkman, Mary Braun, Nancy Cook, Helen Dunbeck, Ted Stanuga, Robert Tilendis, Alene Valkanas, and Naomi Vine, also of the Museum of Contemporary Art; and Christine Jones and Markus Dohner of The Chicago Public Library graphics department. Recognizing the city-wide interest this exhibition has generated, we would also like to acknowledge the active participation in the exhibition of the School of the Art Institute, namely, Anne Wilson and Park Chambers, whose seminar students also assisted with the massive undertaking of installing the exhibition.

We would like to acknowledge the generous support of this major exhibition and accompanying book by the National Endowment for the Arts. The Chicago showing is funded in part by the Illinois Arts Council. This survey of Abakanowicz's major works of the last 20 years also required the generous loan of works from private collections

and museums. Our thanks to the Centre Georges Pompidou, Musée National d'Art Moderne, Paris; Musée des Beaux-Arts, Lausanne; the Stedelijk Museum, Amsterdam; Pierre and Marguerite Magnenat; and Alice Pauli. An essential component of this project has also been the circulating of this exhibition to other major art museums in North America. We would like to express our appreciation to the participating institutions and to those individuals who shared our interest in bringing Abakanowicz's art to their area on a major scale for the first time: Louise Letocha and Claude Gosselin, Musée d'Art Contemporain, Montreal; Donald Jenkins and Rachel Rosenfield Lafo, Portland Art Museum, and Donna Milrany, Portland Center for the Visual Arts; Harry S. Parker, III, and Sue Graze, Dallas Museum of Fine Arts; and Edith A. Tonelli, Jack B. Carter, and Bernard Kester, Frederick S. Wight Art Gallery of the University of California, Los Angeles. The demands of Abakanowicz's installations, each being an individually executed work of art, necessitate the active involvement of the artist at each location of the exhibition. For Magdalena Abakanowicz's participation in all aspects of the exhibition and publication over the past years, we would like to extend our warmest thanks.

MARY JANE JACOB Curator

Introduction

BY MARY JANE JACOB

Magdalena Abakanowicz's life and art have been a constant struggle, working against limitations—limitations in the accepted use of fiber materials, in the tapestry tradition itself, in the constricted spaces in which she has had to work, in every aspect of daily life in a bureaucratic and poor country. By its very existence, her art, in its stylistic and technical innovations and its sheer enormity, speaks out in defiance of each roadblock ever set before her.

It was over 20 years ago that Abakanowicz initiated a totally new approach to the use of fiber: she insisted on the integrity of this material as a vehicle of serious artistic expression with no utilitarian application, and employed sisal and other fibers, in thoroughly new ways, technically and formally. Using weaving materials and techniques associated over the centuries with crafts, she has made an extraordinarily bold statement that is far different from anything produced by weavers in the past. Probably more than that of any other contemporary artist, Abakanowicz's approach to fiber has served as an inspiration for the international development of art in fiber throughout the 1960s and 1970s.

Abakanowicz's first important works were the *Abakans*: huge, coarsely woven forms that are usually tubular or circular abstract shapes and incorporate open slits, folds, and wrapped protruding elements. These pieces were conceived three-dimensionally, first projecting from the wall and then fully sculptural, hanging free in space. Within the group of *Abakans* are several pieces known as *Black Garments,* which hold an important pivotal position. Extending from floor to ceiling, these rectangular shapes, rounded at the top, are suggestive of giant headless figures or enormous costumes on a hanger. Their black or dark-brown color and overly large scale give them the presence of judges or gods hovering over us.

In the early 1970s, Abakanowicz expanded upon the figurative idea, taking the actual human form as the basis for several cycles of works that compose the *Alterations*. In a series of headless *Seated Figures* and torsos called *Backs,* she used the same materials (burlap, string, and other fibers) and the same forms (by pressing these materials into a plaster mold) to create multiple works that, like human beings themselves, retain their unique individuality. Simplifying her forms and intensifying her ideas, Abakanowicz also dealt solely with the abstracted forms of the head. In a series of 16 *Heads,* 42-inch-high standing ovoid forms which are stuffed, wrapped, and stitched together, Abakanowicz traced the effects on human beings of today's artificial environment and unlimited stress. At first the head is calmly contained within the "skin" wrapping; then the seams of successive

pieces begin to open like festering wounds, tear apart and burst, spilling out their insides; finally they re-emerge unwrapped, fully exposed, their internal parts now carefully bound together in rows—a transcendent state after a period of turbulence.

The *Heads* were also important in leading to Abakanowicz's masterpiece, *Embryology*. The ovoid forms, previously all of the same size and upright, are here multiplied into hundreds of pieces of various sizes. Moreover, the use of semitransparent gauze and nylon in addition to the coarser burlap allowed Abakanowicz to reveal sections of their tangled insides. *Embryology*'s organic references are suggested in "Soft" (see pp. 102-103), in which the artist recalls a tadpole whose pierced membrane revealed the substance contained within— an experience met with horror and fascination. *Embryology* marks a culmination point in Abakanowicz's use of the soft materials which, sharing characteristics with living matter, express her ideas about nature. Most recently Abakanowicz has begun to employ another fibrous, natural material: wood. Binding together small birch branches with wire, she has formed a series of ovoid forms entitled *Pregnant*.

Although the *Abakans* seem to represent an abstract phase of Abakanowicz's work, with the *Garments* as transitional and the *Alterations* being more clearly figurative, this distinction is not so rigid as it may at first appear. Abakanowicz has always made reference to the human body in her art, and fiber, a natural, pliable material, is well suited to the organic concepts evident in both directions of Abakanowicz's art: the *Abakans* and the *Alterations*. In their woven material, their fissures and protrusions, *Abakans* have a fleshy look. This is particularly evident in the monumental, round-shaped examples where huge openings and thick, folded areas appear like vaginal forms and, in their female associations, *Abakans* can be seen as aggressive, sexual shapes. Abakanowicz's use of the figure in the early 1970s shifts the focus of her work from the internal to the external, primarily the expressive potential of the body's shell. While some of these series deal literally with the human form, the figure as an abstract shape, in its essential form, was employed to create the *Heads, Embryology,* and *Pregnant*—all titles which reinforce the figurative reference. Much of the energy and beauty of Abakanowicz's art has been drawn from this constant dialogue between abstract and representational concerns.

The *Abakans* and the *Alterations* are different not only in terms of chronology and subject, but also in their approach to media: Abakanowicz wove all of the *Abakans,* while for the *Alterations* she bound, wrapped, stitched, or molded already-existing materials. Again, the *Garments* mark the transition, since the most important

works in this group incorporate mantles of black-dyed burlap sacking laid over their black woven structure. This sacking has become the primary substance for all Abakanowicz's later work. She has also employed industrial tarpaulins, for example, in an untitled installation at the Malmö Konsthall. Thus, Abakanowicz over the last decade has steadily been moving away from weaving toward the use of readymade fibers. Yet, just as with her evolution from abstraction to figuration, this line cannot be so clearly drawn. Her recent environments fabricated from altered, readymade materials have much in common with her early use of the rope, undertaken simultaneously with her *Abakans.* As a means of defining and manipulating space, she selected an industrial hemp rope and wooden wheel—the former altered by the use of paint and some burlap wrappings, the latter by some additional wood attached to its surface—and both marked by time. Her use of rope beginning around 1970 parallels the uses of this medium in the work of Eva Hesse, Jackie Winsor, Robert Morris, and other contemporaries.

In addition to its formal innovations, Abakanowicz's work is most of all an expression of the most intense of human emotions. The powerful *Abakans* of Abakanowicz's early career possess a youthful, aggressive energy and larger-than-life scale appropriate to the work of a new artist emerging from Poland and rapidly commanding international attention. When combined in installations, the forceful *Abakans* take on a dark, mysterious, sometimes forbidding but always magical quality. They challenge the notion that they were made by human hands alone. The *Seated Figures, Backs,* and *Heads* have a very different tenor, and as such, also have autobiographical implications. They seem to mark a more mature period and a growing consciousness and concern for man: for her people and for all humanity. They speak not only about economic plight and physical poverty, but also, more importantly, about the poverty of the mind, the breaking down of man's spirit, and the fear and anxiety that have become all-pervasive. *Embryology* is also particularly significant personally. Both specifically and generally, the cycle is about the process of birth and growth in human beings and in nature, and the changes that bodies or earth undergo when cut or altered. *Embryology* precipitated Abakanowicz's most recent sculptural group, *Pregnant,* and a series of drawings entitled *Bodies,* which are torsos bulging with life.

Abakanowicz's move around 1973 to readymade cloth helped to encourage more widespread interest and knowledge of her work in the art realms, since the distinction between handmade and readymade materials has often been used as a criterion to distinguish craft from

art. Yet in retrospect, Abakanowicz speaks of the ultimate failure of her earlier monumental woven works, not on aesthetic grounds, but in terms of critical response and appreciation. In the end, for all the great acclaim they have aroused over the years, *Abakans* are finally talked about as tapestry or weaving. Despite their revolutionary stance, it is their woven quality that seemingly locks them into this field. It is hoped that this retrospective exhibition, in bringing together all phases of the artist's career to date, will serve to enable us to view her art differently.

The work of Magdalena Abakanowicz possesses a remarkably powerful emotional intensity and mystery. We experience her art in our minds, hearts, and guts. It is made out of the ordinary struggles of daily life, which are expressed in these gnarled, tense forms. Abakanowicz's art is at once intimately personal, as it derives its inspiration from the artist's own thoughts and experiences, and genuinely universal, as it communicates a profound historical sense of the condition of both Abakanowicz's country and modern man.

Seated Figure 1974/77 (cat. no. 64)

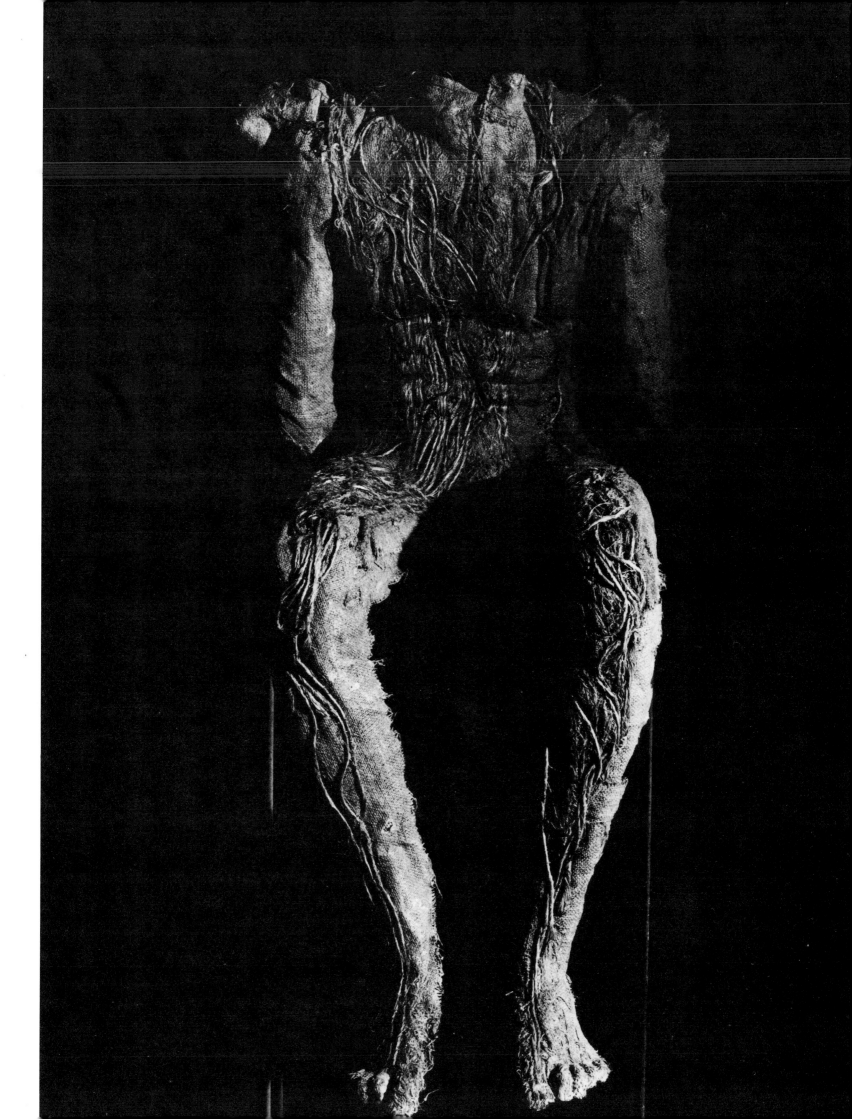

Portrait x 20

BY MAGDALENA ABAKANOWICZ

Introduction

When I learned to use things, a pocketknife became my inseparable companion. Bark and twigs were full of mysteries; and later so was clay. I molded objects whose meaning was known only to me. They fulfilled functions in performances and rituals which I created for myself alone.

I was born in the country and spent my childhood there. I had no companions of my own age. I had to fill the enormously long and empty days, alone, minutely exploring everything in the environment. Learning about all that was alive—watching, touching, and discovering—was accomplished in solitude. Time was capacious, roomy: leaves grew slowly, and slowly changed their shape and color. Everything was immensely important. All was at one with me.

The country was full of strange powers. Apparitions and inexplicable forces had their laws and spaces. I remember *Południce* and *Żytnie Baby*.* Whether I had ever seen them, I cannot say; in the hamlet, peasant women talked about them. There were also some who knew how to bring about illness or induce elflock.

At home, these superstitions were not treated seriously. Yet they existed as an important part of my surroundings.

Imagination collected all that was impenetrable and uncertain, hoarding secrets that expanded into worlds. In anticipation, perhaps, that this font of truths accumulated without control, direction, or pattern would one day be of great use.

* Female ghosts who were said to appear on hot days at noon, and rye hags, respectively.

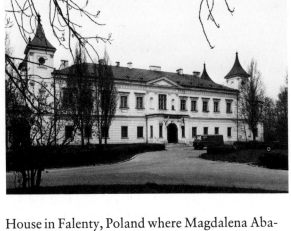

House in Falenty, Poland where Magdalena Abakanowicz was born and in which she lived for the first year

Before

At the very beginning, women took care of me. There were several of them. They carried me in their arms, bathed, and fed me. I remember their cheerful faces. They played with me as a baby, and later, as an infant still unable to stand properly and uttering those first words incomprehensible even to myself. I knew that the women were there, would always be there, and that their merry and happy world was my place. But I also knew, and this was painful, that none of them was my mother.

Mother appeared rarely. She was beautiful. Tall with long hair piled up at the back of her head. Fragrant. She brought unease to my entire world: the women grew silent, I became timid, almost frightened. I wanted to please her, to deserve her attention.

Some years later, I learned and came to understand: she had passionately wanted a son. My birth was a terrible disappointment to her.

Evening

There was no electricity in the country in those days. Oil lamps were cleaned daily. The wicks were trimmed and adjusted, the decorated bronze containers were filled. During the long evenings they had to be watched. An irregular flame could suddenly change into a plait of soot, fine but greasy, settling everywhere.

The light was yellowish, dispersing in circles like a warm suspension. Out of darkness grew interiors of huge rooms. Enormous deep shadows transformed objects into ambiguous shapes. All was quiet. Spaces grew and expanded and, no longer enclosed by walls, remained in blackness. There I waited every evening for those who can approach humans only at night. I knew that these were good spirits safeguarding our peace.

Father

The house was old, large, with walls at least one meter thick. Gothic windows. Father occupied its western wing. One did not go there. The floors creaked. Father did not like children's noise.

He would get up before dawn. On horseback, accompanied by his dog, he rode over the whole estate. In winter and in season, he hunted. He used to go for the whole night, alone. In the morning, a cart would bring the game from the forest. The wild boars were huge. Later their hides lay on the floor, dressed, complete with fangs and hooves.

According to mother's wish, father sat at the head of the table. He was the most important. He ruled and made all decisions. People listened to him. They came for help and advice. According to old custom, they kissed his hand.

Encounter

Between the ponds and the pine grove was a fallow field. Sandy, white, overgrown with clumps of dry, stiff grass. It looked strange. The tips of each clump converged, forming a kind of tent. The whole wide area looked as if it were covered by minute bristling cones. No one ever changed anything there. Everyone knew it should be left alone. "They" live in the grass, it was said.

Only once did I see . . .

While prodding a clump of grass with my hands, he ran out. A tiny man, perhaps a little bigger than an acorn.

The sun was hot. It was time to go home. The bell was ringing for lunch.

Summer

Best when no one saw me. I got up when the light came through the shutters. Carefully, so that the metal bed would not creak. Barefoot, with shoes and clothes under my arm, towards the heavy brass door handle. It must not squeak. On tiptoe along the passage, avoiding the sagging planks. Then the kitchen stairs and across the hallway by the cellar, so as not to be seen by any servant already awake.

Beyond the park, near the marshes, the grass reached my face. I knew each blade. I went where the bog started, overgrown by alders, near the stream, and there I stayed.

There was plenty of time. I knew where the sun would be in the sky when the search for me would begin. I had to return before, through the window, avoiding being seen, avoiding questions.

Secrets

That Place was in the very corner of a dark hall where, on the wall, there was a painted knight in armor with four horses. When silence and tranquility evoked an atmosphere of safety, I would bring over my objects, carefully selected among the grasses and the scrub. They wanted this from me. Slowly they came to life. Slowly they began to communicate with one another, and with me. They were moving independently, approaching one another, approaching me, retreating, again and again. This took time. It grew slowly, then faster, until it turned into a dance. I was inside it, taken over by the movement and the changing image. Obedient to the rhythm, united with them. Overcome by anticipation of what might happen with these living stones and branches.

A large tree by the road was split lengthwise—black inside, burnt. By lightning, maybe. The interior was as strange as any darkness in which anything could happen. I was afraid to stand by the trunk. I felt that from some crevice something might creep out that I dare not name.

A transparent, large *Południca* was shimmering in the sun, in that terribly hot air in which it seems impossible to breathe. One could think about her, imagine her, but one must not look. With the whole body one felt the danger of being in the open fields at high noon. Something would happen above the earth in which we cannot take part and which we dare not disturb.

In the evening, women knelt in the road before the Holy Virgin that hung on a poplar tree not far from the gate. They sang litanies. On the eve of feast days they plaited long wreaths of oak leaves and spruce twigs. They adorned with them the whole poplar tree and on the picture of the Virgin they stuck flowers and ribbons of colored tissue paper.

Christmas Tree

Growing, I was conscious of being a failure. I felt it. I knew it. In prayers, loudly repeating the words kneeling at the side of the bed, I was silently saying: make me become a boy.

Long before Christmas, the first gingerbread cookies were baked. Highly spiced, they had to be stored in a cool larder for weeks. Mother asked: What do you want from Santa Claus? Embarrassed, cornered, I whispered into her ear: I want him to make me a boy.

On Christmas Eve, excited, desperately worried, confused, I looked through the window as He was arriving. The light of a lantern could be seen approaching from the forest. Tall man with a white beard— Santa Claus. He entered brushing the snow off his boots, enormous, in a long coat with a hood. The kitchen maids giggled. I shook, unable to utter a word.

He brought toys, beautiful, unexpected. Then disappeared.

Father was never present then. He arrived later. He sat with us at the table.

Education

When I was six, I was given a teacher. A stranger. I was used to seeing strangers only from a distance. They made me uneasy.

He asked many questions. I was so frightened that I hardly replied at all, and the little I said did not make sense.

He told me to draw a sunset. I could not do this either. Mother asked him what he thought; he shrugged his shoulders.

After some time, a woman teacher appeared in the house and stayed. Everything she disclosed to me was alien and hostile. It refused to become a habit.

Like my prayers, I repeated formulas and facts, distasteful and daunting. I cried. I was so nervous when answering questions, that everything became confused. I wept, helpless in my own inadequacy, conscious of my shortcomings. I went to see mother. She consoled me: you will not have to take any exams or go to university.

I escaped outside.

With a long pole, I pushed a wooden canoe into the reeds. Without a thought I became one with the murmurs of the time of day and with this whole world of movement and stillness, growth and decay. There I belonged. With concentration, for hours I looked at the grass and the water. I wanted to subordinate myself to them, so that I might understand the mysteries which separated me from them.

Illness

Mother taught my elder sister to play the piano. Not me. I myself came to believe that it would have been a waste of time.

When a baby was born in the village, people came to ask my sister to be godmother. Because she was lovely. She enchanted me too, by her delicate softness. But at times, embittered by my otherness, I would pummel her with my fists. She made light of it. Faced with my violence, she escaped to mother to complain. Separated by correctness, she lived apart.

I wanted to listen to the piano. Up in a tree close to the drawing room windows, between the leaves, I felt secure.

The sound of the exercises scattered over the garden, repeated again and again. I felt, or began to understand that there was some knowledge of which I must have been deprived at the very outset, or that I had never been given that "something" thanks to which people know how to act. I groped blindly, desperately, not having any pattern to follow. Exposed to ridicule, certain of being at fault, I feared my own behavior.

I could not even trust my body. Small and frail, I was constantly ailing. Mother did not like weakness. She laughed at it. One day I became really ill. I felt strangely hot. Something was growing inside my throat and filling it. I breathed in with loud snorts. Neither the doctor from the village nor herbs were of any help. Fever. Hoarse breath, more and more difficult, ever harsher, the throat full of some choking softness.

When father came, I understood the uncommonness of this sickness, and of my importance because of it. For once at least. As never before. I now existed. I was *me*. An important reason for the concern of all.

Father ordered a bucket of cold water. He dipped a sheet in it. He undressed me. Wrapped me up in this cold wetness. Laid me on the bed, covered me with a quilt. He waited for the sheet to dry, warmed by my skin, and soaked the next one. Again he wrapped me up in this wet coldness, and when it became dry, began again. Again, and again, so many times. Day and night, he came and listened to my breathing. Temperature began to fall. I spat out some gluey thick gray stuff from my throat. Time passed. I felt better and regretted it. When it was all over, responsibility for myself returned. And the fears. And like a treasure I carried the memory of that helplessness which had been accepted.

That it was diphtheria we learned afterwards. When a few months later my sight began to weaken, a doctor in Warsaw looking for a cause, made that diagnosis.

Necessity

The urge to have around me, to touch, to hoard—twigs, stones, shards, bark—continued. They embodied stories with which I wanted to live. Later, I carved out faces with a knife. I wanted them to resemble people. They did not. I watched mud settle after treading in it with a bare foot, rising between my toes, greasy, soft. I squeezed clay —too obedient in the face of my lack of decision. Near the avenue of chestnuts, by the pond, in a yellow pit, there was a lot of it. I stood there, checking my desire: I was not allowed to get dirty, yet I needed to fill my hands with it. The heads I molded dried, cracked, and disintegrated. Father once brought me from town some plasticine. I molded faces, placing one next to another. All were in profile. But no one liked them—profiles did not look like this. I continued to mold and to carve although sometimes everything had to be thrown away when the nursery was being cleaned. I went to the rubbish heap to look for what could be retrieved. Began anew.

Forebears I

In the spring, potatoes, which had lain all through the winter covered with earth and straw, were sorted. I went to look. Stealthily I collected those which were discarded and shriveled. They had eyes and wrinkles. Strange, they surrounded me like a family, friendly, textured, touched.

Among the plants and the animals, everything was good. Man, I was unable to fathom. Gestures, sudden words, cut-off feelings. One evening that winter there was an all-pervasive stillness. The stoves fell silent after the second stoking. On tiptoe I went to father's study. He was reading. I stood uncertain: he could have ordered me to go away. But he called me in. I am not sure whether he talked or read:

> *At the beginning of the 13th century, a powerful movement came from the depths of Asia: Mongolian tribes, also known as Tartars, began to advance, grabbing everything. When in 1206 they elected Temouchin as the Khan of the whole of Mongolia with the title of Genghis-Khan, their state became a great power. China succumbed to it, as did Central Asia and Eastern Europe. One of the great Mongolian armies under the leadership of Houlagou-Khan, marched towards Persia. Two years of terrible battles and destruction. From conquered Persia and Outer Caucasus, Houlagou created his own Mongolian state, powerful and rich. It was to be ruled by his dynasty. And after his death, his eldest son, ABAKA-KHAN, came to power. The Great Kouriltay—the Mongolian parliament—entrusted to him the throne of China....*

Tense, squeezed into a corner of an armchair, I listened. This was not a fable. Seven centuries have changed the name to its present form. A mighty tribe perished during the Russian Revolution. Two boys survived the conflagration. The brothers fought in a bloody crusade and, having lost their close relatives in Russia, got through to Poland, their mother's country of origin.

The elder was called Konstanty. He was my father.

I imagined those vast areas covered with Tartars' tents. They put fresh meat under their saddles. They sat on it until it became tender. And ate it raw.

Distant, full of strength. How much I wanted to be part of all this. In the story, everything seemed straightforward. Without those small, painful details. Distant, imagined people, only partly real, they were mysterious and magnificent. How to stay in the imagined world. I wanted to, so much.

Forebears II

In the dining room, father's study, and mother's room hung old portraits. Mother knew the history of her forebears. She talked about it —but I did not retain much. The dates and places were real, as in a history lesson, but I myself felt no connection with these individuals in armor and furs, with heads half-shaved according to old custom.

Only one was outstanding. I used to climb on the back of a sofa to peer at his face. He was young, with fair hair. In place of pupils in his blue eyes were two holes. A Swedish sword had wantonly blinded the portrait.

In the attic hung bundles of fox hides, deer and squirrel skins. There were large trunks with unknown contents. Among high beams lived bats. They hung like soft bags, protecting with the membrane of their wings the fur on their bellies. Delicate but ready to bite an intrusive finger with teeth like needles. I used to go there from irrepressible curiosity, never entirely able to penetrate the darkness.

Once when an aunt arrived, one of the trunks was brought downstairs. It contained documents. Old parchments with seals as large as saucers dangling on silken cords threaded with gold. Each of the seals was enclosed in a protective box made of brass. For their bravery in battle, knights were rewarded with land by Polish kings. These deeds were written on beautifully worked leather resembling paper. I remember three odd signatures. First, of King Casimir the Jagiellonian who ruled Poland between 1427 and 1492; second, of King Jan Casimir of the 17th century; and, finally, that of the last King of Poland, Stanislaus Augustus Poniatowski. Their writing! They had long since vanished. Like opening a coffin. Dead fingers holding a goose quill. A twirl at the beginning and at the end. Then, suddenly, a fear of responsibility towards the achievements, bravery, and sacrifices of these ancestors. No. Better to forget quickly, at once. To remain as before, without the uncomfortable burden of other people's victories, and the shame of impotence.

War

I was nine. It was autumn. On the very edge of the park, a road led from the mill to the avenue of alders. German tanks were coming. We stood on the terrace, taken by surprise, watching. They were looking at us, standing as if on parade. I saw them for the first time, faces, uniforms.

I did not know how to hate. I did not believe it. I could not understand why they should hate the four of us on the terrace.

They fired, aiming, probably on purpose, at a wall.

I stood fearless, suddenly humiliated by their violence, helpless in the face of injustice and the impotence of my parents.

Some years later, father taught me to shoot. To clean and assemble weapons.

At night, partisans would come. Poles, Russians, very often the same people known to us and friendly. Later, more and more frequently, just robbers. Germans by day. The house exposed us, it ceased to be a shelter. The forest also became alien. I no longer went there to talk to it as before.

Killing

I remember, once upon a time. I was then still tiny. I sat near mother on the steps of the terrace. She was playing with my sister and I wanted to join in, clumsily, jealously interfering. Pushing me away, mother said mockingly: "I bought you from a Jew." I felt as if my insides had turned to stone, suddenly without the certainty of my situation, a stranger to myself, filled with the panic of doubt.

Moshe had a small shop in the village. His wife wore a yellowish wig. He delivered groceries to our house and bought things from us. He looked timidly around, bowed many times, his cap held awkwardly in both hands. In the autumn, he leased part of our orchard. With his son he lived in a makeshift shed. The boy had black curly hair, a flat nose. I was allowed neither to play with him, nor with other children who, wild and dirty, might carry lice. I longed for friendship but achieved it only in daydreams. I imagined myself, with excitement and clarity, walking with somebody across an immense plain, understood, sharing confidences.

It was several years later, on the day when it was already known that the Germans were going to deport all the Jews to their death, I was with father in the village. Almost stunned, I did not listen to what Moshe was saying to him. His face seemed to be smiling, but from nearby I saw that his skin was shaking and twisting.

To reach our sawmill, it took over an hour to walk through the forest. Foresters lived with their families in wooden houses and, since the outbreak of war, other men had joined them. Allegedly they worked in the sawmill or helped father in other jobs and only father knew who they really were.

One day, after this conversation in the village, I saw Moshe's son carrying some timber between the houses in the forest. My father thought that there he would be safe. This lasted for about a month. Then he was killed by a man from the village called Bolek. It was said that he spied for the Germans. He did not get very far. Soon after, he was killed by our men who had seen him shoot the Jewish boy from behind. I went to the spot where Moshe's son died. There I found a small piece of flat bone. I picked it up. There were many similar bones scattered in the bushes near our outbuildings. I had seen farm animals being killed. I had not thought of it as death, and with human beings it was the same.

Once I wanted to have a frog's skeleton. The way to get this was to place a dead frog on an anthill. So I threw stones at a frog for a long time, yet it refused to die. I suffered with it most terribly until, at last, covered with sweat, I ran away.

Mother

They came at night, in 1943, drunk. They bashed at the door. Mother rushed to open it. One opened it to everybody. She did not make it: they began to fire. A dumdum bullet tore her right elbow. It severed her arm from the shoulder, wounded her left hand. The capable, wise hand suddenly became a piece of meat, separate. I looked at it with amazement. I had seen dead bodies, but they somehow had always preserved their completeness in front of others.

We had to wait until the morning to go by carriage to the small town where there was a doctor.

She survived in spite of a terrible loss of blood and excruciating pain.

When she returned from the hospital, maimed, I attempted to replace for her the hand she had lost. I never left her alone. It was thought at the time that I would become a nurse, yet I only wanted to make up to her for the great disappointment of my gender. I wanted to be both needed and loved, if only now, to attract her attention, and perhaps even praise.

1944

Things were more and more frightening. The front line was approaching. A revolution.

One day father ordered horses to be harnessed. We left for Warsaw.

As our home and the countryside receded, I felt increasingly hollow. As if my insides had been removed and the exterior, unsupported by anything, shrank, losing its form.

Insurrection

I do not remember the beginning, the firing from all sides, mother and the two of us lying in the street. Later everyone was running, we too. Suddenly I was alone in a crowd of people. Strange faces. I shouted: "Mama, Terenia!" Impossible to turn back; only forward. Suddenly Terenia was there. She grabbed me: "Where is Mama?"

Afterwards, we were with father in Milanówek, and mother was cut off from us somewhere in Warsaw. The city was closed. At night the sky was bright with flames. In daytime, a mushroom of smoke. In it, burnt pieces of something enormous lifted very high by hot air. Huge sheets, papers, falling down, disintegrating on the pavements, in small gardens.

I do not remember what happened during the long wait. I dreamt about her. Not maimed. I willed her to have hands again. So that what had happened would be undone. I thought about it intently and continuously, demanding that time be reversed, wishing her to return to us as before. Two months later, she arrived.

Embracing her, thin and shrunken, I could feel her infirmity very precisely. An empty sleeve.

The Boy

They were bringing the wounded from Warsaw. The hospital was in the school and in some other buildings and barracks. I went there to help. Taller than my contemporaries, nobody could tell that I was only 14. I carried water and stretchers. I remember one day they brought someone with his face completely burned. He screamed all the time from his open mouth while on the stretcher, and later, when laid on the floor, until he died. Constantly new people, always horribly wounded. There were neither analgesics nor disinfectants. Lice thrived. I killed them on a comb. They were everywhere; everybody had them. Lack of beds. Too many damaged people. A crowd. I do not think I talked to anyone. I did not know how to. Frightened that someone might ask a question and I, as during lessons, would not have an answer.

Only once was it different and this has stayed with me. I remember it still so precisely that even now I could draw the face and the hands of that boy. He started talking to me as soon as they had brought him in. He had fever and flushed cheeks. I sat on his bed. I felt that I should listen quietly. Jurek Godlewski—that is a pseudonym. Soldier with the Home Army, he was 18. He talked about what he wanted to do in the future and of the time when he was small and lived with his parents. I listened, hiding my chapped hands under my apron. He talked to me as if he knew me, looked at me, and smiled as if I were someone close to him. Afterwards, I came to sit at his bed every

day. On leaving him, I thought about him joyfully and in my dreams he was with me in my childhood forest. I do not remember how many days passed, such long days, filled with words and dreams. When he died, he seemed very small: both his legs had been severed by shrapnel.

School

In my class there were only girls. They wore dresses and ribbons in their hair. I was self-conscious about my size, and my clumsy ill-matched clothes.

Their homes had remained untouched. Everything had passed them by. I looked at my feet in men's shoes. Once probably light tan, now distorted, they deformed my feet. Who wore them before me?

In the market with the detritus of the burned city everything was sold together, crested antique silver along with old rags. From the old house, a single summer dress remained. The winter was terribly long, cold, and damp.

Worst of all were the breaks between classes. A noisy crowd, gesturing, staring, joking. How to begin, how to find words, how to take part in these completely alien jollities? Impenetrable, because unfamiliar from the very beginning. I stood alone.

MAGDALENA ABAKANOWICZ 1978-80

Magdalena Abakanowicz

BY JASIA REICHARDT

ABOUT MAGDA

Had times been different in 1942 Magda, like Isadora Duncan, might have awoke one sunny day to the conclusion that she would devote her life to beauty and truth, or indeed any of the other absolutes of cosmic importance to a 12-year-old. As it was, with nothing either absolute, true, beautiful, or sacred in Poland at that time, there could be no models for heroic plans and Magda came to confront life by hiding her inner dreams from the outside world: "When I was 12 in 1942, one could only escape from human cruelty inside oneself (into a world of dreams, imaginings), and I learned that it was necessary to cover carefully the traces of these flights."[1]

To survive, one had to be flexible. And indeed, Magda readily admits that she started working with cloth because it could be folded and stored under the bed. In this way she became an artist, using the loom as her tool and fiber as her medium. However, in Magda's view the cause and effect are not so simple: "It was not weaving that my weaving was about," she wrote. "People consider me a weaver, so to confuse them, I say: 'I was weaving because it could be rolled up.' I delude myself that this will provoke thought because, after all, it is not possible for such practical considerations to decide one's life and creative work."

Had Magda spent her childhood in Tibet, the description of her model for the world, her own future, and her work might have been a clay pot—the clay pot which the Tibetan Buddhists give as a metaphor for the world and its creation. The clay is the earth which is mixed with water, the primeval element in the creation of the universe; it is then dried with fire and finally comes to exist in space/air. In Tibet, Magda might have become a potter.

Had Magda found herself at the age of 12 in Japan, she would have watched carp swimming in ponds, would have learned to observe minute seasonal changes and, with her schoolfriends, would have looked for those 17 apt syllables of the haiku to embody the mood and the quality of some natural event, however miniscule. She might have become a poet.

Had times been different, she would have entered her teens giving vent to her predilections for the romantic and the mysterious. She would have trembled reading Edgar Allan Poe's stories of horror and the imagination; she would have pored over Shakespeare, Rimbaud, and Kafka. She would have understood the passions of the legendary Argentine gaucho Martin Fierro and the intoxication of Don Quixote but, try as I may, I cannot see her reading science fiction, comics, or romantic novels.

As an adult, Magda's life has been about responding to the domain of nature and creating things as a counterpart to what is already in the world. Her pursuits as a child, adolescent, and adult have always been to grasp, to understand, and to absorb those minute, painstaking changes of form, season, and sensation which the world offers, and to create something in response—rather like a gigantic animal that moves slowly and deliberately over dangerous territory, always leaving a trail of its own footprints.

BIOGRAPHY

Magda came to the Academy of Fine Arts in Warsaw in 1950, having completed a successful year at the art school in Sopot. She wanted to leave her old environment and come to the capital, but her life as a student was to become extremely hard. She was very poor, being one of the few students who had no help whatever from their parents. Magda's parents, formerly landed gentry, were surviving by running a newspaper kiosk. Even so, Magda vividly remembers how she had to hide her family background because a student's admission to a school, and his grant, could depend on the former socio-economic standing of the family. Children of pre-war aristocracy were denied places in higher education.

Students lived in the academic house, 16 to a room. But even this sort of accommodation was not always available and Magda recalls a time when she slept in the railway station and later in a room which she occupied together with a couple, their child, and another girl from the Academy. There were other memorable overcrowded rooms that Magda shared or in which she slept illegally, taking turns to use the bed. She earned money and rations donating blood, and every other night she was employed to hold a light for men repairing the street-car lines. She ate at the University of Warsaw. For this, one needed coupons which Magda could not afford, but since they were collected only when the students went up for the second course, she survived on the first course: soup. And so on—a list of occupations, situations, hardships, which seem stranger today than they did then.

Asked about her early years as an artist, Magda has replied without elaboration: "When one stops studying, one has to do all sorts of things to live." Not surprisingly, an interviewer interpreted this as a reluctance to talk about her past.[2] But now and then Magda has talked about her early life, sometimes even as if her student days were still palpably around the corner. She recalls Professor Mieczysław Szymański with admiration. He was teaching at the Warsaw Academy of Fine Arts, working with students on compositions woven from string, newspaper, and other unlikely materials. Magda was not one of his students and this was probably just as well since he was severe, critical, and a strong individualist, and Magda was aware consistently and fervently that she did not want to be taught. The early

1950s was a time of academic Socialist Realism but, try as she might to produce the desired effects, the only images that came out when Magda was drawing were, as she referred to them, "large smudgy things." It was the same with oil painting. Here is Magda's own vivid description of her time at the Academy:

> *The Sopot art school was still liberal at the time, the Academy in Warsaw already was not. I liked to draw, seeking the form by placing lines, one next to the other. The professor would come with an eraser in his hand and rub out every unnecessary line on my drawing, leaving a thin, dry contour. I hated him for it. I liked the transparency of oil paint laid on a white primed canvas. The professor did not allow me to paint in this way. He said that these were accidental effects. Layers had to be solid. When he came to our vast studio full of easels he would say, standing in the doorway: "Abakanowicz started well, but she will spoil it anyway." Of course, I spoiled everything. I had bad grades. I hated the school more and more.*

She hated the atmosphere of the studios and the risk that a professor might interrupt her during the course of work and tell her something —anything. And yet it was important to conform because, in the end, she would need the diploma in order to join the Polish Artists' Union (Związek Polskich Artystów Plastyków), so that she could live and work as an artist. But even despite her resistance, they taught her

Fig. 1 *Composition with Plants* 1957 (cat. no. 1)

Fig. 2 *Butterfly* 1958 (cat. no. 2b)

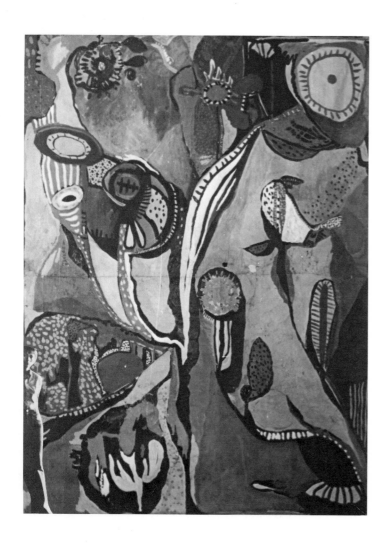

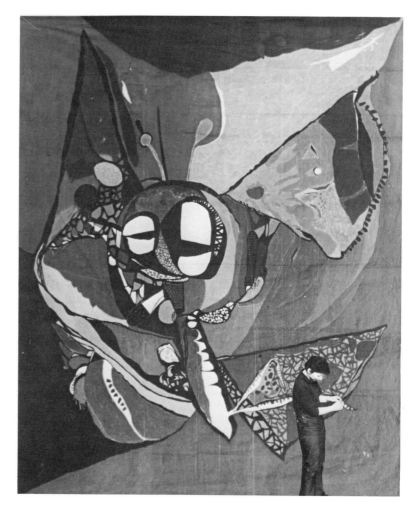

too much. So she still maintains. When years later, in 1965, she herself was asked to teach at the University of Fine Arts in Poznan, she was filled with those awful memories of art schools from her student days and frightened by "the problem of existing among those people!"[3]

In 1954 Magda graduated from the Academy and began work in Milanówek as a tie designer in a silk factory. She hated the job. During her free time, at home, she painted huge gouaches of enormous flowers on sheets of paper pinned to the wall (see figs. 1, 2). Magda has written about this period:

> *Thanks to an extraordinary coincidence, I found, just in the district where I live now, a tiny attic room. It was in a flat in which every room was occupied by a different person. We shared the kitchen and bathroom. I did not have a wardrobe. My clothes hung on a wall. As in all typical attics, the walls were crooked. One was occupied by a stove covered in ceramic tiles, leaving a bit of empty space 220 by 150 centimeters. That was the area to which I stuck sheets of paper on which to paint. My gouaches were as large as the wall permitted. Depressed by years of study, I was fighting back by making those gouaches for myself. For so long it had been repeated that I could not do it; my response had to be on a big scale. I wanted to take a walk among imaginary plants. The wall was too small. I went to the Academy, to one of the professors who had not taught me before. I showed him what I was doing and asked if he would allow me at night to use a studio of which he was in charge in the department of architecture. He was surprised by my work and agreed to my coming to paint. He did not interfere with my work. After some time he said that I should show these paintings at the 1955 competition sponsored by Cepelia,[4] for which he was working.*

> *I won a prize. The judge was Professor Jerzy Soltan, who had recently returned from France where he had been working with Le Corbusier. I was glad to have the prize, but I could already see a basic misunderstanding. The Cepelia competition was for fabric design, but these plants painted on paper had nothing to do with the designs for tapestry [fig. 1]. They simply were. They were not at all intended to be repeats or for decoration. Because they found their way to Cepelia, suddenly they became something that should be practical and utilitarian. If it had been a painting competition—what would have happened then?*

> *I won the competition and was asked to collaborate with Cepelia.[5] I did not know how to. The papers tore. They got dirty in the confined space of my room. I replaced them with linen sheets sewn together and I painted on these. Later I wanted everything to be in different shades of black. I got special paints. They were thick to apply, spattered when the cloth was folded, and my husband* [Magda married civil engineer Jan Kosmowski in 1956] *said they lacked solidity.*

It was then that Magda decided to learn weaving and return to the Academy. But it was not long before a well-meaning teacher tried to teach her conventional methods of weaving. Magda could not stand it and left. She constructed her own one-and-one-half-by-one-meter frame. She has it still.

The first three small compositions done on this frame made Magda realize that there was something mysterious about the uneven surface that gradually became a composition in its own right. "I thought,"

wrote Magda, "that it was truer than depicting matter, because what remains within the frame of a painted picture is just the painting, and matter is left somewhere else to be what it is." And so Magda discovered this soft and powerful medium.

She made a few other experiments during the late 1950s: small sculptures and reliefs from wood and cork (see figs. 3, 4) and, without much enthusiasm, a few oil paintings to see whether, after years of being told that she was unable to do it, it was really true.

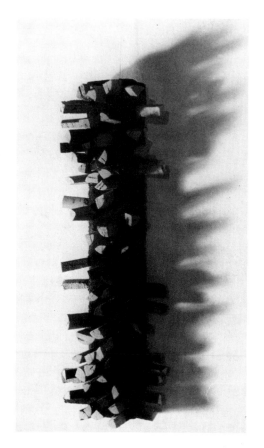

Fig. 3 *Relief* 1958 (cat. no. 3)

Fig. 4 *Relief* 1958 (cat. no. 4)

In 1960 Magda had her first one-person exhibition; she tells the story of it:

My first exhibition was to open on April 2, 1960. It did not open on schedule. Kordegarda, where I was arranging this show, is an exhibition hall in Warsaw belonging to the Ministry of Culture. The Director of the Department of Fine Arts came to look. "Abstract painting," he said. "We will not show it to the public." This was still the time of Socialist Realism. I was showing my paintings on cotton sheets, a few oil paintings, and my first experiments with weaving [fig. 5]. Friends came to the opening. I stood crying behind the closed doors. Through the huge windows on the ground floor one could see what was inside. Maria Łaszkiewicz, a professional weaver, was walking by and looked inside. About a year later at the Ministry a list was being compiled of the best-known weavers to represent Poland in the "1st International Biennial of Tapestry" in Lausanne. I do not know what Maria Łaszkiewicz was doing that day at the Ministry. She saw the list and, with a

pencil, added my name at the bottom. I was invited to submit a project to the international jury in Lausanne. It was accepted. Maria Łaszkiewicz's project was rejected.

The Biennial regulations demanded that the size of tapestries be no less than 12 square meters. That was the size I proposed, but where could I weave something that big? The room which I shared with my husband was 12 square meters. Thinking about this, I was walking down the street when suddenly Maria Łaszkiewicz stopped me and invited me to work in her basement where she had a loom two meters wide. This was in 1961. Maria Łaszkiewicz became my mentor and friend. The place was dark and damp and without heat. I worked obsessively. Having had no practice, I did not really know how to work. I used clothes lines. Colleagues came and were shocked. "Polish weaving will be discredited," they said. I had a toothache, but it seemed a waste of time to go to the dentist; I rinsed my mouth with sage infusion and kept weaving ropes into lumpy surfaces.

Maria Łaszkiewicz would bring me coffee. She was old, with a terribly wrinkled face, quick in her movements, energetic, strict. She considered work to be the most important thing, and self-discipline the most significant quality. She had contempt for comfort and all that is easy. Perhaps she regretted that I had been accepted and she had not. I don't know. She was glad that I was working. She respected work and was severe with herself.

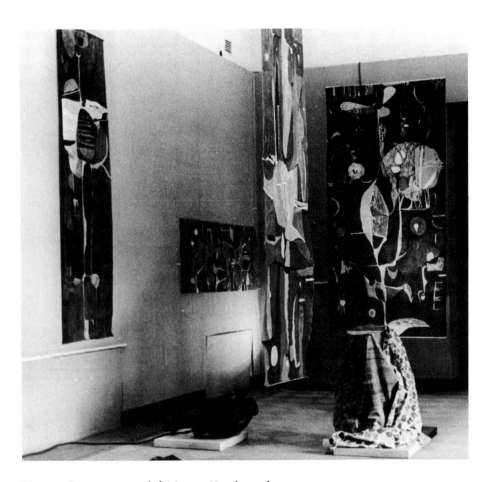

Fig. 5 One-person exhibition at Kordegarda, Warsaw, 1960

For seven years I came to that basement early every morning and left at night-fall [see fig. 6]. Sometimes it was necessary to line up for the loom because there were several of us making use of the equipment. Maria Łaszkiewicz kept on bringing me coffee and the latest gossip. She told me how they disliked me, how they envied me, how they criticized me. She advised me on how to get raw materials. In 1964 she helped me to build my own loom, three meters wide. It stood against the wall in her basement. She helped me to find Stefa Zgudka to assist me.[6] There, at her place, I prepared the woven reliefs for the São Paulo Bienal.

And so Magda started her career as a weaver. During the following 12 years her work developed in her own way, in scale, color, and range of materials. Although since 1973 it has not involved weaving, the substance of the materials she uses has remained the same: it is still natural fiber.

Fig. 6 Magdalena Abakanowicz at work in Maria Łaszkiewicz's basement, Warsaw, 1964

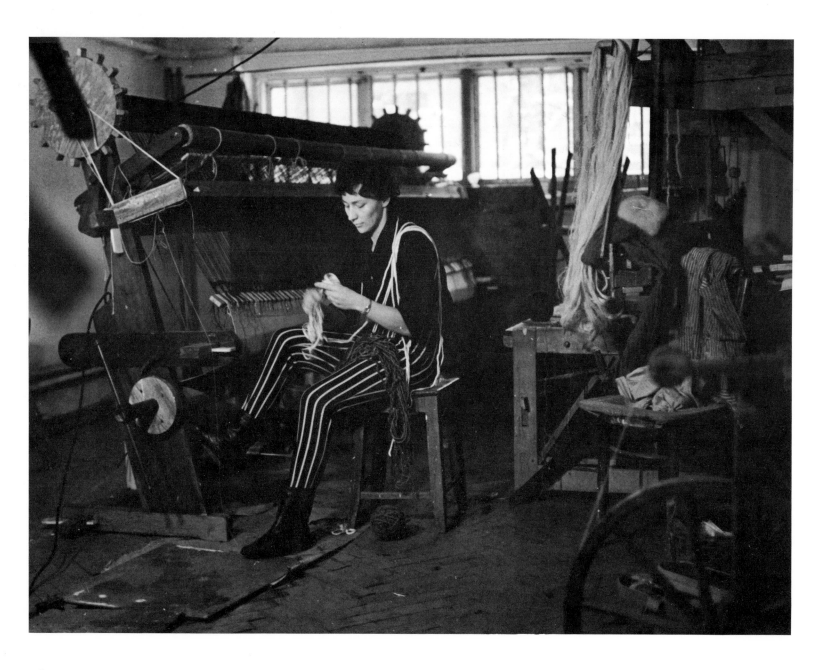

But while the Academy could have taught her only the basic techniques of weaving, Magda's artistic development was stimulated largely by her contacts with avant-garde artists grouped around the Constructivist painter Henryk Stażewski (see fig. 149). Two of them, the painter Maria Ewa Łunkiewicz (Mewa) and Roman Owidzki, she met on her first visit abroad in 1957 when she joined a tour to Italy, organized by the Polish Artists' Union. These people gave her support, encouragement, an introduction to the world of ideas, and standards vital to a young beginner. Her friendship with Mewa lasted until the latter's death in 1967, after which, Magda wrote, she felt very much alone. That friendship was among the contacts Magda valued most.

Perhaps the most significant proof of Magda's universal success as an artist has been the enormous influence that she has exerted on her own and, subsequently, on younger generations. Asked on several occasions if she has founded a school, she admits that her way of working seems to have created one, and now she often finds some works, not unlike her own, at the other end of the world. They may be viewed as unsolicited compliments, but her work as a teacher has also had a considerable impact. When Magda first started teaching in Poznan, she had conflicting feelings about the whole idea. For the first ten years she hated teaching and was frightened of students, yet she believed that this was a valuable service which she could contribute in her own country. She did not know what to teach in the weaving department—she could hardly, after all, pass on her own obsession. Technique must come first. Discipline. Construction of verticals and horizontals. Color theory. The students had to look, to feel, to ask questions.

Today, at the University in Poznan, Magda has a department with two assistants who teach basic techniques and seventeen students who elect to do weaving plus one other specialization. These third- and fourth-year students, aged twenty-two to twenty-four, work on weaving three days per week (see fig. 7). It is a tradition at the University to undertake some work in and for the town; this provides students with contacts and practice in dealing with the everyday problems of the outside world. For several years the weaving department has done projects for institutions such as hospitals and children's homes, each student producing a work for a particular location: a kindergarten, a center for the blind, a home for war veterans, a cancer ward, a psychiatric screening room, and so on. More and more Magda enjoys the contact with young people and she takes great personal interest in everything relating to their work and their lives.

Today Magda has three jobs: she is a housewife and an inventive cook; she is her own secretary and makes all the practical arrangements for her work and her exhibitions; and she is an artist, although she says that being an artist is not a job but a state, a condition. Here

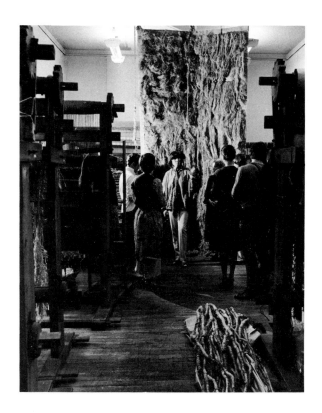

Fig. 7 Abakanowicz with students at the University of Poznan, Poland, 1981

is how Magda describes her day, an ideal day she says, because an average day is full of interruptions—necessary, but a nuisance all the same:

> *I get up at 6:30 a.m. My husband has to be at work at 7:00. After he leaves, I prepare lunch so that on his return it only has to be heated up. I am in the studio before 8:00. My assistants, Stefa and Krysia, come at 8:00. Work is slow and consists of many simple activities. In the case of Embryology, for instance, thread has to be prepared. It has to be soaked, dyed, rinsed, and dried. Readymade thread in the required color does not exist. Gauze must be dyed, the sacking cut. Only then can one start building the form. That I do myself. Then we must cover it together. Afterwards I make changes, corrections, and meanwhile Stefa and Krysia prepare material for the next form. At 3:00 p.m. my husband returns from work. We eat very quickly and I return to the studio. At 4:00 Stefa and Krysia go home. I continue to work by myself. Around 6:00 I go to the room next door and write letters. Around 7:30 we have supper. It is usually prepared by my husband: bread, butter, cheese. Then I return to writing letters. I finish about 12:30 and go to bed.*

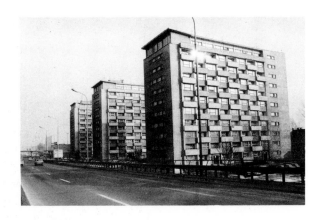

Fig. 8 The apartment house (foreground) where Abakanowicz lives in Warsaw, 1981

Fig. 9 Abakanowicz in her study, 1981

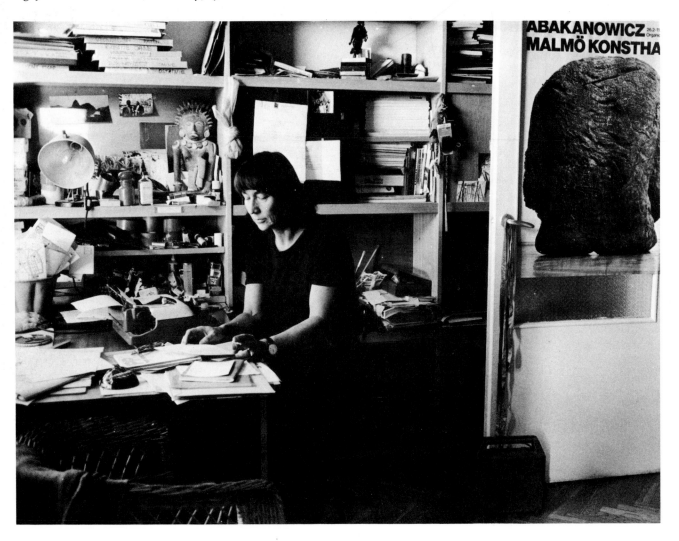

38

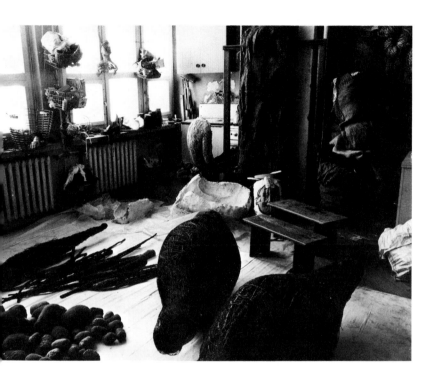
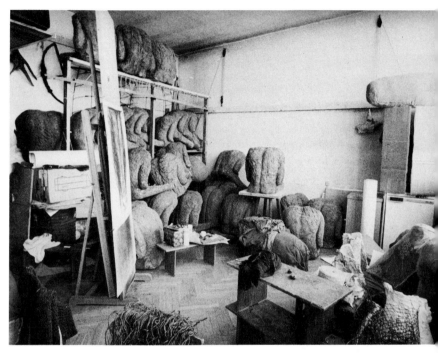
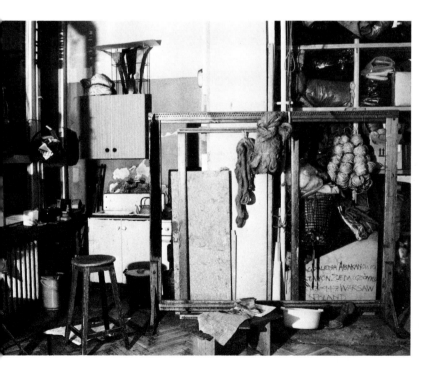
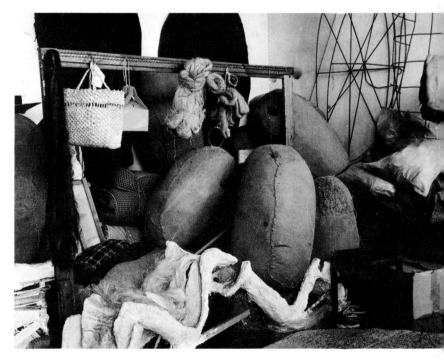

Figs. 10–13 Abakanowicz's studio, Warsaw, 1981

Magda's correspondence is vast and takes up a lot of time. For her, letter writing is a powerful form of communication and her letters are always very personal, although they deal with professional matters; all are translated—some by Magda—into the language of the addressee, and most are typed by her. She says: "I do not like writing letters because they take up time necessary for work, but I very much like the ensuing conversation. I have met so many people as the result of my correspondence." During 1977 Magda's husband became ill; she stopped work for a year and started writing about her art and her life. Her series of notes, "Portrait x 20" (see pp. 18-29), belongs to that period. Many artists write about their early childhood and adolescence and stop at a time when they begin to take responsibility for themselves and the world. They inevitably return to that magic time when they saw entire worlds in peeling ceilings, listened to the threatening sound of footsteps on a wooden floor, saw the expression of some animal befriended or molested, and heard the disconnected phrases of conversation. Magda has written about these years in "Portrait x 20." That is her real biography—an autobiography.

Fig. 14 Making a face mold; from left to right: Magdalena Abakanowicz, Stefa Zgudka, and Krysia Kiszkiel, 1981

Fig. 15 Abakanowicz and her husband Jan Kosmowski, 1981

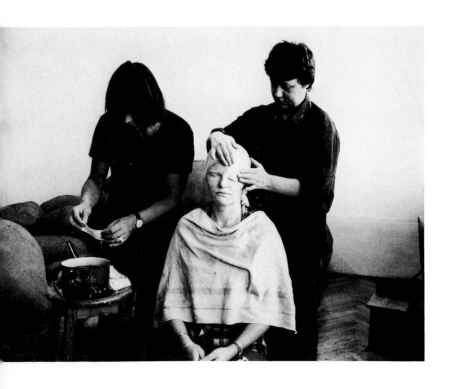

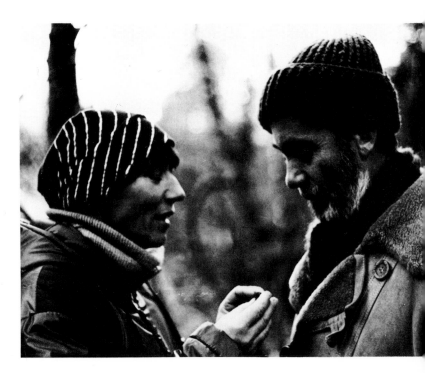

A TAPESTRY REVIVAL

The international success of the Polish artist/weavers is usually associated with the great impact of the "1st International Biennial of Tapestry" in Lausanne in 1962. The Biennial was started by Jean Lurçat four years before his death, and has since become an important and vital institution.

Lurçat is generally considered responsible for the tapestry revival in France in the late 1950s and 1960s. He came out against the making of a cartoon by copying an existing work of art and then rendering the image as a tapestry. He tried to involve artists in creating new designs for tapestries by making cartoons specifically for that purpose. This was thought to be the first step in liberating weaving from its role of being subservient to works in other media. Magda, who spent some time visiting weaving workshops in France in 1962, found that these specially made cartoons still had very basic limitations. The artist and the weaver worked independently, never meeting one another. The cartoon (its scale was always one-to-one) was divided into areas numbered to indicate color of a limited range. At the time of the first Lausanne Biennial, most of the new French tapestries were designed by painters of the School of Paris and executed by professional weavers in Aubusson, Beauvais, or Paris.

Lurçat, the President of the first Biennial, saw the new tapestries as murals to be incorporated into architecture; Le Corbusier, who also wrote a contribution to the catalogue, called them "the murals of modern times."[7]

With the exception of two exhibitors (Lilly Keller and Jan Yoors) who specifically said that they wove their own works, everyone else gave the name of a weaving workshop responsible for the actual production. Magda, who showed *Composition of White Forms* (figs. 16-18), and other Polish participants who also did their own weaving, nevertheless gave as their workshop, "Atelier Expérimental de l'Union des Artistes Polonais"—a heroic name for Maria Łaszkiewicz's basement in which they all worked.

At the next Biennial, which took place three years later, Magda was among the nineteen exhibitors, out of eighty-five, who said they did their own weaving. Attitudes changed rapidly; by 1979, in the catalogue of the ninth Biennial, thirty-five out of forty-two artists said that the execution of the exhibits was their own.

In each successive Biennial, the flat tapestries and wall hangings gave way to works hanging in space and to objects made of materials that had little to do with those of the traditional weaver. No appropriate name for these strange new things has yet been found. Suggestions so far have included: textile art, fiber objects, and soft sculpture. The last is particularly misleading since many of the works are by no means soft—the idea of softness belonging more to the tradition out of which they have emerged than to the qualities which they really possess.

>

Fig. 16 *Composition of White Forms* 1961–62 (cat. no. 5)

Fig. 17 Magdalena Abakanowicz in front of *Composition of White Forms* at the first Lausanne Tapestry Biennial, Switzerland, 1962

Fig. 18 *Composition of White Forms* (detail)

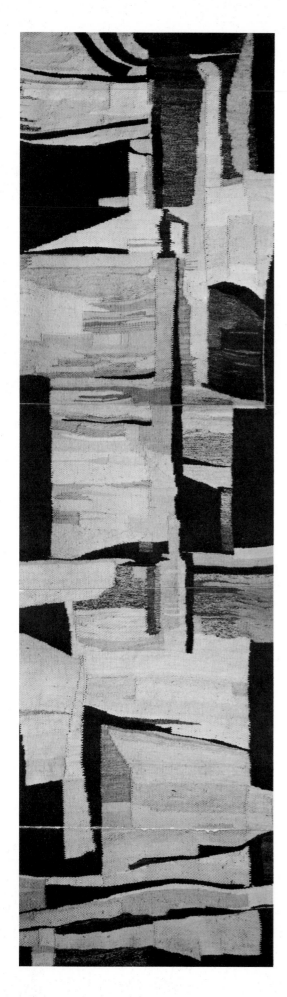

Magda was exhibiting outside Poland more and more often. Sometimes she showed with other Polish artists: Zofia Butrymowicz, Ada Kierzkowska, Jolanta Owidzka, and Wojciech Sadley, but usually by herself. She encountered enthusiasm as well as problems on the part of critics who were trying to find a suitable way of discussing her works. The fact that these new woven pieces had very little in common with what weaving was supposed to be did not prevent critics and journalists from being apologetic for introducing into the context of fine art, works which had been made with materials and techniques of a traditional craft. Two characteristics were repeatedly mentioned in reviews: first, the loss of utilitarian function; and second, the departure from the traditional form of the wall hanging.

For the most part, Magda received great praise from the beginning. In the introduction to the catalogue of her one-person show at Galerie Dautzenberg in Paris in 1962, Michel Tourlière said that her importance lay in her departure from the norm and that above all she was a painter.[8] Without knowing it, he was echoing the words of a Polish critic, Stanisława Grabska, who declared two years before that Magda's works were first and foremost "good painting," and that the route she had chosen would lead inevitably to a greater limitation of color and the eventual exclusion of unnecessary forms.[9]

The Lausanne Biennial has continued to introduce new ideas into the realm of weaving. Magda has taken part in every tapestry Biennial at Lausanne, up to and including the ninth in 1979. She was well aware that she would initially be outside any accepted canon, but that from this uncomfortable position she would be able to help bring about some changes. And indeed this is just what happened. Especially since the spectacular sixth Biennial in 1973, in which Magda showed a vast wooden wheel and a rope, the exhibition has included many extraordinary objects totally innocent of the loom.

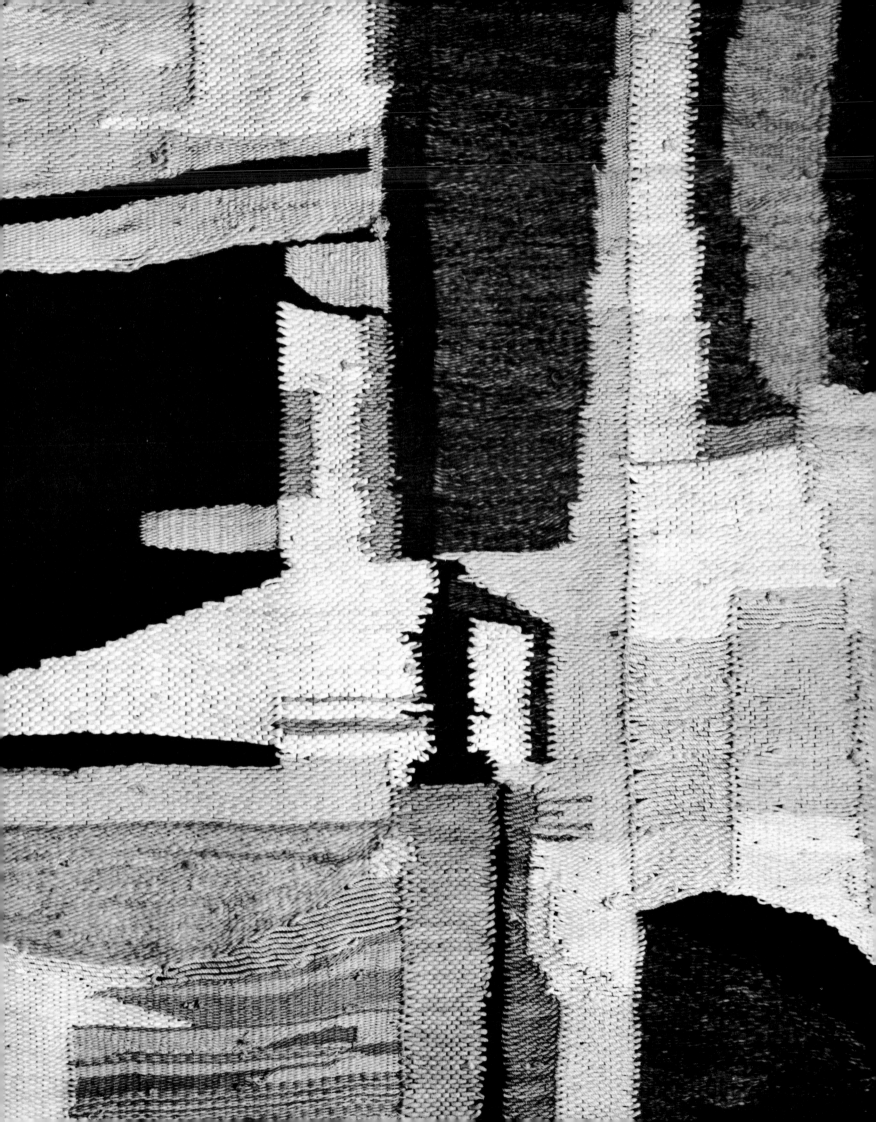

Magda started with bold, colorful paintings on pieces of cloth and from these she turned to weaving.

Out of weaving she made three-dimensional forms and spatial arrangements.

She abandoned color.

She abandoned weaving.

She started to write.

She continues to make three-dimensional forms and to organize spaces.

Thus goes a brief outline of 30 years.

Magda's painted textiles of the early 1950s were done on linen sheets with elements similar to those that eventually left the flat background and emerged into space—round shapes with attenuated tails that almost break, then acquire more substance and recommence their dance on the canvas. All have a sense of movement. From the mid-1950s the color gradually became more and more limited, but the forms of plants continued to appear. In the late 1950s, they were mostly in black and white with a strong vertical emphasis, and the black was actually composed of shades of brown.

Magda's first woven works were improvised on a frame. Later, when she started weaving huge compositions on a loom, with only a small fraction of the piece visible as she was working, she used small sketches for guidance. These indicated spatial divisions on a scale of one-to-twenty-five.

Her first one-person exhibition at the Kordegarda gallery in Warsaw in 1960 included small weavings as well as gouache and oil sketches. Another critic immediately recognized Magda's desire to consider a woven object as an element in its own right, rather than something to be applied to a chair, a sofa, or a window, and thought that such an approach could help develop an art instinct in people and lead them to contemplate things they might not have considered before.[10]

Sculpture

I have wondered from time to time why Magda did not turn to sculpture in conventional media. She explained:

> When I was quite small I did not draw, but collected and made three-dimensional objects. At school I sculpted wooden dragons as presents for my friends. Having decided to go to the art school in Sopot, I was sure that they would accept me for the sculpture course. After the entrance exam they threw me out. The professor said: "She has no feeling for form." So I started to paint. This judgment had been so unequivocal that only after finishing my studies at the Academy in the late 1950s, did I make a few wooden reliefs.

One of them [fig. 4] served as a point of departure for a huge seven-meter-high steel sculpture which I made in 1965, when I participated in the first Biennial of Three-Dimensional Form in Elbląg. This was organized by sculptors for sculptors and a few specially invited painters. One of the organizers drank a lot. He invited me while he was drunk and everybody was very surprised when I actually arrived. Their surprise was so ungracious that I was asked straight out: "What are you trying to do?" Despite this, I constructed a sculpture. I made friends with a few workers from a factory making ships' engines, and they helped me to weld and to erect this form. I later continued to think about this piece while making Abakans. This sculpture is still there [fig. 19]. I am pleased with it. Why didn't I take up sculpture? Perhaps it would have been too easy and lacking in conflict.

In the summer of 1981 Magda started carving again. She took a series of wooden cylindrical fenceposts and made incisions in them, creating a narrower neck at one end. She calls them *Trunks* (see fig. 20).

Fig. 19 *Untitled* 1965 (cat. no. 13)

Fig. 20 *Trunks* (detail) 1981 (cat. no. 80)

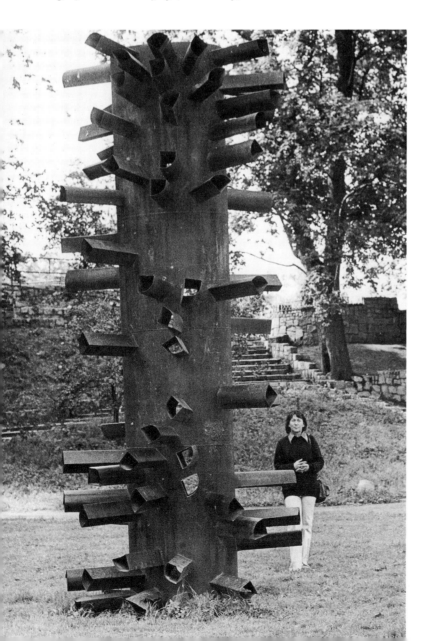

Weaving

At the beginning Magda did all the weaving herself, but gradually, on very large compositions, Stefa Zgudka would do some weaving as well, and then they would change places because Magda had always found it impossible to explain to anyone else what is required. Stefa also helped with the preparatory work, washing of materials, dyeing, winding the thread, and with countless other tasks that must be done before one can start weaving. She recalls that the first works she helped on were comparatively flat and were intended for hanging on a wall; reds, browns, and blacks were the usual colors. The relief element became increasingly pronounced after the mid-1960s.

Materials have always come from various sources, but most of them are cast-offs from different factories. Hemp, flax, and sisal come from factories that make rope; warp (the discarded thread used for stitching boots) comes from shoe factories; but even the rejects are increasingly difficult to come by, since industries have become unwilling to sell to private people. Other materials such as horsehair which comes from the country and wool from sheep belonging to the peasants of the Tatra mountains are acquired with considerable difficulty.

Magda does not like artificial fibers, only natural ones. The contact between Magda and her materials is of great importance. Materials which suit her imagination are those which always conserve their natural properties: hemp, horsehair, flax, wool, sisal—all of these not only have the sensitivity that all organic things possess, they are also traditional materials with a past. Magda's is the contact of the fingers, hands, and muscles: manipulating both nature and history. Once when asked about the fact that her work is antitechnological, she did not deny it, but remarked that, after all, she works with her hands and thinks of her work as a protest against the misuses of the environment.[11]

Abakans

Abakan is the name given to the majority of Magda's woven sculptures, to her work in space, to that "new genre she has invented somewhere between the wall and the floor."[12] In 1964 a critic, Hanna Ptaszkowska, coined the work *Abakan* when talking to friends at the Club of the Architects' Association, at the time of Magda's exhibition at Zachęta, the main exhibition hall in Warsaw. The term was used in 1965 to describe these same pieces when they traveled to the São Paulo Bienal (see fig. 21). Since then, *Abakan,* designating a woven relief or a free-hanging three-dimensional work, has become a useful means of identifying both the artist and the art.[13] Magda was ambivalent about

this new name, but there was nothing better. She herself used the name *Abakan* for the first time on the occasion of her one-person show at the Helmhaus in Zurich in 1968, for her works done after 1965 (see figs. 30, 31, 34).[14]

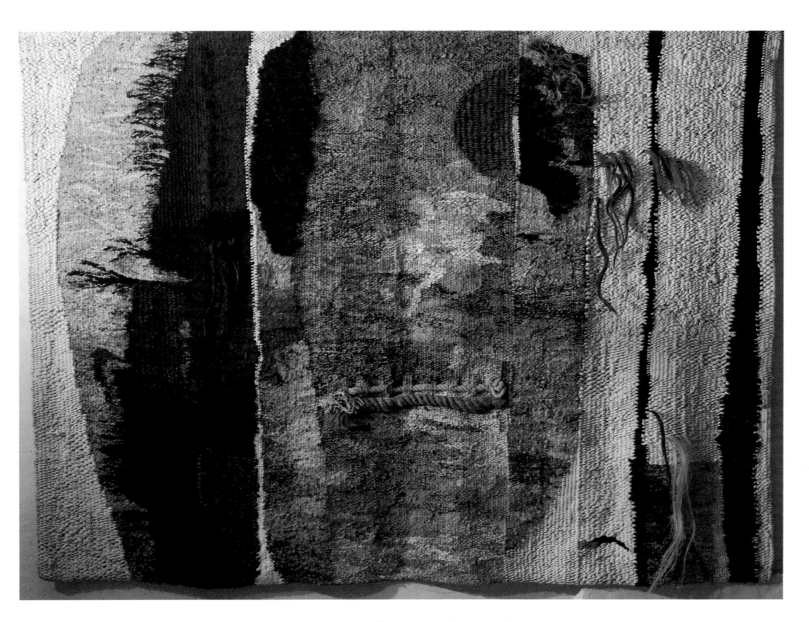

Fig. 21 *Dorota* 1964 (cat. no. 9)

Fig. 22 *Composition with Hands* (detail) 1966
(cat. no. 15)

I like neither rules nor prescriptions, these enemies of imagination. I make use of the technique of weaving by adapting it to my own ideas. My art has always been a protest against what I have met with in weaving. I started to use rope, horsehair, metal, and fur because I needed these materials to give my vision expression and I did not care that they were not part of the tradition in this field. Moreover, tapestry, with its decorative function, has never interested me. I simply became extremely concerned with all that could be done through weaving. How one forms the surface reliefs, how the mobile markings of the horsehair will be put into place and, finally, how this constructed surface can swell and burst, showing a glimpse of mysterious depths through the cracks.

In 1966 I completed my first woven forms that are independent of the walls and exist in space. In creating them I did not want to relate to either tapestry or sculpture. Ultimately it is the total obliteration of the utilitarian function of tapestry that fascinates me. My particular aim is to create possibilities for complete communion with an object whose structure is complex and soft. Through cracks and openings I try to get the viewer to penetrate into the deepest reaches of the composition. I am interested in the scale of tensions that intervene between the woven form, rich and fleshy, and the surroundings.

I feel successful each time I reject my own experience. There are all too many fascinating problems to confine oneself to a single one. Repetition is contrary to the laws of the intellect in its progress onward, contrary to imagination.

Magdalena Abakanowicz 1969

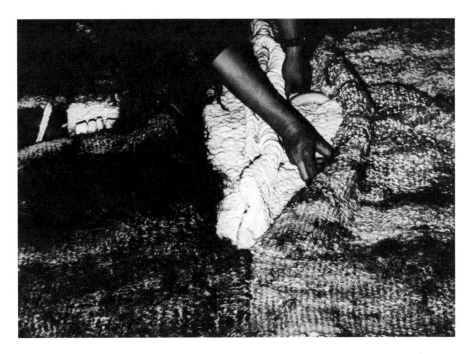

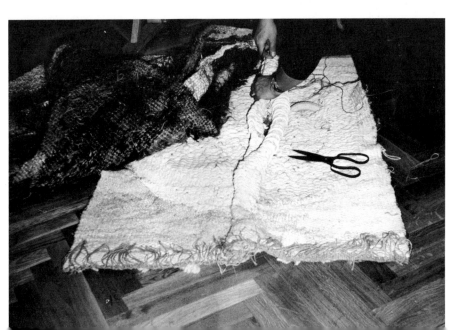

Figs. 23–25 Magdalena Abakanowicz at work on *Silver Abakan* 1966–67 (hemp ropes and sisal weaving; 136 x 200 cm [53½ x 78¾ in.]; collection of the artist)

Various forms woven on the loom were sewn together into three-dimensional entities. Their initial form already had the desired overall shape or contour, for example, rectangular, round, or oval. Three meters high (the height of Magda's studio), they were woven to incorporate holes and apertures, and smooth or hairy surfaces. Onto these fundamental forms, other, smaller elements were added. *Abakans* have three basic shapes. One is a rectangular form that became a tube sewn around a metal ring at the top which gave it the required shape and provided a structure for hanging it in space (figs. 31-34). Second, there is a round or oval woven form, usually three-by-three meters, with a metal tube sewn in at the top which is invisible and allows the *Abakan* to hang partly open, with the sides left loose (figs. 34-41). The third shape belongs to those *Abakans* which Magda has called *Garments*. These are the largest of all *Abakans* and consist of three woven parts: one constitutes the back of the jacket, and two become the two sides of the front. Everything is fixed on a metal construction resembling a huge coat hanger (figs. 42-44).

These *Garments*, suggesting mantles or jackets over long skirts or trousers, are reminiscent of a cross between giant headless peasants and petrified trees, bulky and overwhelming. They are monumental. All *Abakans* were showing this tendency and gradually they were becoming more and more enormous. They are made up of contrasts of dense, nearly monochromatic textures and surfaces. Critic John Russell described the final effect of this shaggy amalgam of materials as "barbaric, bizarre and distinctly unlike anything else."[15] One of the main points of the *Abakan*, wrote Paul Overy, is "the fact that it hangs and therefore functions quite differently from something that goes on a flat surface."[16]

Fig. 26 *Violet Abakan (Studium Faktur)* (detail) 1964 (cat. no. 11)

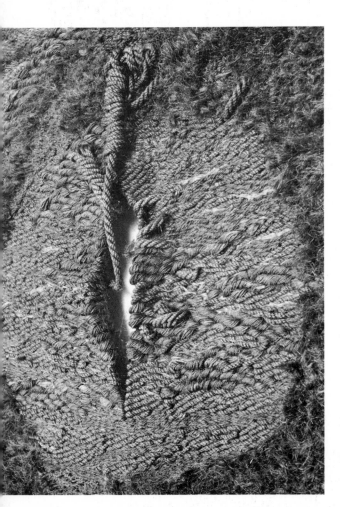

Fig. 27 *Black Assemblage II* 1967 (cat. no. 24)

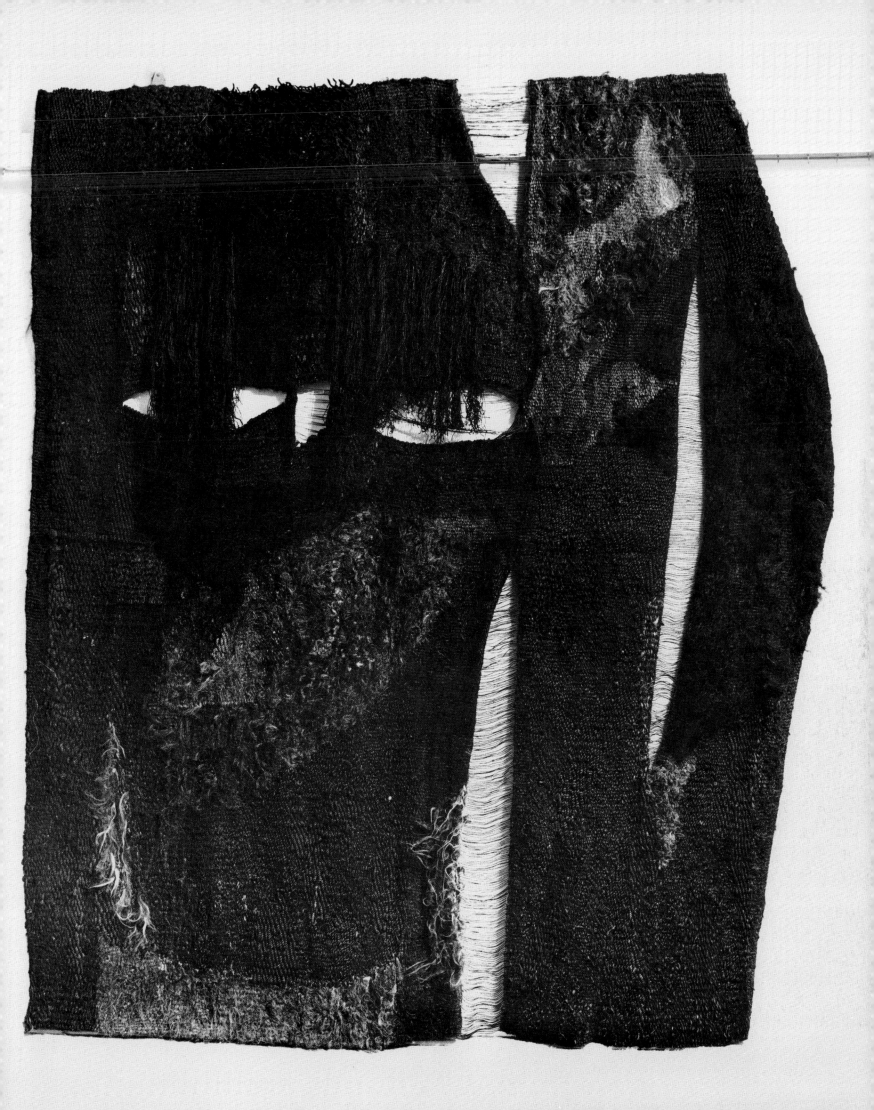

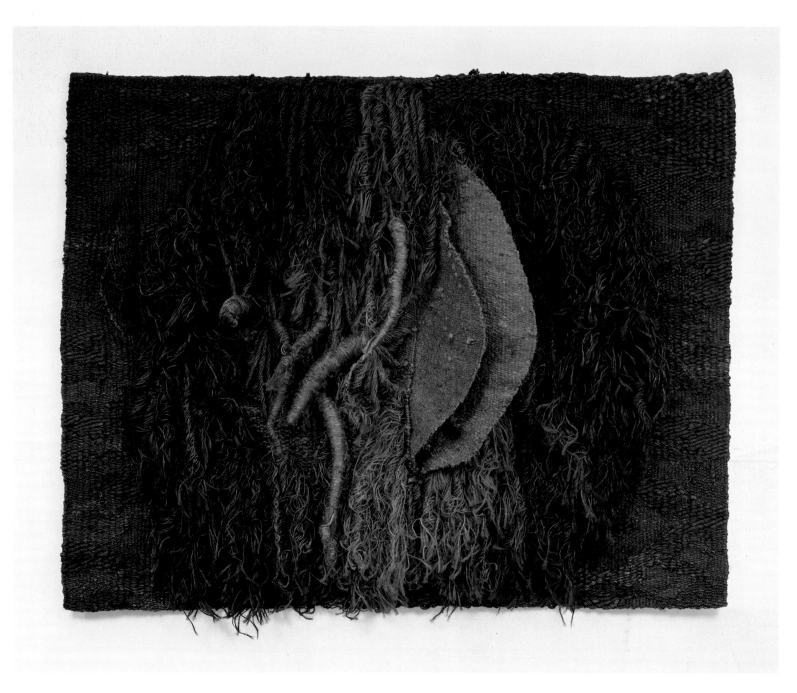

Fig. 28 *Abakan 27* 1967 (cat. no. 19)

Fig. 29 *Studium Faktur II* 1967 (sisal; 100 x 140 cm [39⅜ x 55 in.]; collection of the artist)

Fig. 30 *Abakan 29* 1967–68 (cat. no. 27)

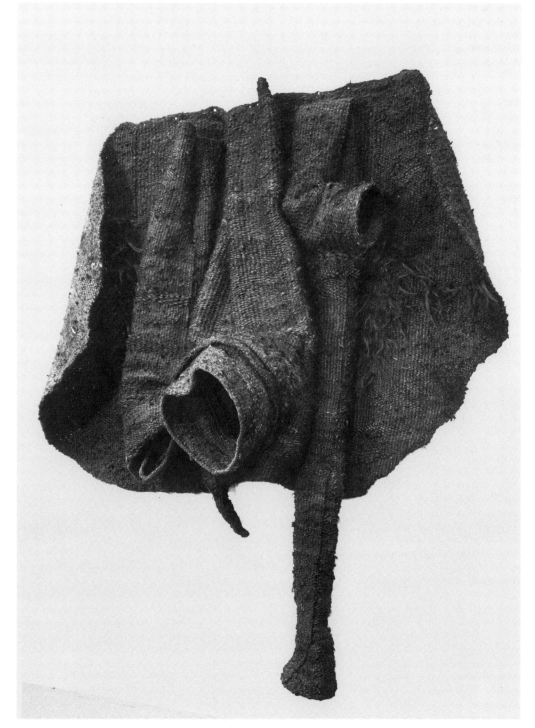

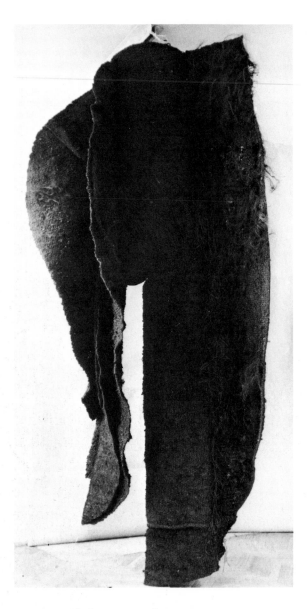

Fig. 33 *Black Environment* 1970–78 (cat. no. 43)
at Zachęta, Warsaw, 1975 (cat. no. 65)

Fig. 32 *Great Black Abakan* 1967 (cat. no. 25) and
Abakan Open 1967 (cat. no. 20) at the Pasadena
Art Museum, California, 1971 (cat. no. 50)

Fig. 31 *Abakan Winged* 1967 (cat. no. 22)

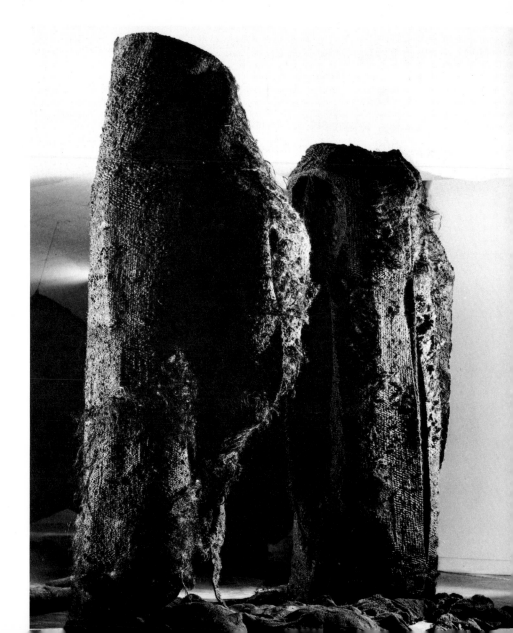

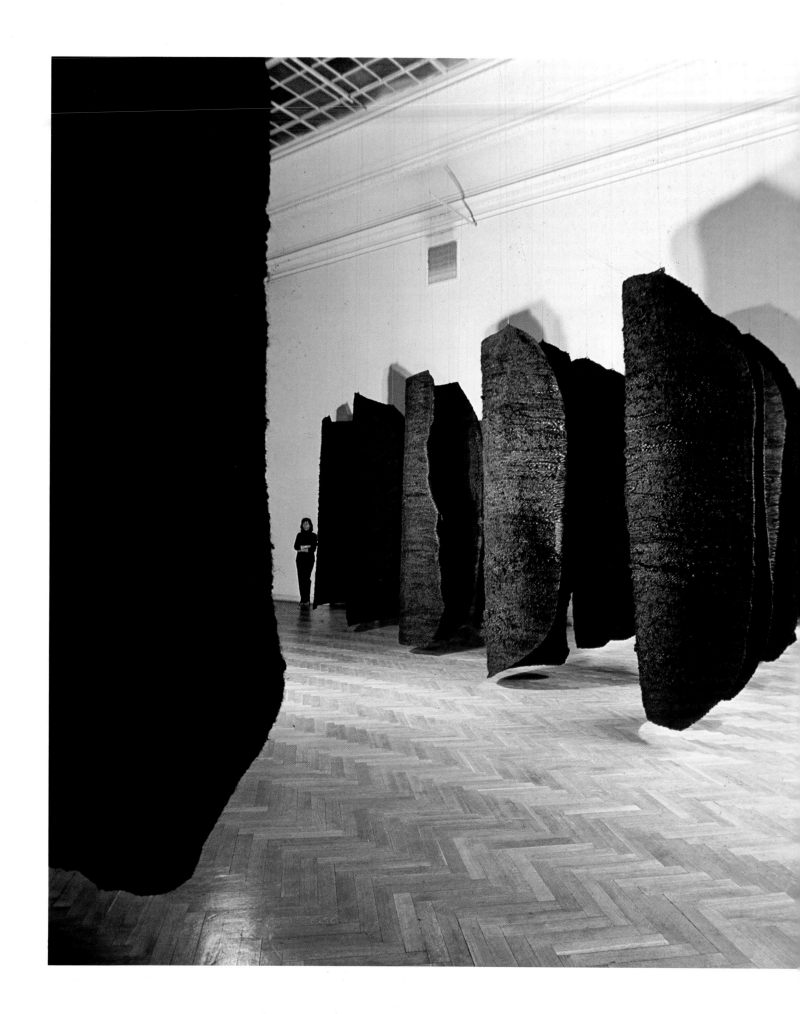

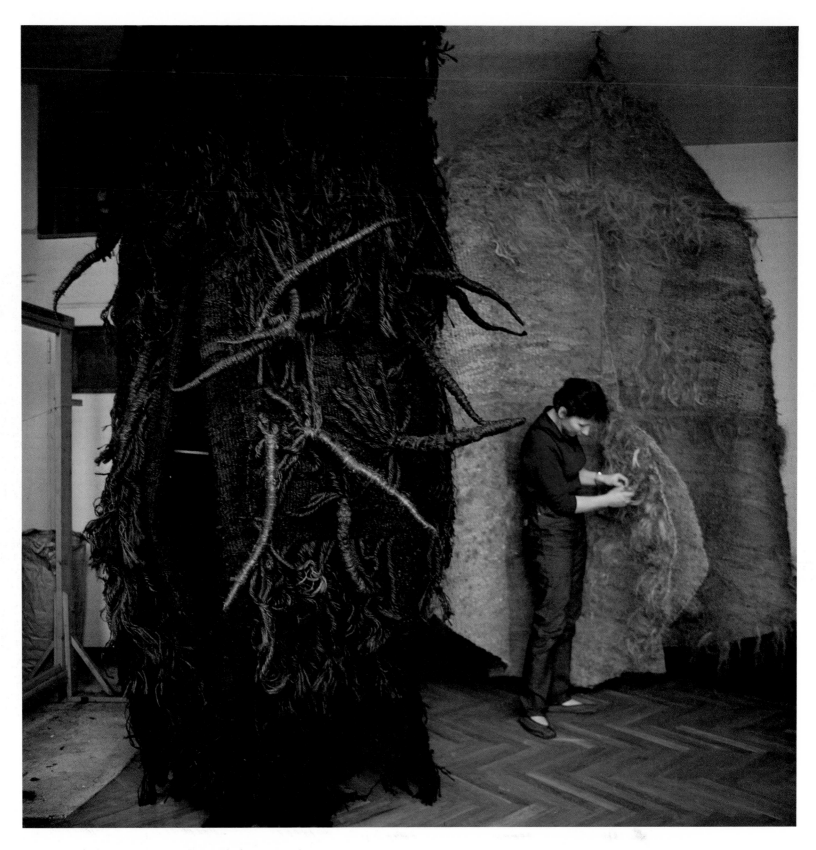

Fig. 34 Abakanowicz at work on *Abakan Round*
1967 (cat. no. 21) and *Yellow Abakan* 1967–68
(cat. no. 28)

Fig. 35 *Red Abakan* 1967 (cat. no. 26)

Fig. 36 *Brown Abakan* 1968 (cat. no. 29)

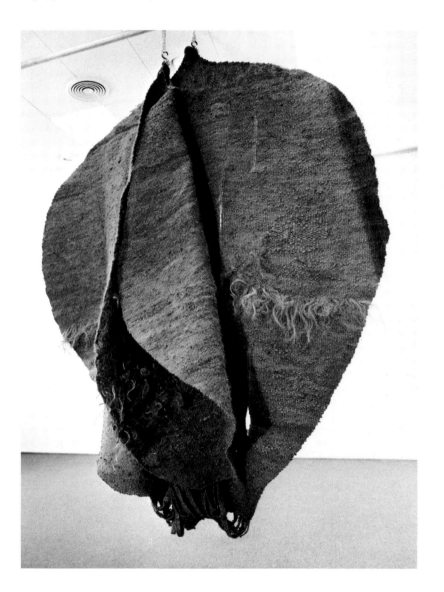

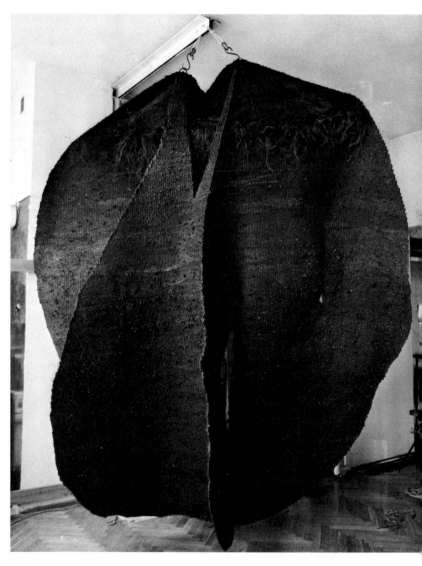

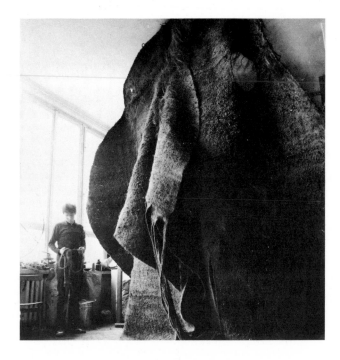

Fig. 38 Abakanowicz at work on *Baroque Dress* (detail) 1969 (cat. no. 31)

Fig. 39 *Baroque Dress* 1969 (cat. no. 31)

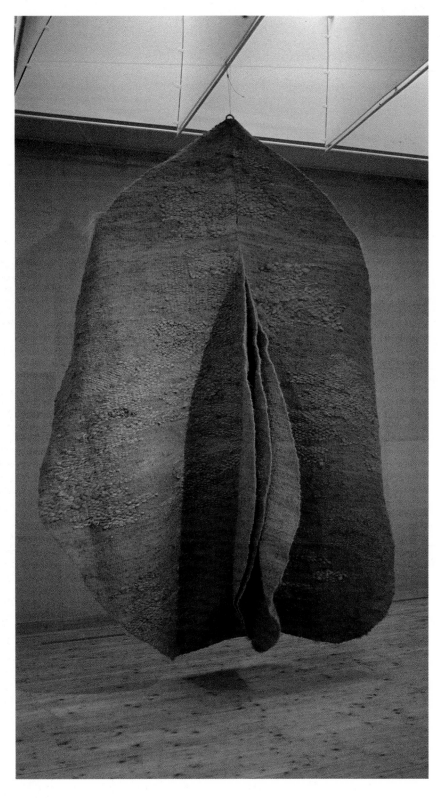

Fig. 37 *Yellow Abakan* 1970–75 (cat. no. 42)

>

Fig. 40 *Red Abakan* 1969 (cat. no. 34) at Zachęta, Warsaw, 1975 (cat. no. 65)

Fig. 41 *Red Abakan* 1969 (cat. no. 34) at the Art Gallery of New South Wales, Sydney, Australia (cat. no. 69)

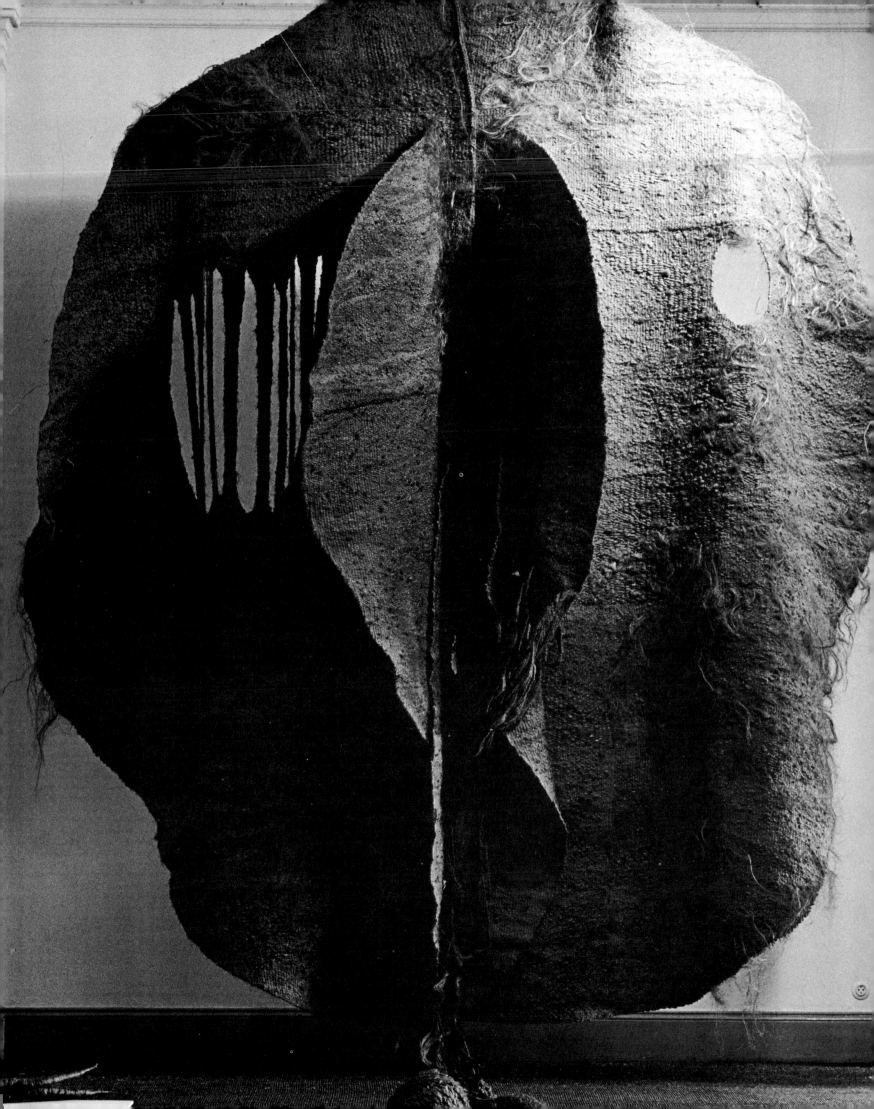

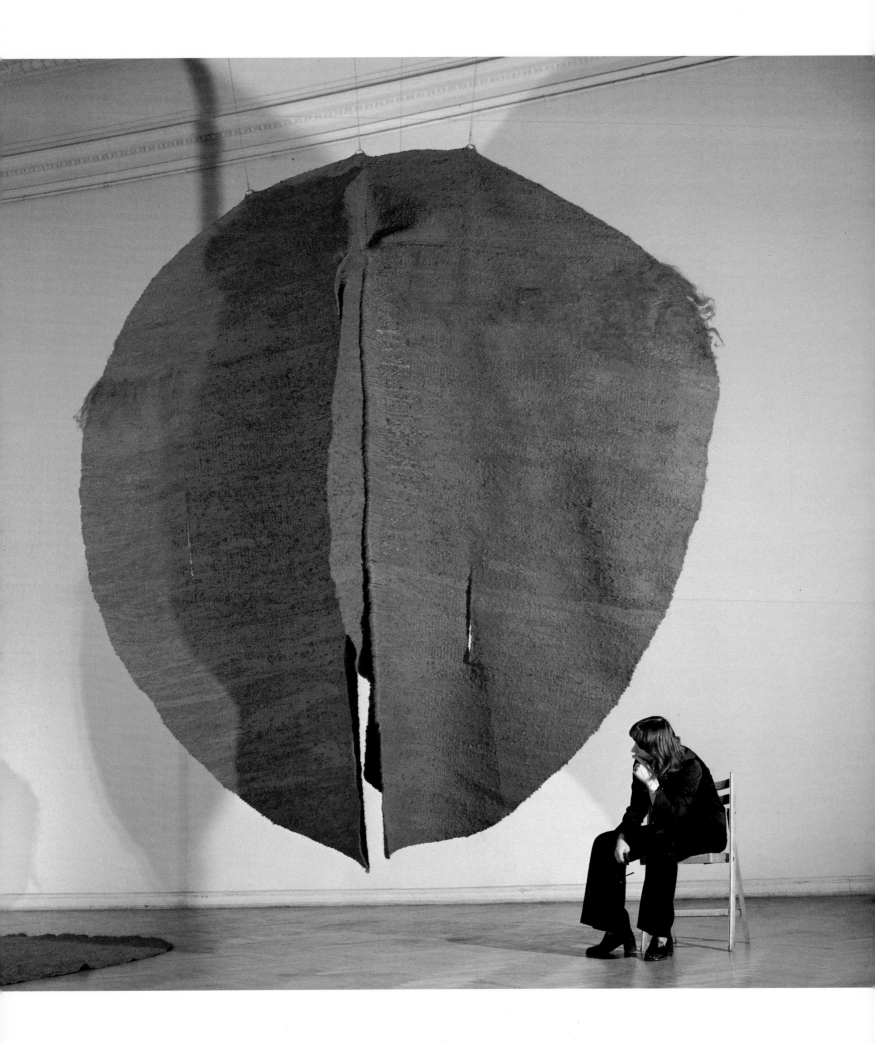

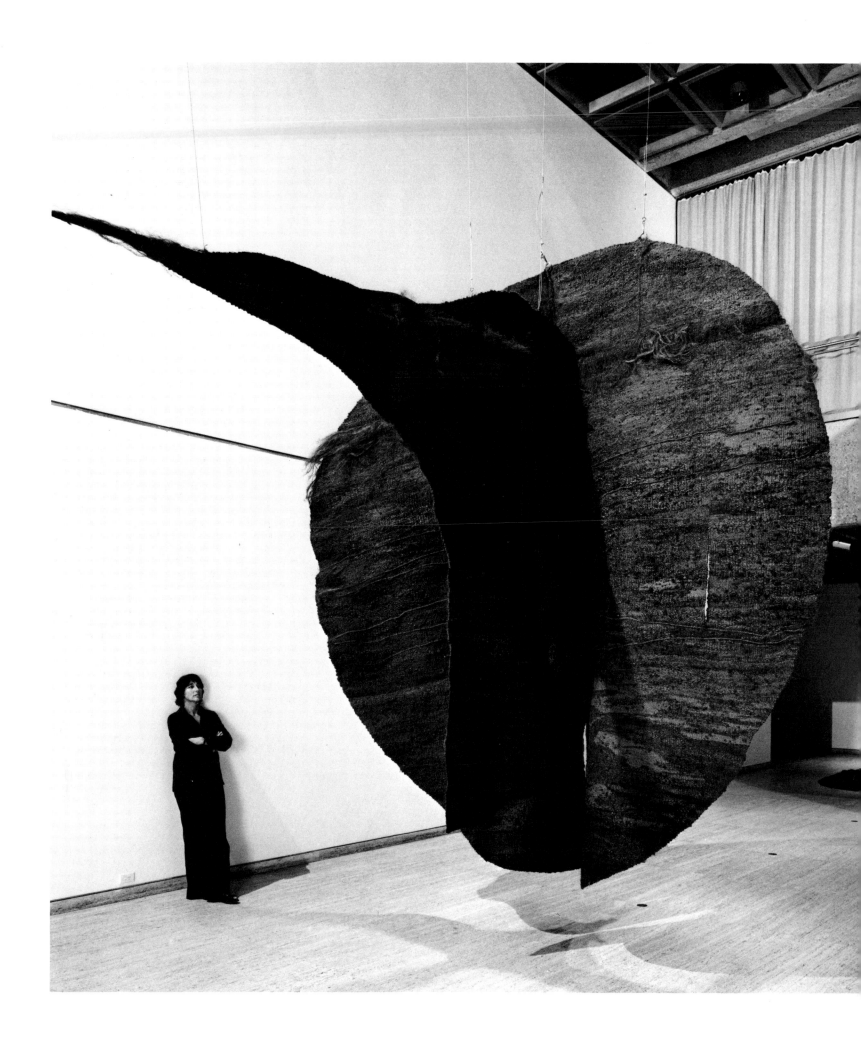

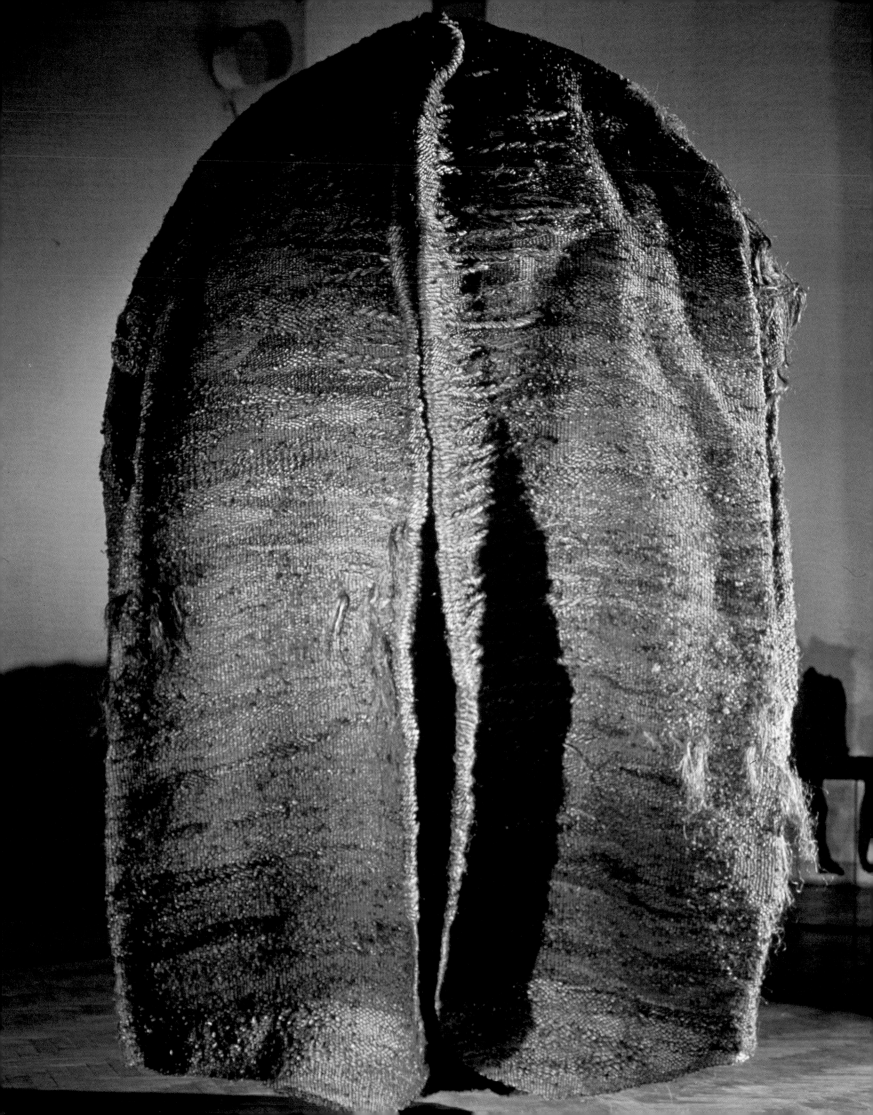

Fig. 42 *Brown Coat* 1968 (cat. no. 30); *Black Garment Rounded* 1974 (cat. no. 60); *Black Garment with Sack* 1971 (cat. no. 46); and *Black Garment (Rectangle)* 1974 (cat. no. 58) at Zachęta, Warsaw, 1975 (cat. no. 65)

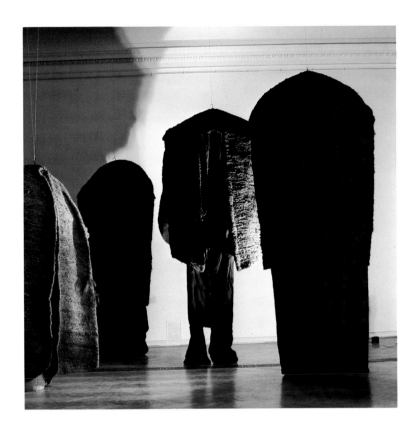

Fig. 44 *Black Garment* 1969 (cat. no. 32)

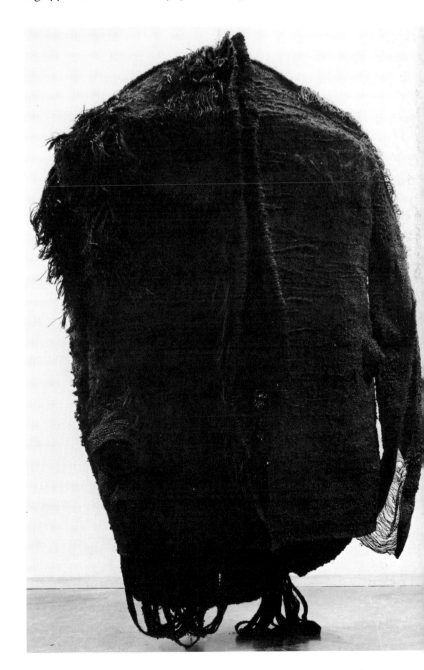

Fig. 43 *Brown Coat* 1968 (cat. no. 30)

Abakans acquired their characteristics during the process of their construction (see figs. 23-25). They were never designed beforehand. When in 1961 Magda started working in relief, she stopped making studies. A prepared design, a drawing, could easily have counteracted the inherent possibilities of the material, which itself must play a major role in improvisation.

Many of the works have individual titles. Most of the woven wall reliefs are called by women's names, both common and romantic, or by their predominant color. *Abakans* are called by the name of the month or by their shape: *Straight, Round, Open, Winged, Baroque.* There are also other titles such as *Dream.* Magda does not always use titles, believing them to be a purely administrative necessity. Thus, she sometimes derives titles from their exhibition situation, calling individual *Abakans* or their groups names such as *Environment — Situation 2* or *For Contemplation.*

Abakans amazed one and all.[17] Response was immediate and largely enthusiastic; even those who were wary of modernism embraced Magda's work because it was tactile, intimate, and had the feeling of something very ancient and animalistic. Reviews of Magda's shows were not only favorable, they were imaginative, and mostly without jargon. Here is one from Denmark in response to the 1967 Lausanne Tapestry Biennial:

> *In the next hall you find yourself confronted with Magdalena Abakanowicz from Poland. It's like getting a blow on the head. Her carpets have an inner power that makes you think of Africa's jungles and black magic. The surface has a raw, animal effect, for goats' hair and cows' tails, gathered straight from the byre, are mixed with tarred and colored sisal, fat irregularly spun wool and thin flax. The frayed, long-haired surface of the sisal glides under strongly formed contours into woven sections. Long fringes hang down over open air-holes and masses of thin, waving threads provide the compact parts with links, cohesion and unity. The way Magdalena Abakanowicz proceeds is to take the woven carpet off the loom and then start to work on it like a piece of sculpture. Her works are searching and experimental—overwhelmingly expressive and extremely engaging. You need both time and distance to digest a carpet of this kind.*[18]

The best way to approach Magda's *Abakans* is without preconceived notions. This comes more easily to people outside the art world than to those within it. This was amply demonstrated with Magda's most ambitious work in the *Abakan* cycle, installed in the Netherlands.

Fig. 45 *Abakan—Situation Variable* 1970 (cat. no. 37) at the Södertälje Konsthall, Sweden, 1970 (cat. no. 39)

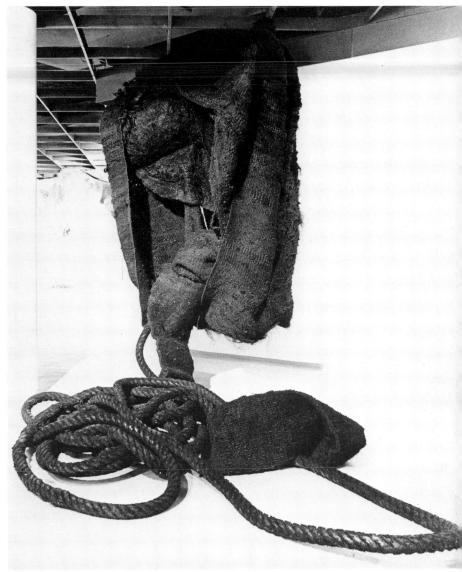

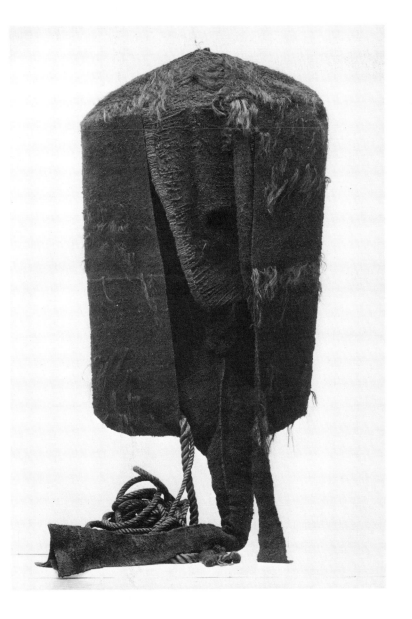

Fig. 46 *Abakan—Situation Variable* 1970 (cat. no. 37) at the fifth Lausanne Tapestry Biennial, Switzerland, 1971

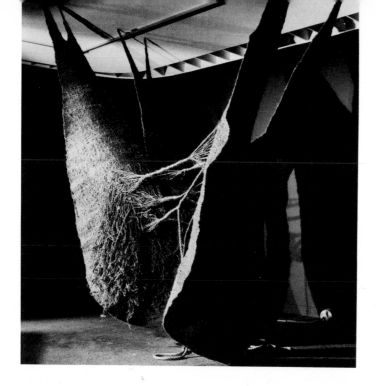

<
Fig. 47 *Turquoise Abakan* 1970 (cat. no. 38) at the Pasadena Art Museum, California, 1971 (cat. no. 50)

Fig. 48 *Untitled* 1971 (cat. no. 49)

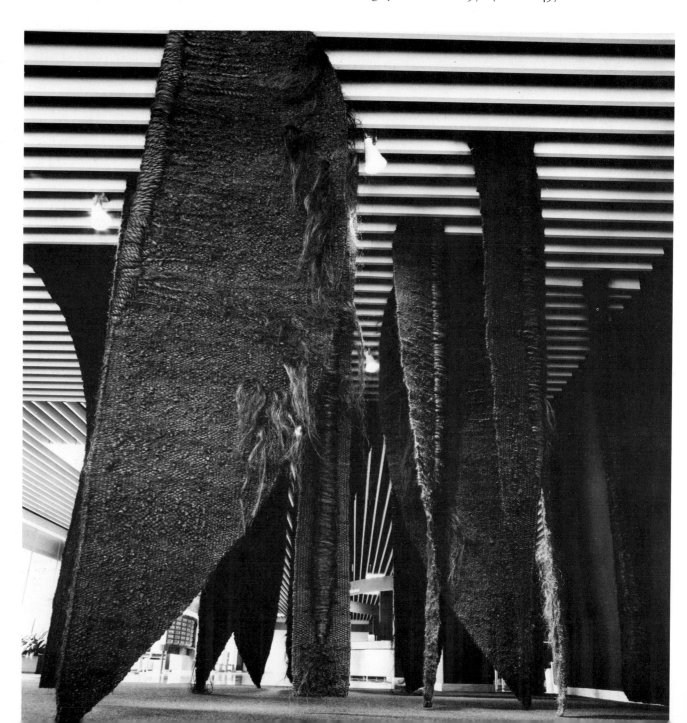

Bois-le-Duc

An enormous, hairy, heavy, dark composition in several segments hangs in the reception hall of the North Brabant government building in s' Hertogenbosch (Bois-le-Duc). It is the largest of all Magda's compositions, measuring eight-by-twenty-by-two meters (figs. 50-52). Like all her work of the early 1970s, this too is mostly black, although some of the segments turn into bronze towards one end and others into red.

The workers completing the building thought that this huge work was very romantic and they called it *Bois-le-Duc*. Those in charge of the commission did not know what to think about this strange tapestry as it was gradually being assembled, and they hovered around uneasily, complaining, and giving increasing signs of their disquiet. Magda, with her two assistants and several young Dutch helpers, tried to ignore them. The work itself was already extraordinarily difficult. In the early stages, work was done on a scaffolding on a nine-meter-high frame, close to the ceiling (fig. 49), in a large hall in Utrecht provided by the Dutch paint manufacturing firm Sikkens. One of the minor discomforts, as Krysia Kiszkiel recalls, was the tar dripping on their heads when it got hot.

The work took more than six months. *Tygodniak Polski* described it as the "largest tapestry since the middle ages."[19] Visitors to the government building liked it and, in the end, much to their own amazement, those in charge were duly impressed and delighted.

Fig. 49 Abakanowicz and assistants at work on *Bois-le-Duc* 1970–71 (cat. no. 41)

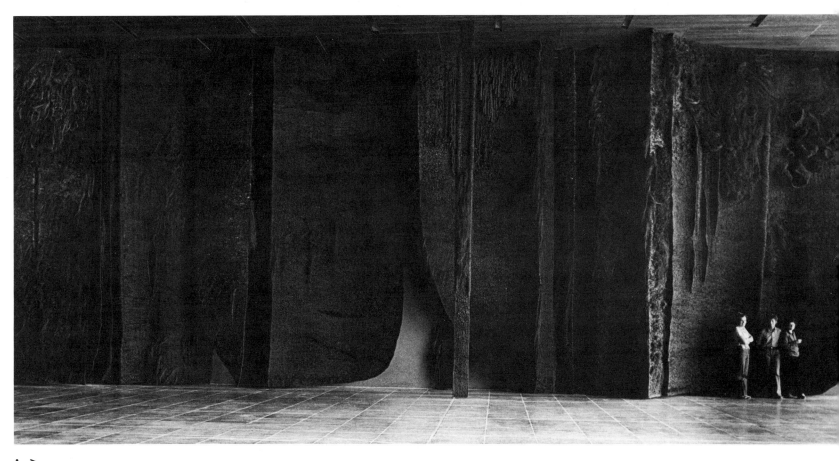

∧ >

Figs. 50–52 *Bois-le-Duc* (cat. no. 41)

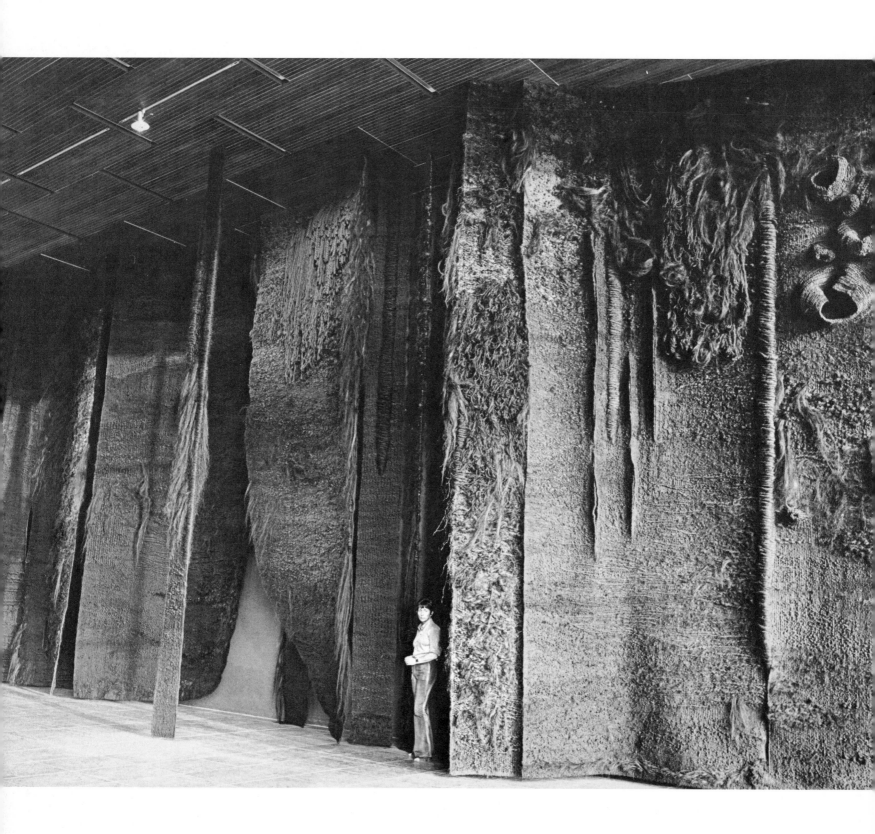

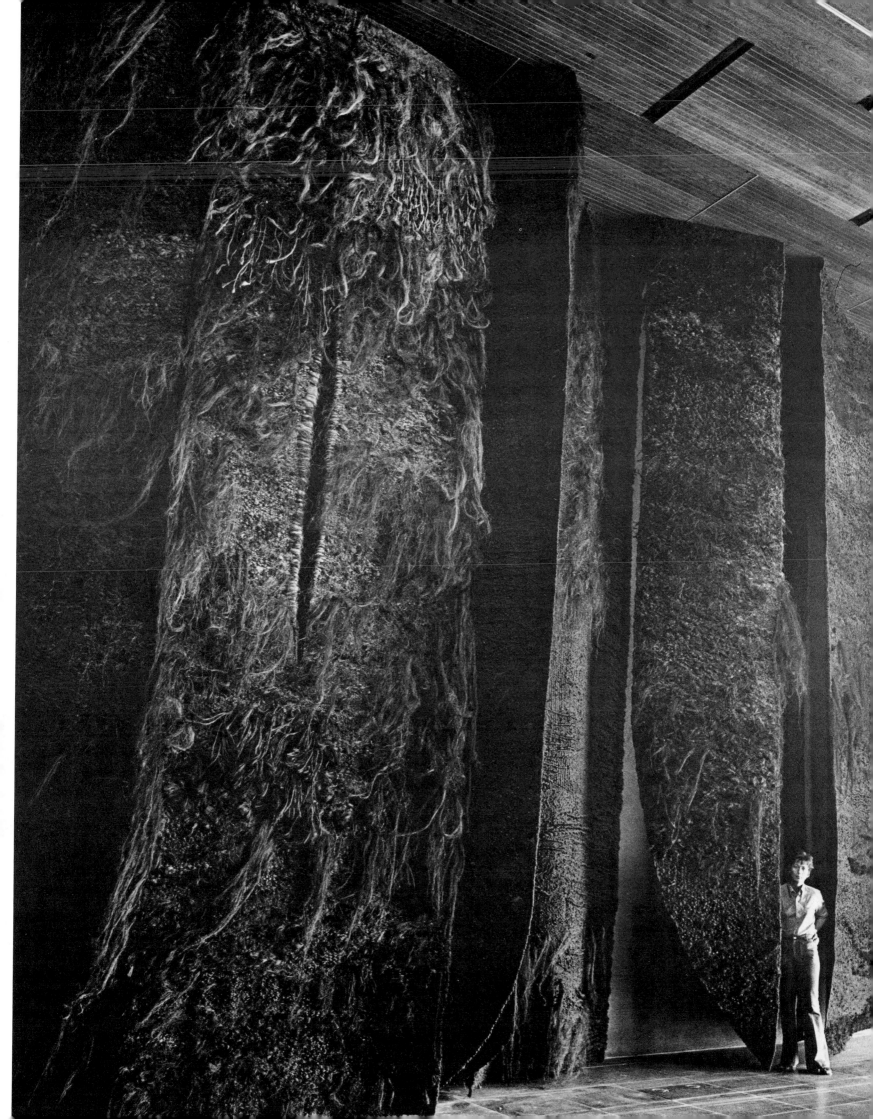

The Rope

Magda's rope is a well-traveled rope; it has journeyed to many parts of the world playing a somewhat different role in every place. It is even difficult to say if it is always the same rope. In 1970 in Södertälje it hung in an enormous tangle from the ceiling, terminating in a three-pronged green carrot (figs. 53-55). In 1971 in Pasadena, after traversing the space between ceiling and floor, it came to rest coiled on a large brass bed (fig. 59). In 1980, it was in the Polish Pavilion at the Venice Biennale where it curved around the entrance and into the Pavilion, wound around a huge wheel, and eventually disappeared into the massed forms of the *Embryology* (see figs. 139-143).

Figs. 53–55 Rope installations at the Södertälje Konsthall, Sweden, 1970 (cat. no. 39)

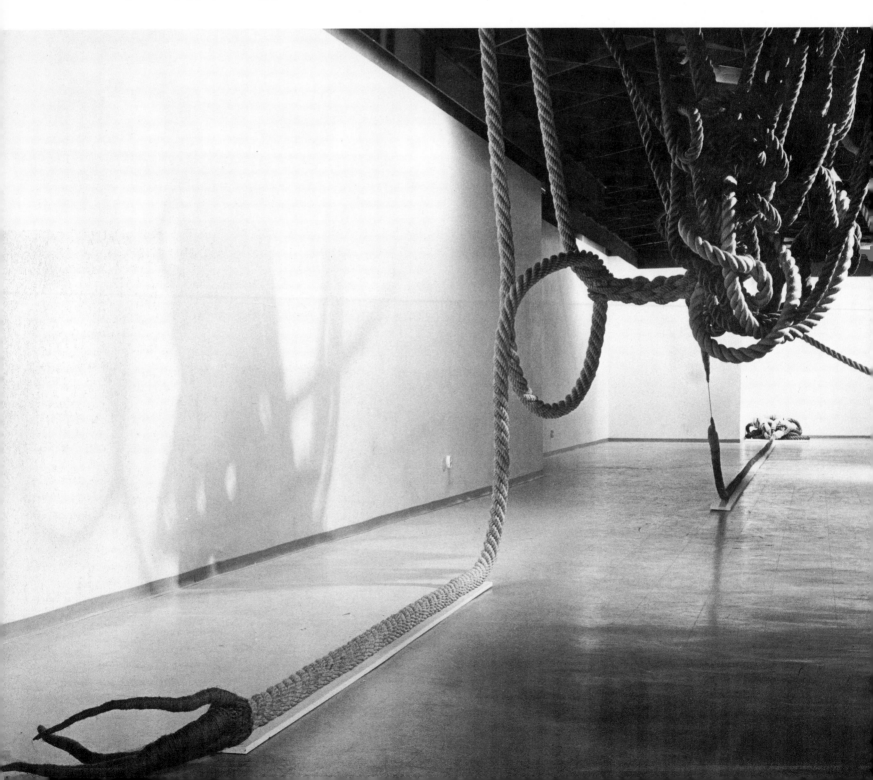

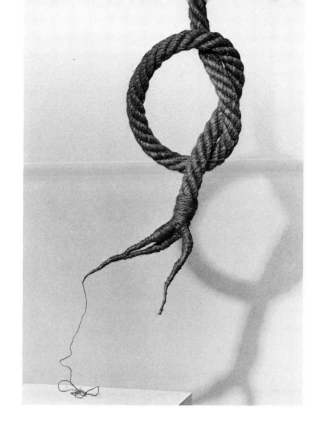

Magda herself has written about the rope and has discussed it in an interview, comparing it to a meandering river, a pathway which changes direction because once there was a good reason for it. It is not the shortest or the quickest possible way, it is rather like a country path that built up over years because people stopped at a shrine, rested under a tree, or climbed a hill to see the view.[20]

The relationship between the rope and the woven form is not only associated with the pathway between one object and the next. Weaving involves the use of a thread that moves in one direction and then returns, sometimes covering longer distances, sometimes shorter. This, Magda said, started her interest in working with thread.[21]

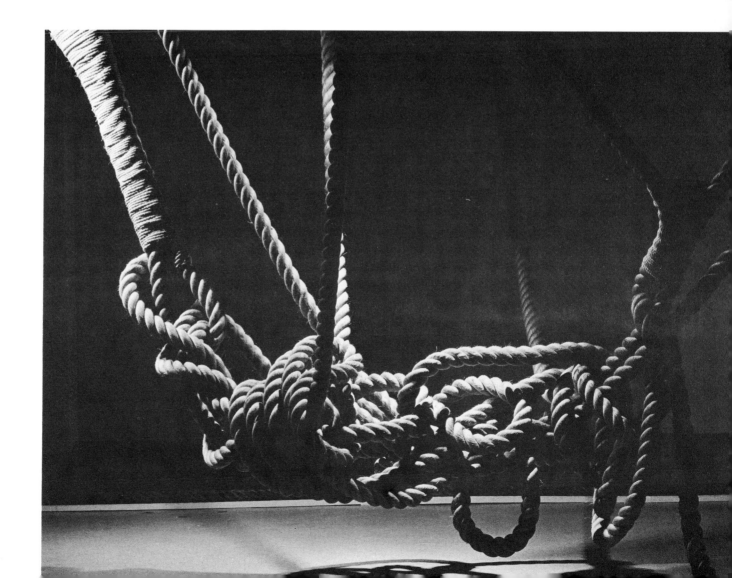

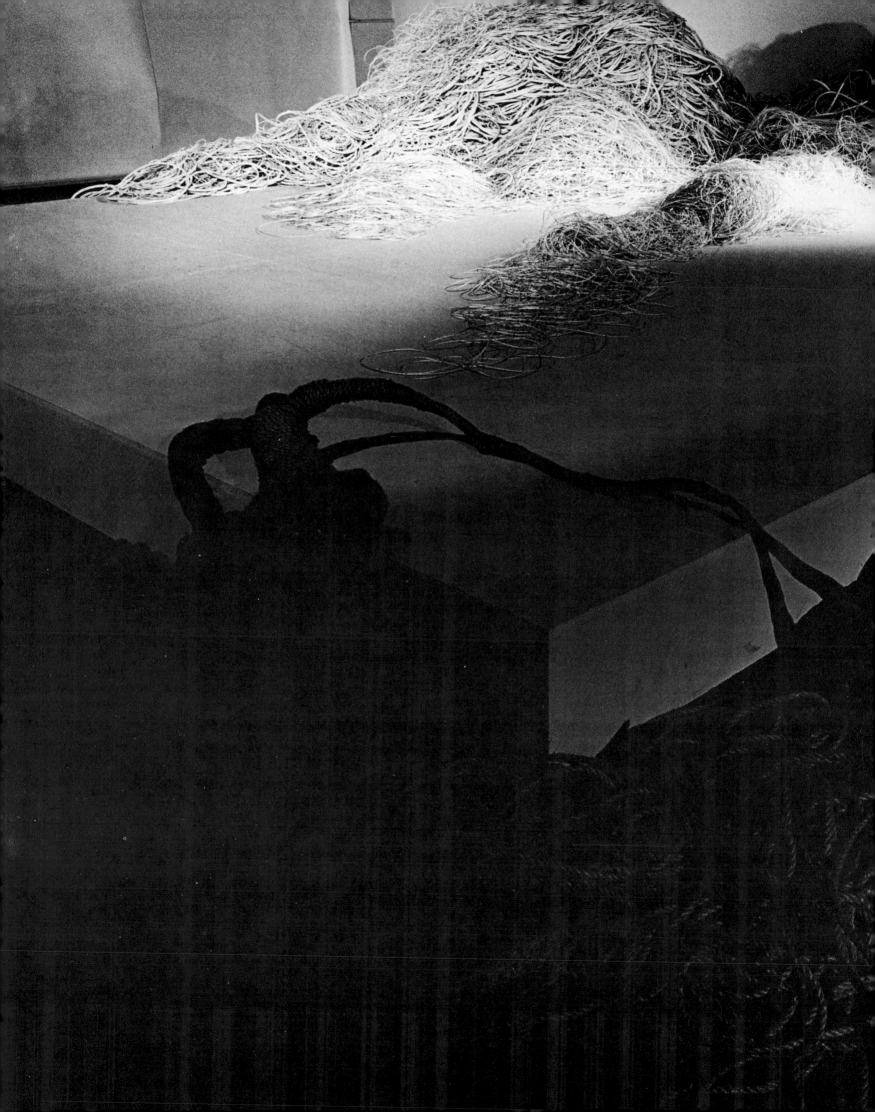

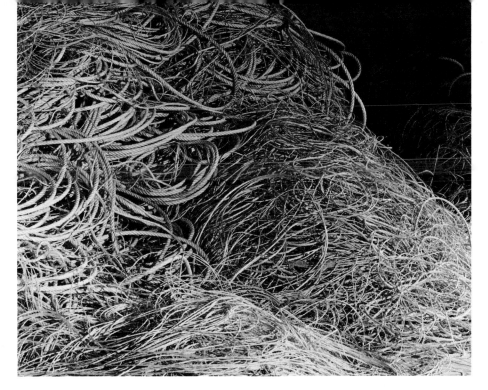

< ∧

Figs. 56, 57 Rope installations at the National-
museum, Stockholm, 1970 (cat. no. 40)

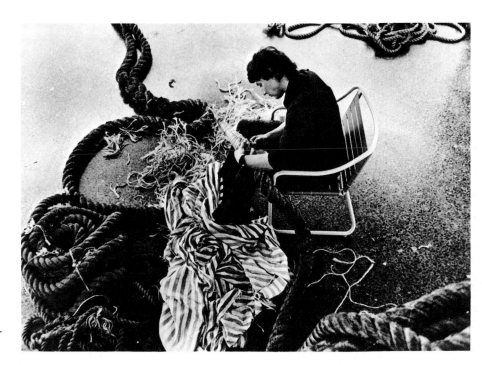

Fig. 58 Magdalena Abakanowicz at work on the
rope installation at the Pasadena Art Museum, Cali-
fornia, 1971 (cat. no. 50)

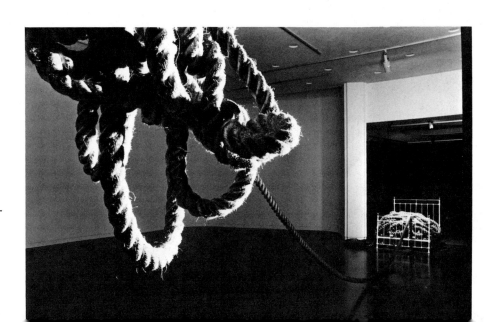

Fig. 59 Rope installation at the Pasadena Art Mu-
seum, California (cat. no. 50)

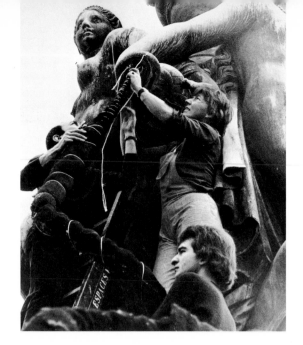

Magda described how she came to use the rope at the Edinburgh Festival in 1972 (figs. 62-64):

I sat for one week doing nothing, because I had no idea what I should do there. The gallery space was not large enough to show all the works I had brought over. So sitting there and thinking, suddenly I saw Edinburgh as a monumental city. I looked at the façade of the Demarco Gallery and I thought I would bring the rope through it into the gallery and out again through the window. It disappeared on top of the building. Then it reappeared on Edinburgh Cathedral which you could see from the gallery; from the top of the cathedral it went to the chapter house, from the chapter house in a straight line to the garden, and then it disappeared. The rope could be seen from many angles from a long way off, and so the environment created by the rope seemed to get larger and larger. But this was possible only in Edinburgh and could never be repeated anywhere else. It was inspired by this particular city. I liked it and I think people understood what I meant. My work is always connected with thread and sewing. And this was a sort of sewing through one building and then through another.[22]

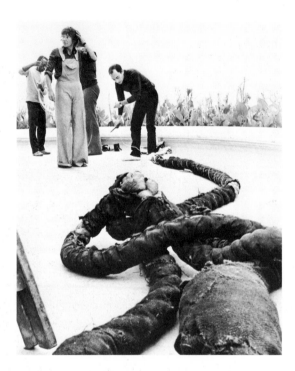

Figs. 60, 61 Installation of ropes at Bordeaux, France, 1973 (cat. no. 53)

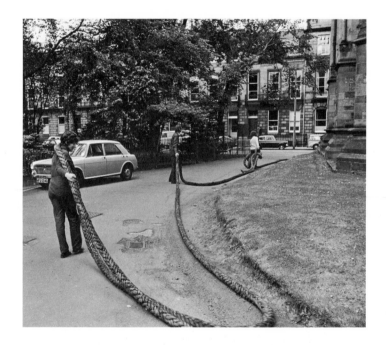

>

Figs. 62–64 Installation of ropes at the Edinburgh International Festival, 1972 (cat. no. 52)

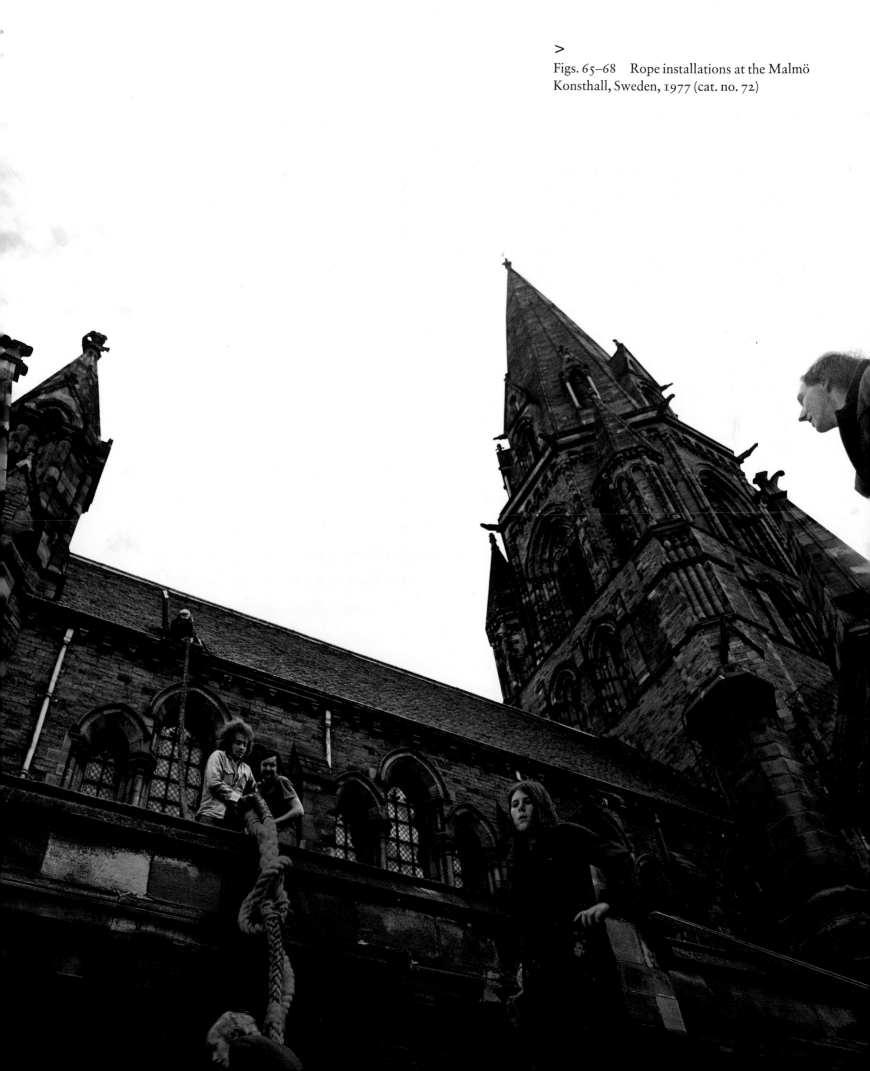

Figs. 65–68 Rope installations at the Malmö
Konsthall, Sweden, 1977 (cat. no. 72)

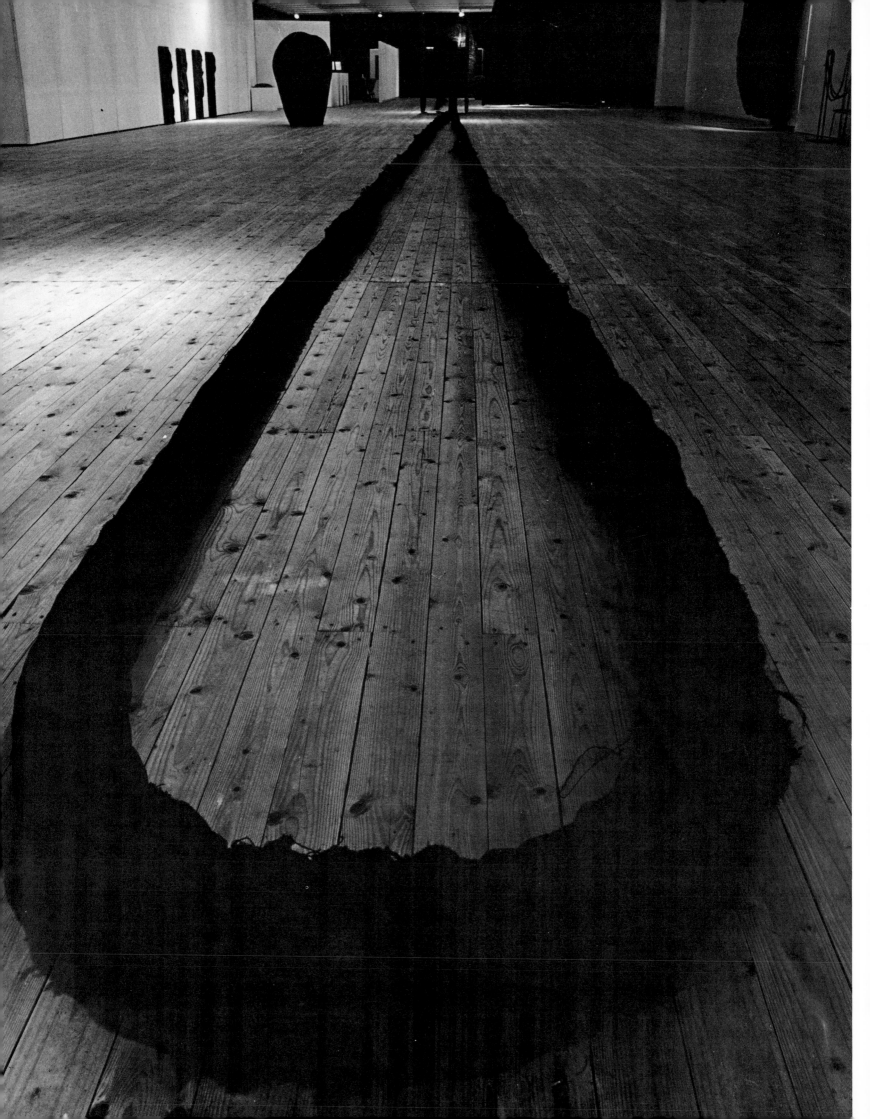

The rope is to me like a petrified organism, like a muscle devoid of activity. Moving it, changing its position and arrangement, touching it, I can learn its secrets and the multitude of its meanings.

I create forms out of it. I divide space with it.

Rope is to me the condensation of the problem of thread, the thread composed of many fibers whose number nobody tries to establish.

Transported from one place to another it grows old.

It carries its own story within itself, it contributes this to its surroundings.

I used it in urban landscapes where it became an echo of the banished organic world. It enabled one to see architecture with all its artificiality of hard decorative shell.

I sense its strength which is carried by all inter-twined elements, such as those in a tree, human hand, or a bird's wing—all built of countless coop-erating parts.

Magdalena Abakanowicz 1975

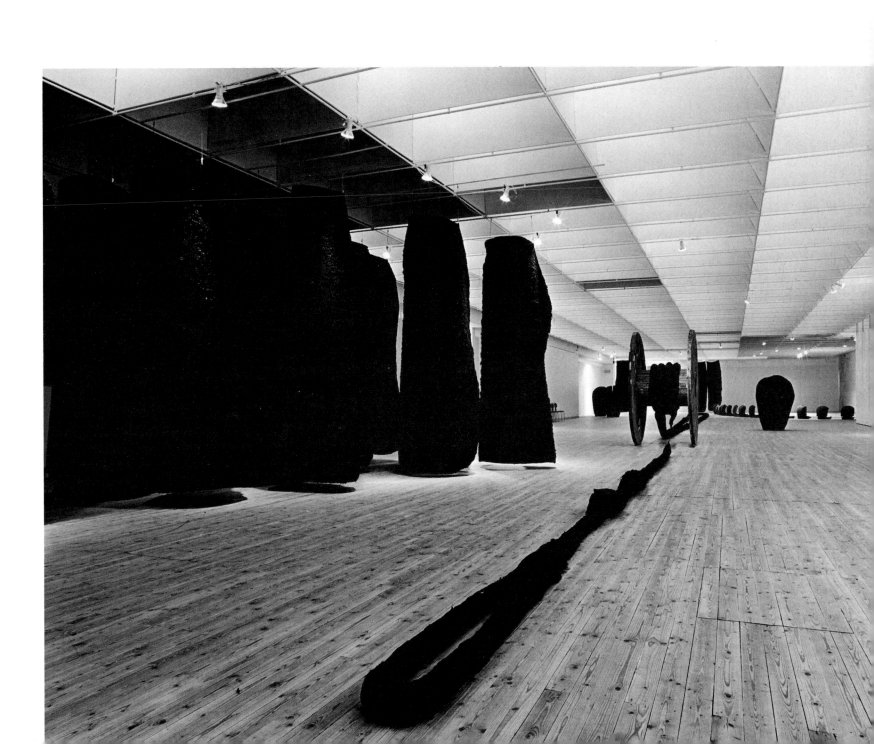

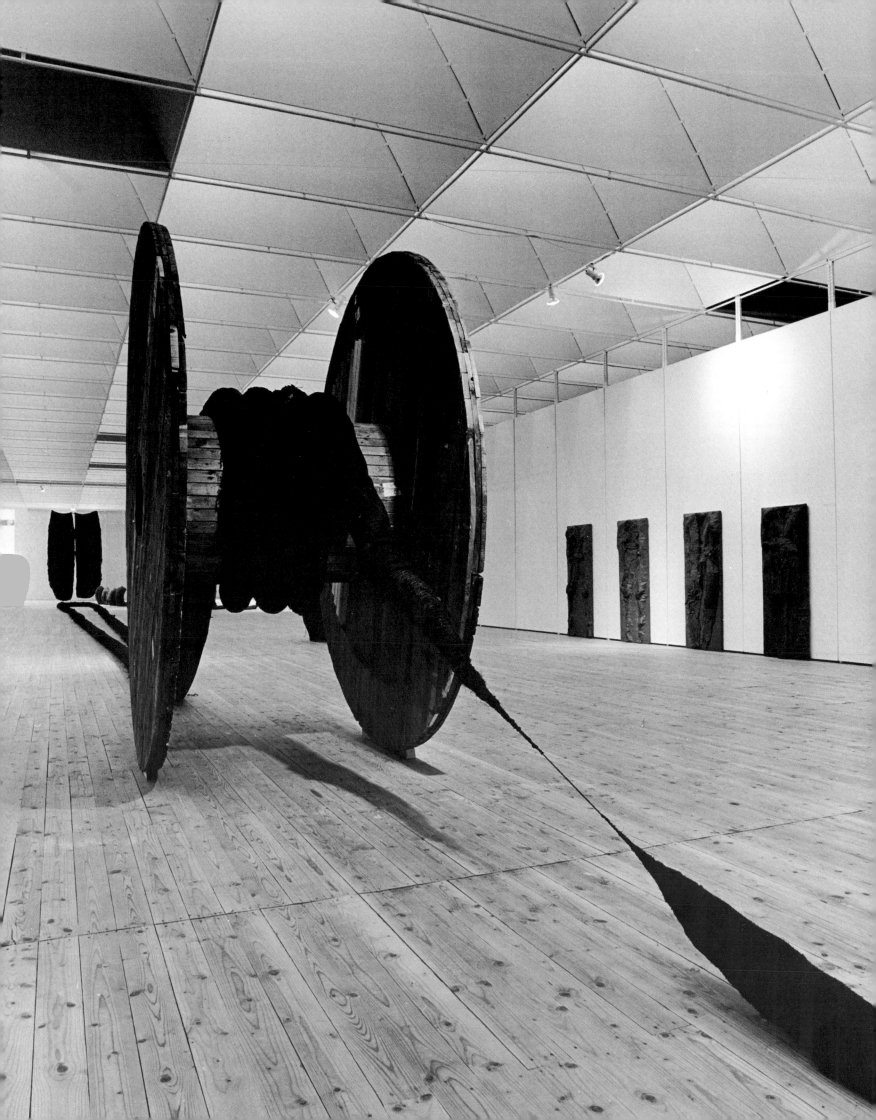

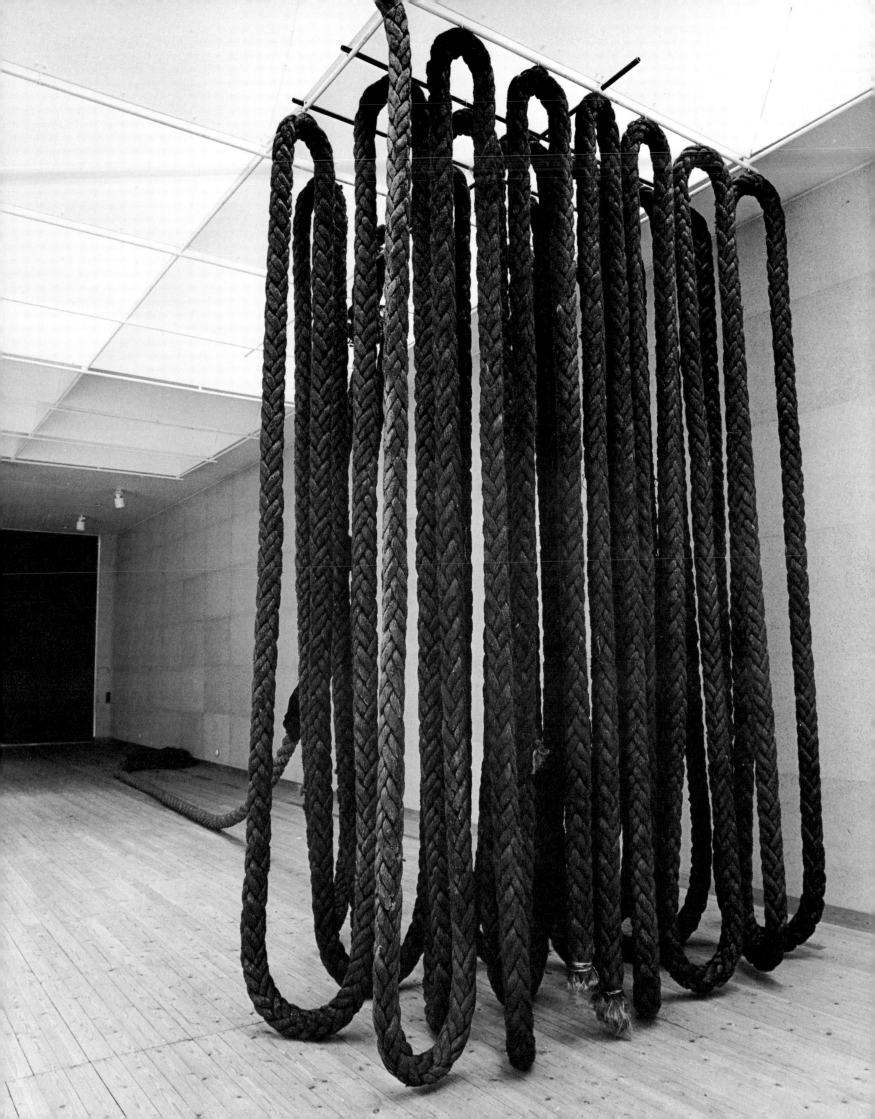

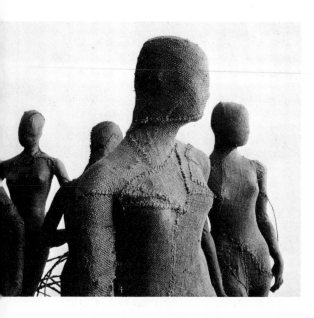

Alterations

When *Abakans* became huge, Magda wanted to reduce the scale of her work to approximately life-size. Her first step, in 1972, was to use some dummies. These were shop mannequins covered in hessian dyed black. She showed five of them with black balloons in an exhibition in Düsseldorf (fig. 70), and never again. She concluded two things on the basis of this experiment: one, that the dummies were too elegant, and two, that human bodies were too complicated. *Alterations* followed.

Fig. 69 Mannequins in progress in the artist's studio, Warsaw, 1972

Fig. 70 Installation at the Kunstverein für die Rheinlande und Westfalen, Düsseldorf, 1972

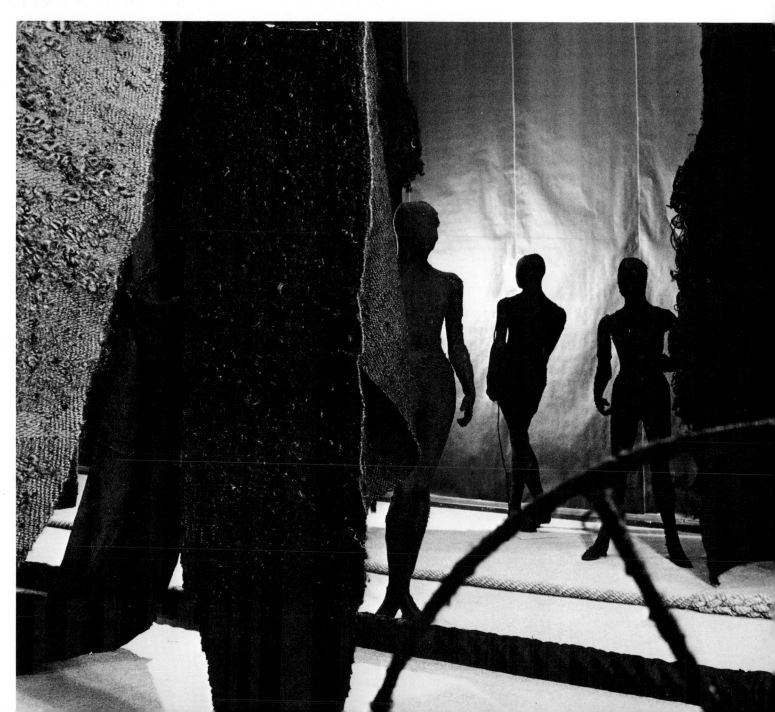

In the early 1970s, Magda moved to a new apartment on the tenth floor, with a studio four-and-one-half-by-five-and-one-half-meters square. This was her first real studio and the one in which she has worked since. *Alterations* originally consisted of three groups of works made in this new space. One group is called *Heads* or *Schizoid Heads* (figs. 73-76). Constructed on metal frames, these bulky objects are stuffed like mattresses and covered in roughly sewn hessian split in places, with hemp occasionally spilling out. The *Heads* stand firmly on the floor; they are large, round, and without front or back. Then came the *Seated Figures* (figs. 76-81). Magda found it imperative to impose some limitations to minimize the many intricate body components demanding attention. Heads and necks were cut off. The figures have no hands and no sex. In their final form the bodies are seated on high metal frames. They give the impression that they should be seen from the front because the backs are hollow, but Magda says that for her they are equally important from the rear and are intended to be seen in the round. When Magda started making the *Backs,* she eliminated the legs as well. "A great relief!" she exclaimed. The *Backs,* first made in 1976, are rear views of a man from neck to knees, seated on the ground and leaning forward with curved shoulders (figs. 82-86). With *Alterations,* work in the studio extended beyond weaving to whatever techniques and materials were required for a cycle of works. For instance, both *Seated Figures* and *Backs* were made from plaster casts. Magda has described their making as follows:

> I made a plaster cast of a tall, broad-shouldered man. The cast was in two parts: the front of the figure and the whole back. The model was seated. For several months I did not know what to do with it. In the end, I decided to make a positive cast in sacking. I smeared wax on the front part of the plaster so that it would stick. Then I lined it with pieces of sacking dipped in glue. Material dipped in glue sets, creating a hard shell of fairly precise form of the plaster cast, that is, the human form. To strengthen the figure in hardened sacking, I smeared it from the inside with synthetic resin, which I covered again with a layer of sacking dipped in glue.

All this Magda does herself because, as she says, "each movement, each piece of sack dipped in glue and laid inside the form, determines its expression."

These three groups of works have been called *Alterations,* although originally Magda had the idea of calling them "Deviations." The problem of titles for her has always been connected with their translation from one language into another, without a change of meaning and without a change in the sound quality of the words. Thus, no titles are absolute because only in one language could they ever be ideal in all contexts. For instance, *Figures Dorsales* was originally translated as *Seated Shoulders,* but ended up as *Backs.* Magda's works acquire different titles according to how and where they are shown. The same *Backs,* 16 of them, exhibited in Malmö in 1977, were called *The Session* (fig. 84).

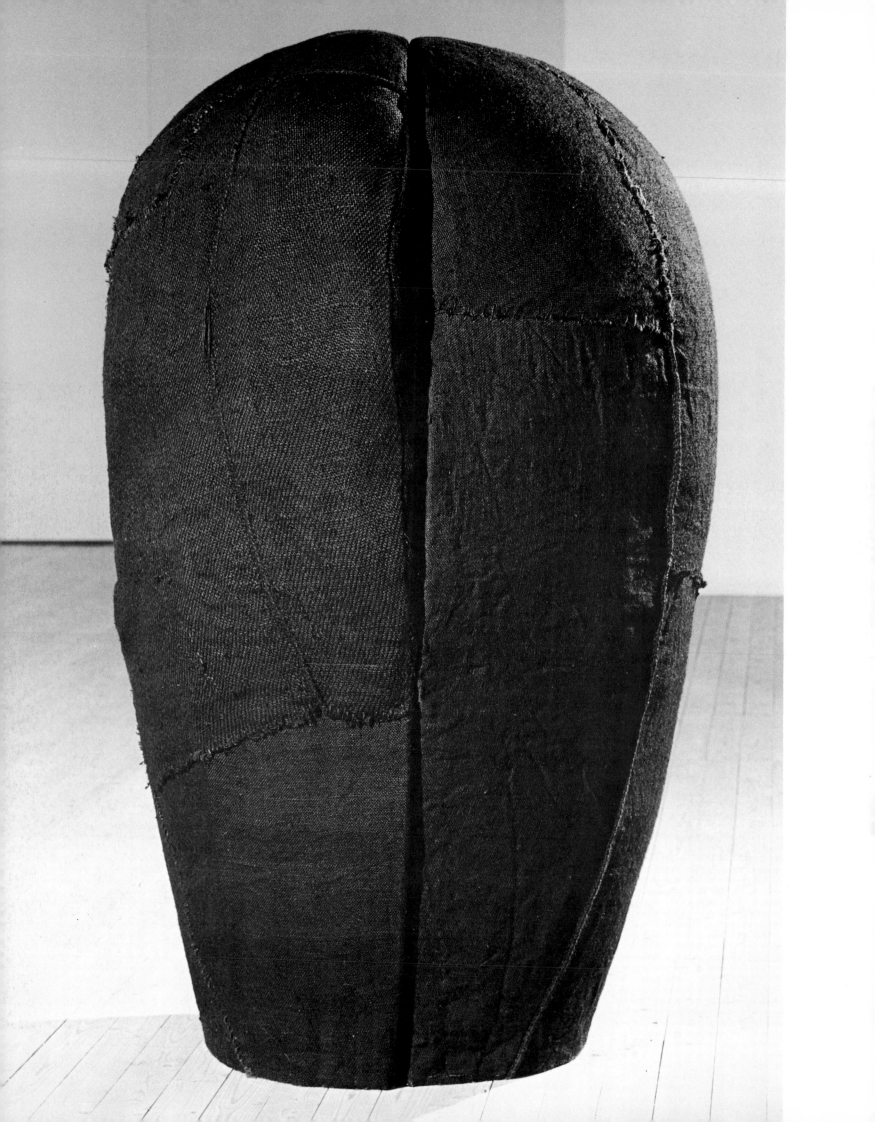

Fig. 71 *Head* 1973 (burlap; 170 x 100 x 100 cm
[70 x 39½ x 39½ in.]; destroyed)

Fig. 72 *Heads* 1973–75 (burlap; 170 x 100 x 100
cm [70 x 39½ x 39½ in.]; destroyed) at the Biuro
Wystaw Artystycznych, Łódź, Poland, 1978 (cat.
no. 74)

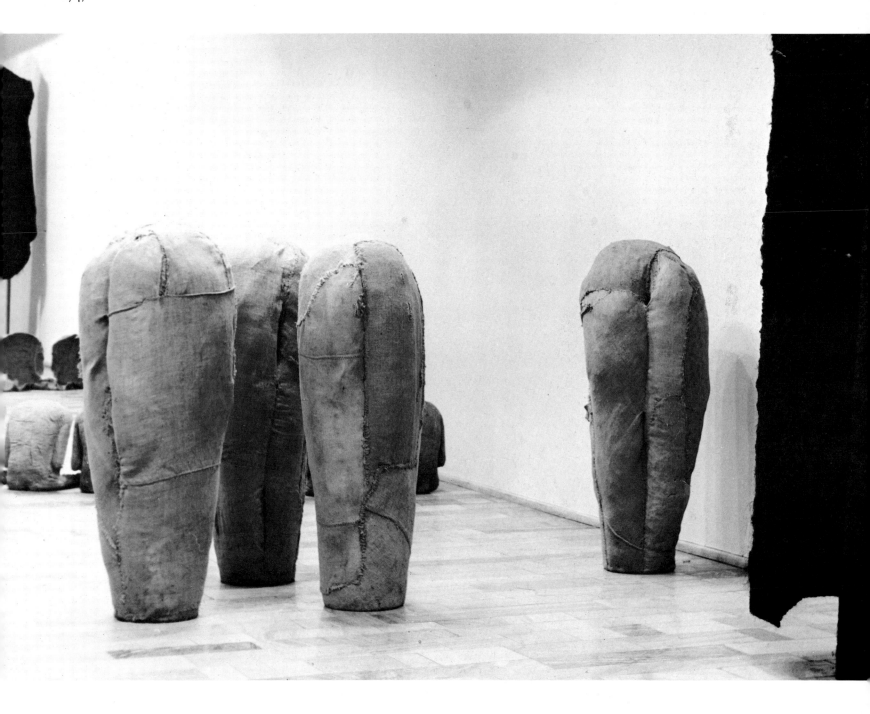

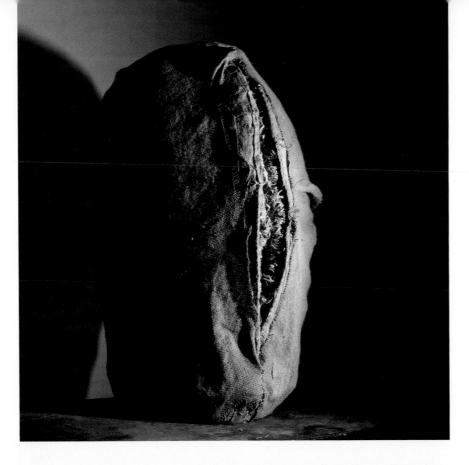

Fig. 73 *Head* 1973/75 (cat. no. 57)

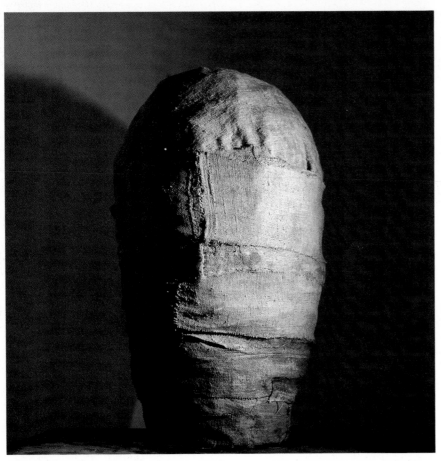

Fig. 74 *Head* 1973/75 (cat. no. 57)

>

Fig. 75 *Heads* 1973–75 (cat. no. 57) at Zachęta,
Warsaw, 1975 (cat. no. 65)

Those forms which I also refer to as *Heads* relate to my fear that to exceed the rate of one's biological rhythms leads to a loss of ability to meditate. I am apprehensive about the consequences suffered through the effects of artificial environment and unlimited stress.

Magdalena Abakanowicz 1975

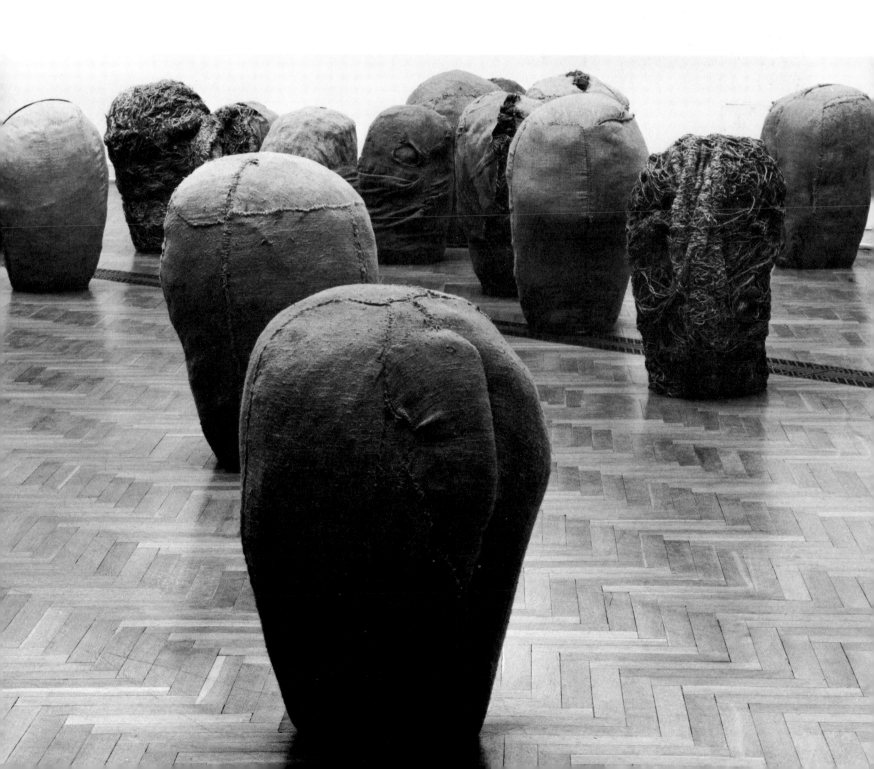

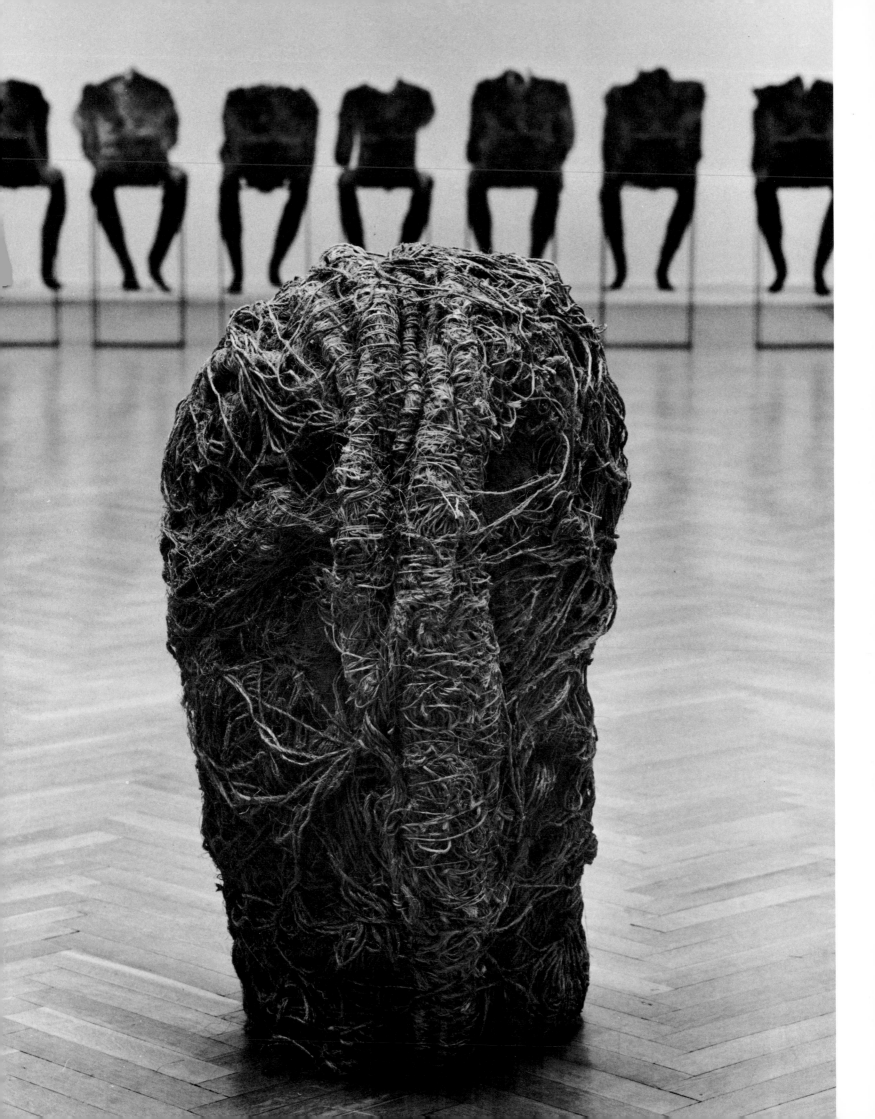

The *Seated Figures*—shell-like negatives of the bulk of the human body—deal with the problem of containing and enclosing. The cycles touch upon the questions of empty space which can be filled by means of our imagination, and with the sphere of the palpable, the rigid, which is an incomplete trace of our body's spatial adherence to its material surroundings.

Magdalena Abakanowicz 1975

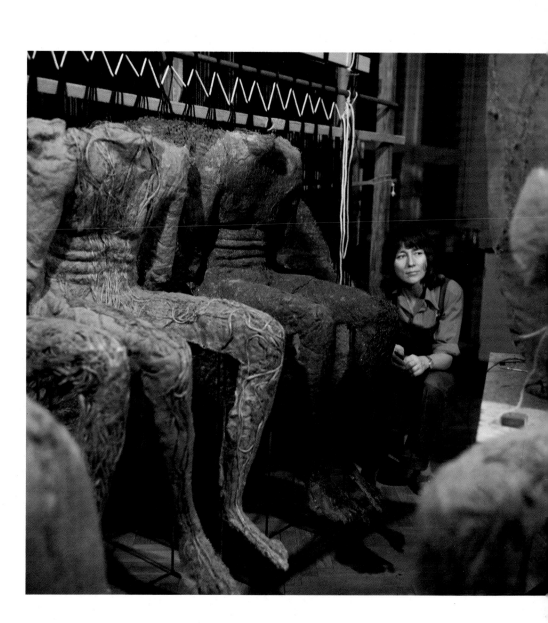

Fig. 76 *Head* 1973/75 (cat. no. 57), and *Seated Figures* 1974–75 (cat. no. 64) at Zachęta, Warsaw, 1975 (cat. no. 65)

Fig. 77 Magdalena Abakanowicz in her studio with *Seated Figures* (cat. no. 64), 1974

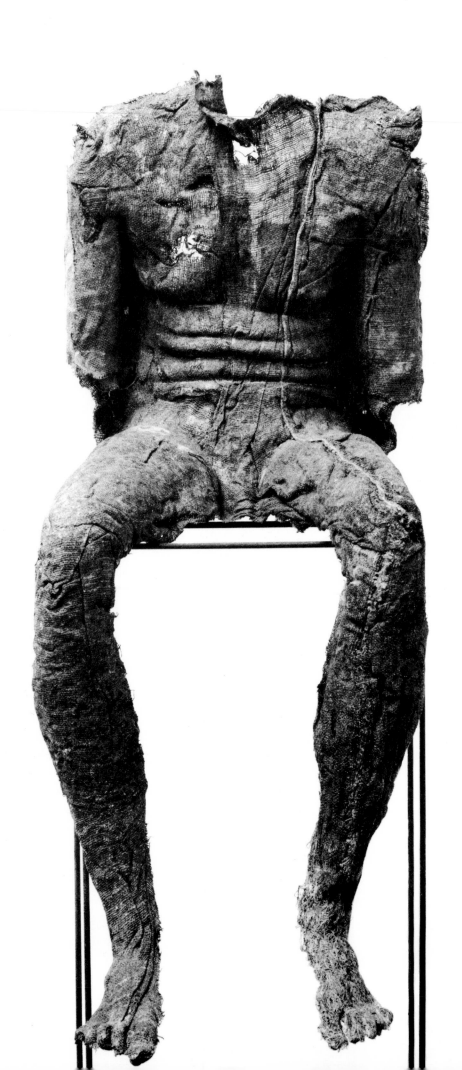

Fig. 78 *Seated Figure* 1974/77
(cat. no. 64)

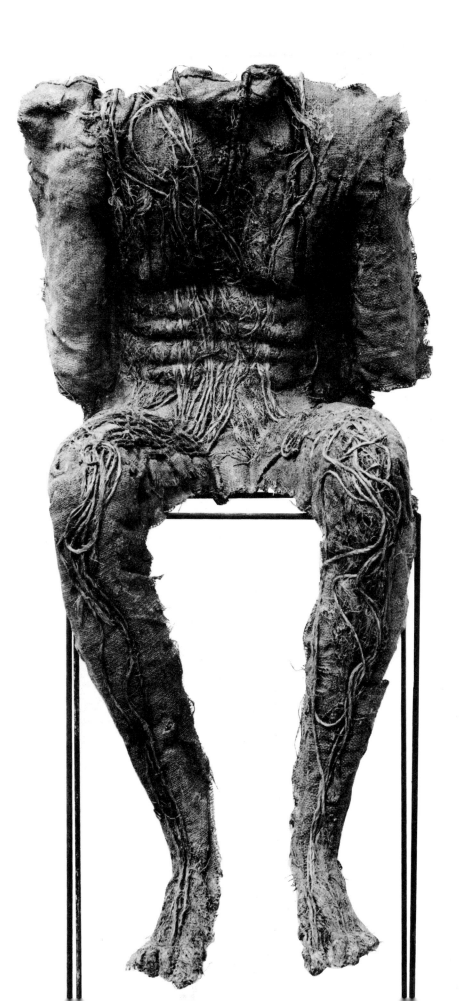

Fig. 79 *Seated Figure* 1974/77
(cat. no. 64)

Figs. 80, 81 *Seated Figures* 1974–75 (cat. no. 64)
at Zachęta, Warsaw, 1975 (cat. no. 65)

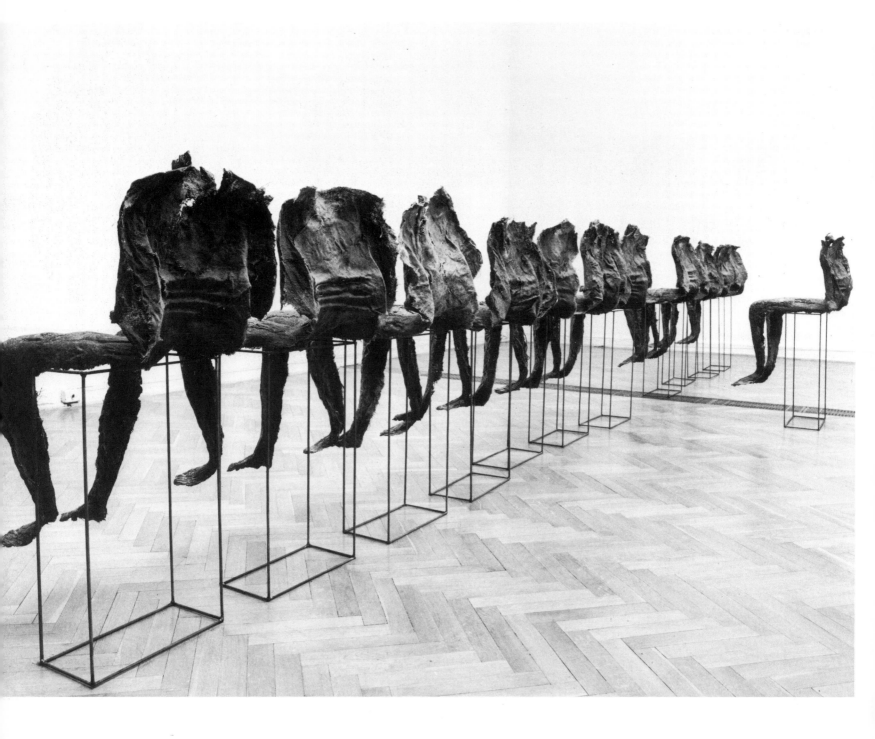

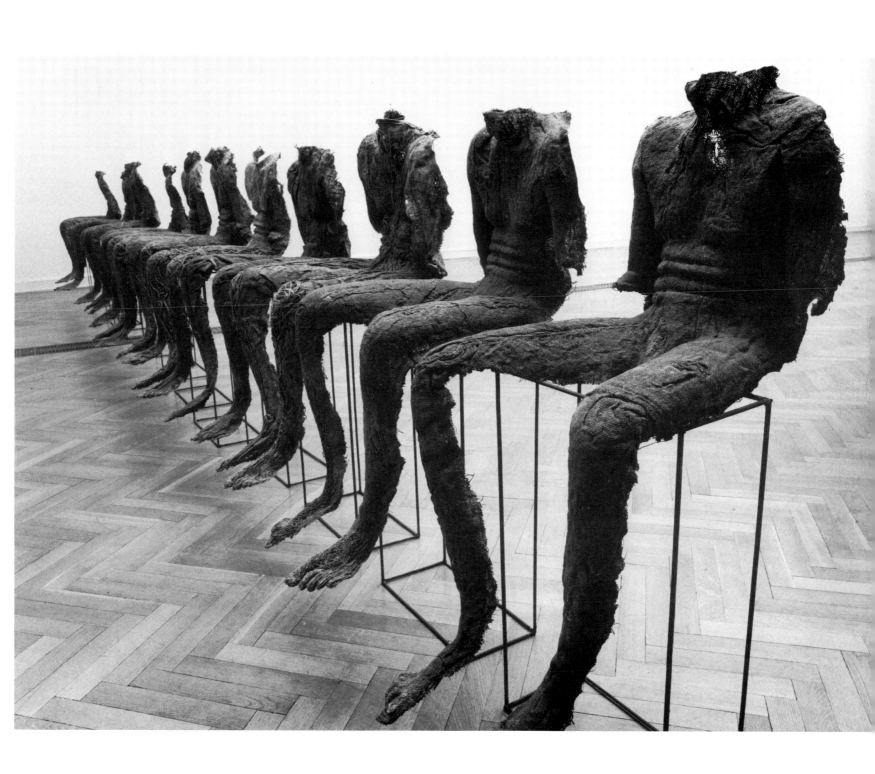

Fig. 82 *Back* 1976/82 (cat. no. 71)

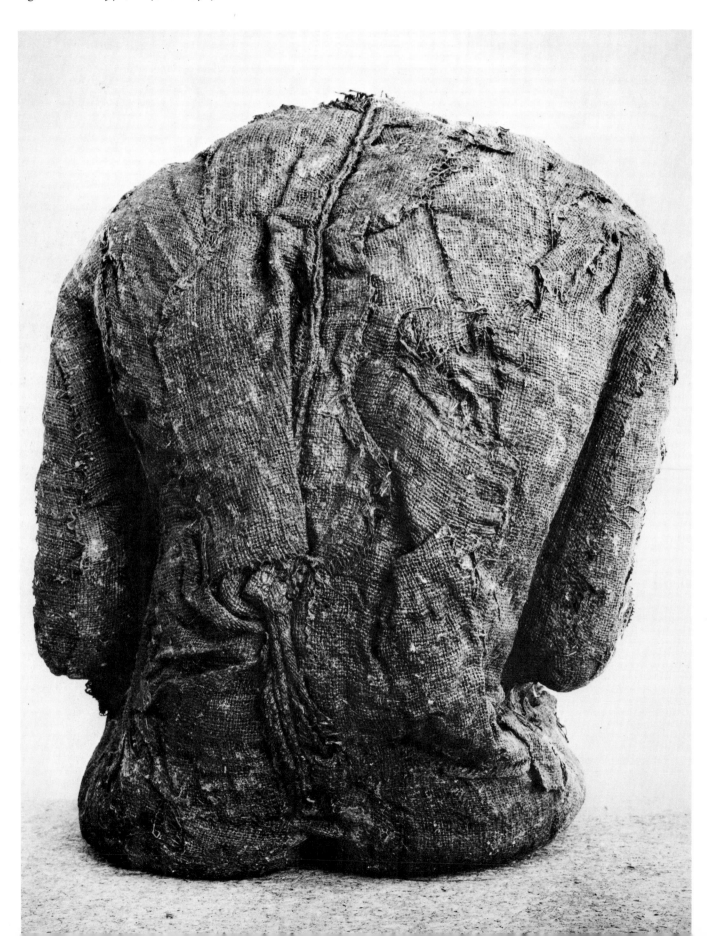

Fig. 83 *Back* 1976/82 (cat. no. 71)

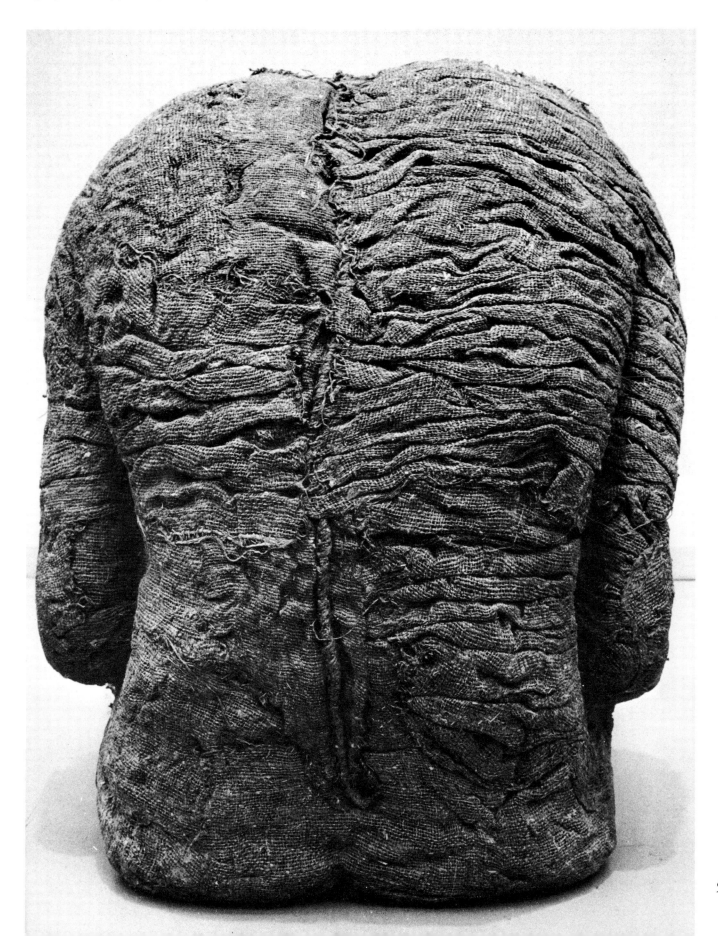

I see fiber as the basic element constructing the organic world on our planet, as the greatest mystery of our environment. It is from fiber that all living organisms are built— the tissues of plants, and ourselves. Our nerves, our genetic code, the canals of our veins, our muscles.

We are fibrous structures. Our heart is surrounded by the coronary plexus, the plexus of most vital threads.

Handling fiber, we handle mystery. A dry leaf has a network reminiscent of a dry mummy.

What can become of fiber guided by the artist's hand and by his intuition?

What is fabric? We weave it, sew it, we shape it into forms. When the biology of our body breaks down, the skin has to be cut so as to give access to the inside, later it has to be sewn, like fabric.

Fabric is our covering and our attire. Made with our hands, it is a record of our souls.

Magdalena Abakanowicz 1978

Fig. 84 *The Session* (16 *Backs*) 1976–77 (cat. no. 71) at the Malmö Konsthall, Sweden, 1977 (cat. no. 72)

Fig. 85 Abakanowicz with *Backs* 1976–81 (cat. no. 71) at the Musée d'Art Moderne de la Ville de Paris, 1982 (cat. no. 85)

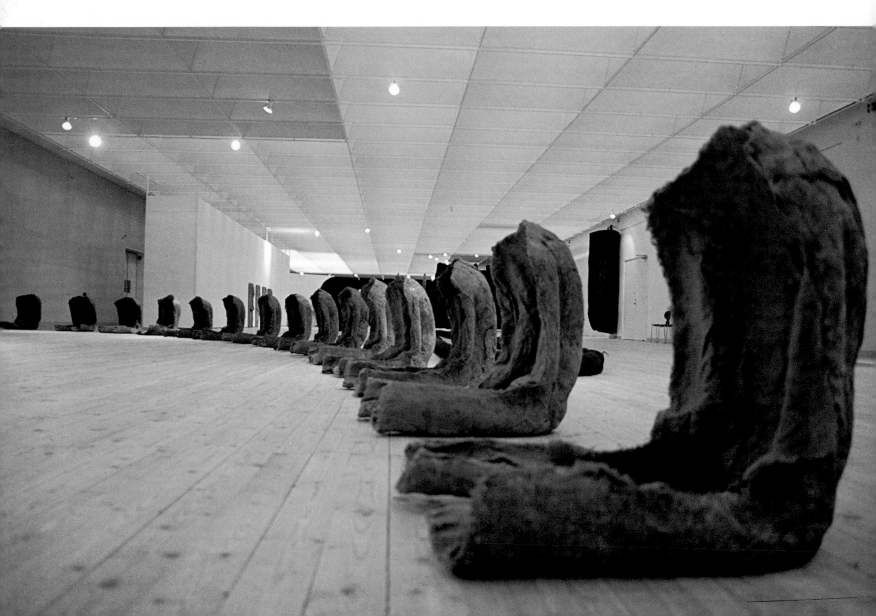

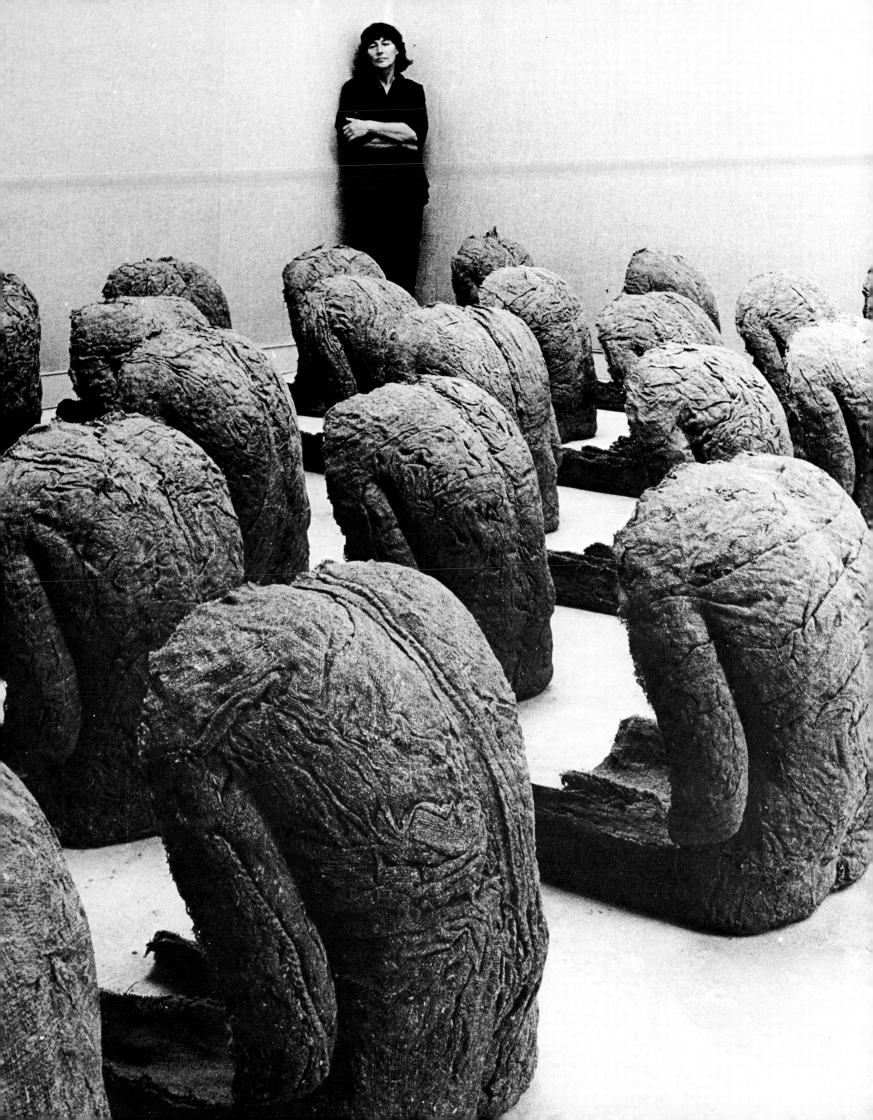

Fig. 86 *Backs* 1976–81 (cat. no. 71) along the
Vistula River, Warsaw, for the production of "L'Art
et les hommes: Magdalena Abakanowicz," directed
by Jean-Marie Drot, 1981

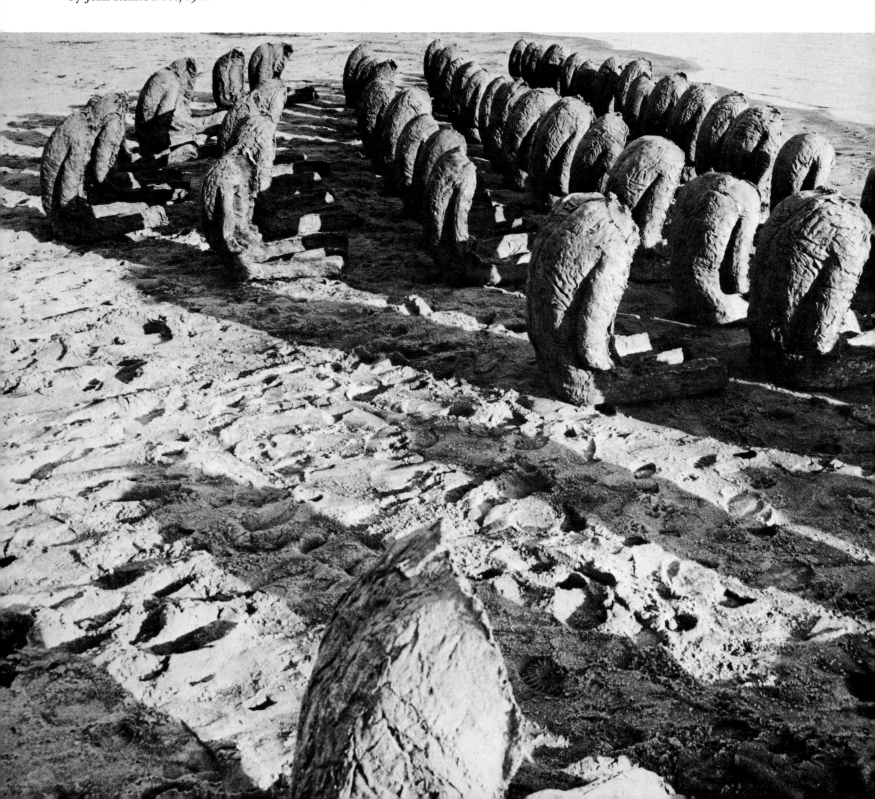

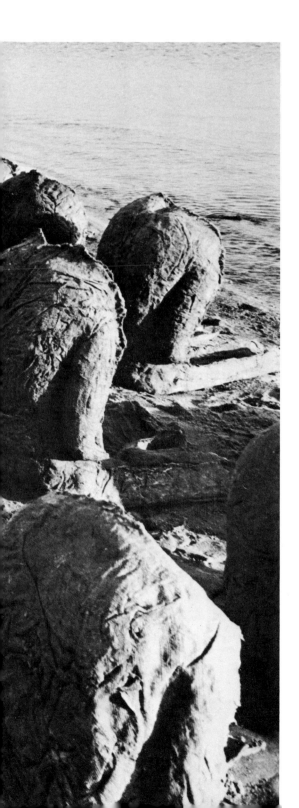

Most works in the *Alterations* cycles are placed firmly on the floor. They sprout from this horizontal surface like encrustations of the earth. Their color is that of nature left to its own devices, with forms reminiscent of the residue of an excavation. They are like things that time has left behind, sinking imperceptibly once more into the soil.

Magda once confirmed this reading, although she has found such an interpretation too concrete. Interestingly enough, the series of panel reliefs of fronts of bodies, which is another cycle of *Alterations* and which is made to go against the wall, she has called *Landscape* (figs. 87-90). In this way, the verticality is contradicted and, as one of Magda's friends has suggested, this work, too, suggests a body already turning to earth.

A major and extensive part of *Alterations* is the *Embryology* cycle. Begun in 1978, it was first presented at the 1980 Venice Biennale and consisted of 500 rounded forms, the biggest on metal frames covered in fine sacking, others in gauze or stocking, not unlike potatoes lying in heaps on the floor, but with an enormous variety of sizes from tiny to huge (figs. 91-99). The semitransparent fabrics with which the smaller ones are covered allow the viewer to see inside the once turbulent mesh of hemp, kapok, and string, now ossified. Occasionally Magda makes smaller families of *Embryology* for special exhibitions and she does not feel that their number has to be limited.

Figs. 87–90 *Landscape I–IV* 1976 (cat. no. 68)

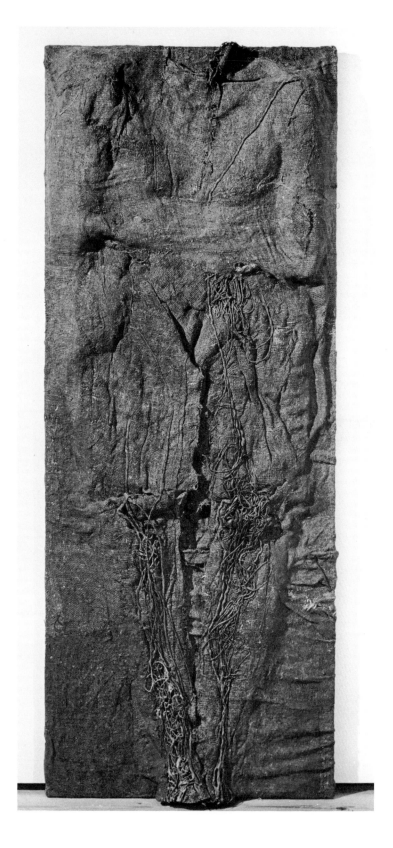

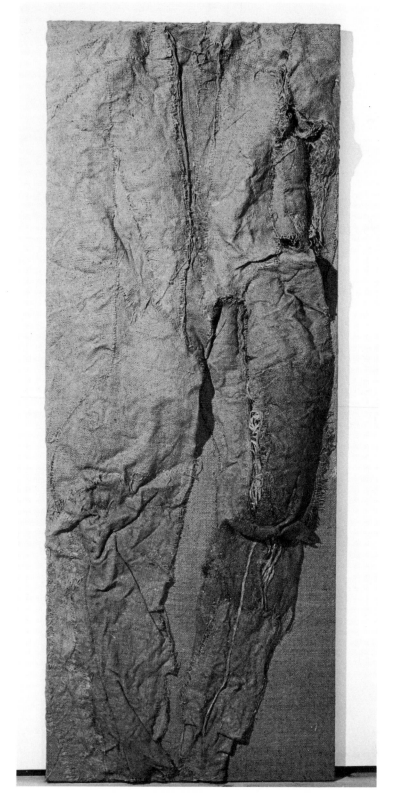

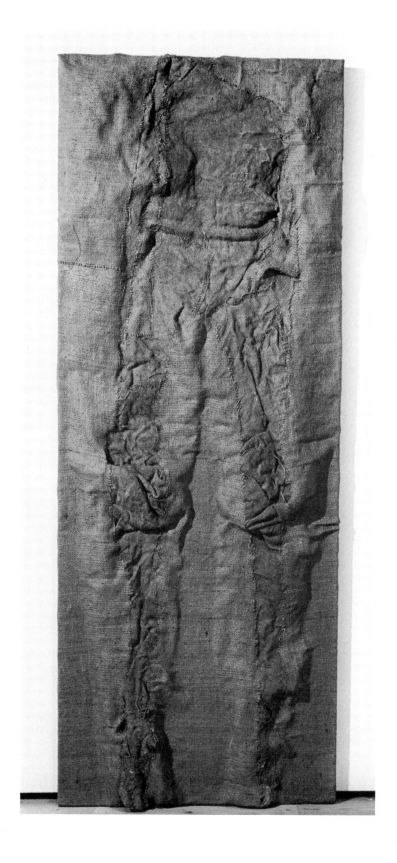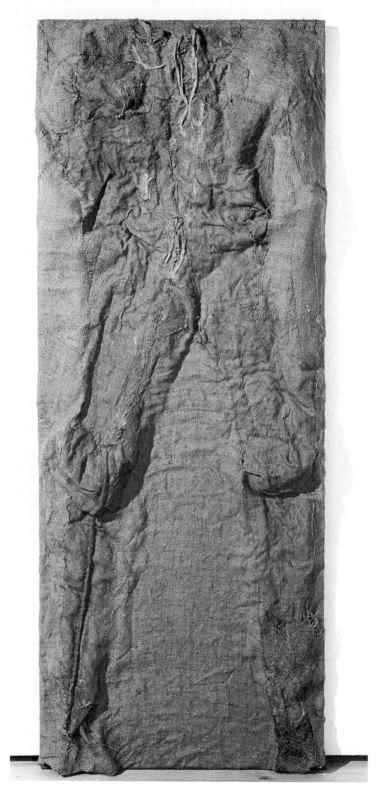

Figs. 91–95 Abakanowicz at work in her studio on *Embryology* (cat. no. 76), 1979

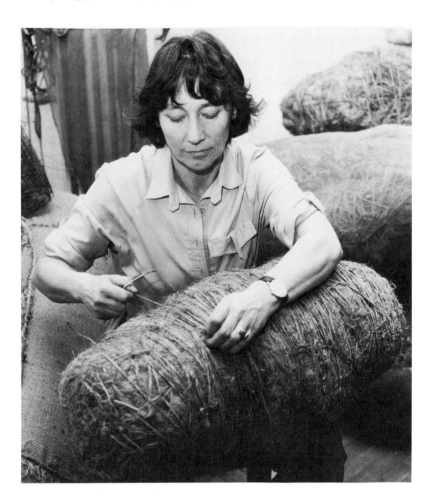

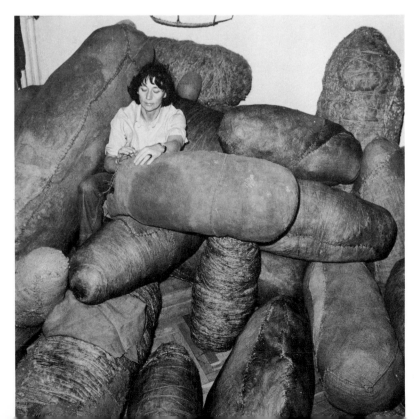

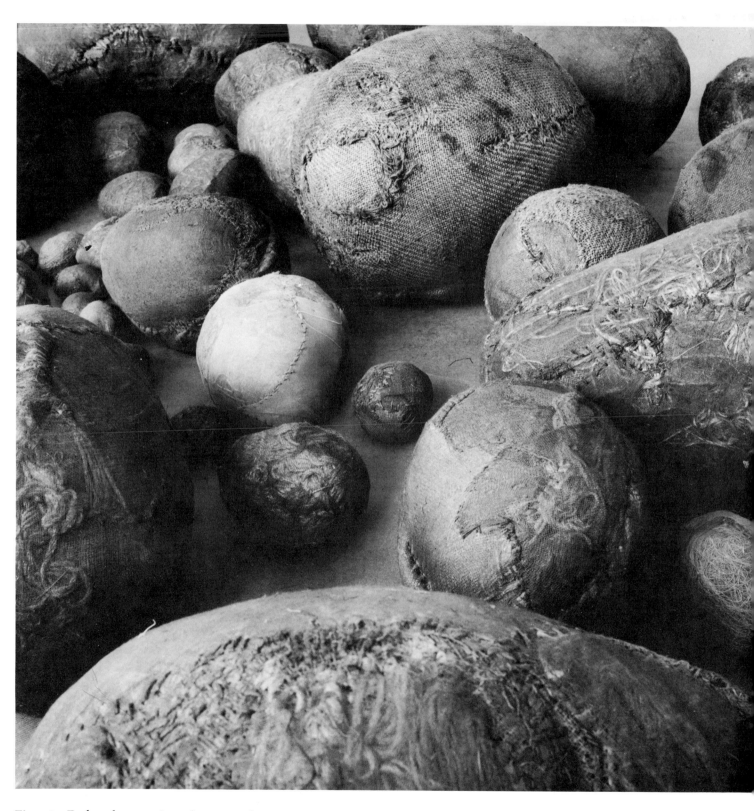

Fig. 96 *Embryology* 1978–79 (cat. no. 76)

Soft

Once upon a Time

I was a small child, crouching over a swampy pond, watching tadpoles. Enormous, soon to become frogs, they swarmed around the bank. Through the thin membrane covering their distended bellies, the tangle of intestines was clearly visible. Heavy with the process of transformation, sluggish, they provoked one to reach for them. Pulled out onto shore with a stick, touched carelessly, the swollen bellies burst. The contents leaked out in a confusion of knots. Soon they were beset by flies. I sat there, my heart beating fast, shaken by what had happened. The destruction of soft life and the boundless mystery of the content of softness. It was just the same as confronting a broken stem with sap flowing out, provoked by an inexplicable inner process, a force only apparently understood. The never fully explored mystery of the interior, soft and perishable.

Many years later, that which was soft with a complex tissue became the material of my work. It gives me a feeling of closeness to and affinity with the world that I do not wish to explore other than by touching, feeling, and connecting with that part of myself which lies deepest.

Becoming

Between myself and the material with which I create, no tool intervenes. I select it with my hands. I shape it with my hands. My hands transmit my energy to it. In translating idea into form, they always pass on to it something that eludes conceptualization. They reveal the unconscious.

Interior

The shapes that I build are soft. They conceal within themselves the reasons for the softness. They conceal everything that I leave to the imagination. Neither through the eye nor the fingertips nor palm that informs the brain can this be explained. The inside has the same importance as the outer shell. Each time shaped as a consequence of the interior, or exterior as a consequence of the inside. Only together do they form a whole. The invisible interior which can only be guessed at is as important as when it opens for everyone, allowing physical penetration.

Meditation

To make something more durable than myself would add to the imperishable rubbish heaps of human ambitions, crowding the environment. If my thoughts and my imaginings, just as I, will turn to earth, so will the forms that I create and this is good. There is so little room.

Coexistence

My forms are like successive layers of skin that I shed to mark the stages along my road. In each case they belong to me as intimately as I belong to them, so that we cannot be apart. I watch over their existence. Soft, they contain within an infinite quantity of possible shapes from which I choose only one as the right, meaningful form.

In exhibition rooms I create spaces for them in which they radiate the energy I have imbued them with. They exist together with me, dependent on me, I dependent on them. Coexisting, we continually create each other. Veiling my face, they are my face. Without me—like scattered parts of the body separated from the trunk—they are meaningless.

Confession

Impermanence is a necessity of all that lives. It is a truth contained in a soft organism. How to give vent to this innate defeat of life other than by turning a lasting thought into perishable material?

Thought—a monument. Thought—a defense against disappearance. Timeless thought. A perverse product of the soft tissue that will disintegrate, that one day will cease to connect. Expressed in material whose durability is related to the matter from which it came, it begins to really live—mortally.

Contact

I touch and find out the temperature. I learn about roughness and smoothness of things. Is the object dry or moist? Moist from warmth or from cold? Pulsating or still? Yielding to the finger or protected by its surface? What is it really like? Not having touched, I do not know.

Embryology

Carried for a long time in the imagination, shapes ripen. When out of pent-up tension, they have to be discharged, I become one with the object created. My body grows ugly, exhausted by bringing forth an image. My body gets rid of something that had been a part of it, from the imagination to the skin. The effort of discharge makes it hideous.

In my belly life was never conceived. My hands shape forms, seeking confirmation of each individual specimen in quantity. As in a flock subordinating

the individual, as in the profusion of leaves produced by a tree.

Reminiscence

But, at the very beginning, when I started to weave and to use soft material, it was from a need to protest. From a wish to question all the rules and habits connected with this material. Soft is comfortable and useful. It is obedient, wrapping our body. It deadens the sound of footsteps. It covers walls, decoratively and warmly. It is easy on the eyes. It is practical. Accompanying our civilization from its very beginnings, it has its roles, a definable range of tasks governed by our needs and habits. It has its own system of classifications.

That is why I found the struggle with these acquired habits so fascinating. That is why it has been so fascinating to reveal and disclose the organic quality of fabric, of softness. To show the qualities overlooked through the blindness of habits. The autonomous qualities. To show all that this material could be as a liberated carrier of its own organic nature.

And later, the showing of objects which contradict the former functions of this material, broadening man's awareness of the matter which surrounds him, the objects which surround him, the world which surrounds him.

Softness

I touch my body. It still obeys me. It fulfills orders efficiently, without resistance. The muscles move wisely. When needed, they raise my hand, move my fingers. When needed, I lower and raise my eyelids. I move my tongue. Under the skin the flesh is precisely shaped. Springy. Everywhere, in the wholly enclosed, porous skin-covering—pulsation. All uniformly heated, saturated with moisture, with thick red juice, white mucus, jellylike secretion. All stretched on bones. Inside them—canals, intertwined with nets and threads, soft and fragile. Hot, greasy. It belongs to me. It is me. It causes me to be.

Magdalena Abakanowicz 1979

∨ >

Figs. 97–99 *Embryology* 1978–80 (cat. no. 76) in the Polish Pavilion, Venice Biennale, 1980 (cat. no. 78)

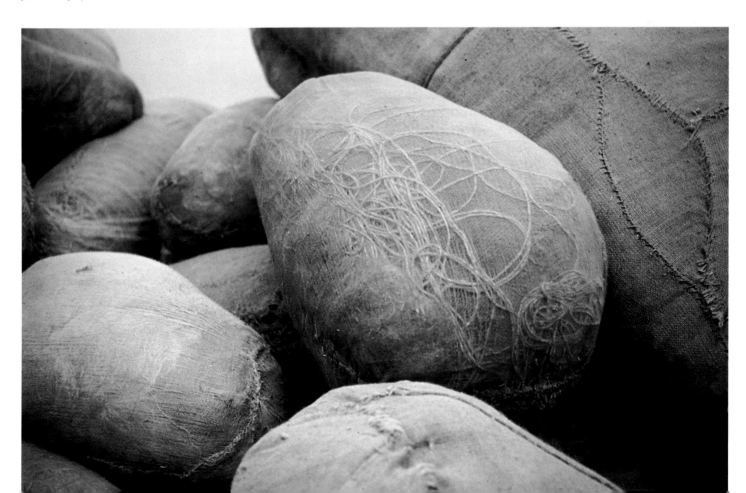

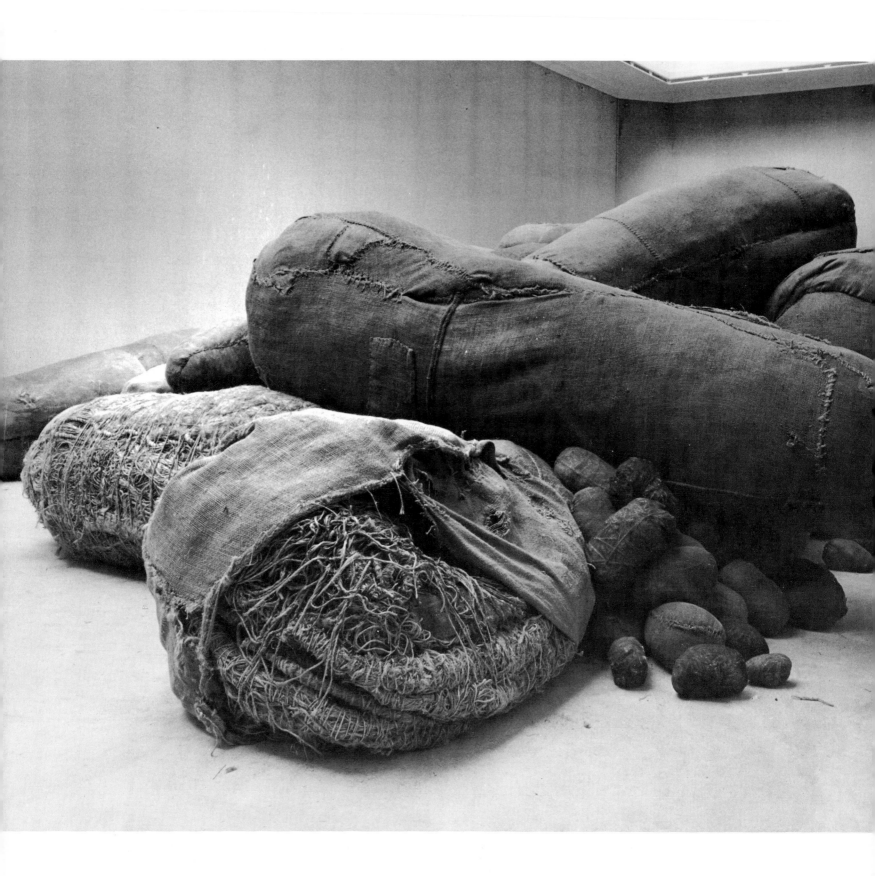

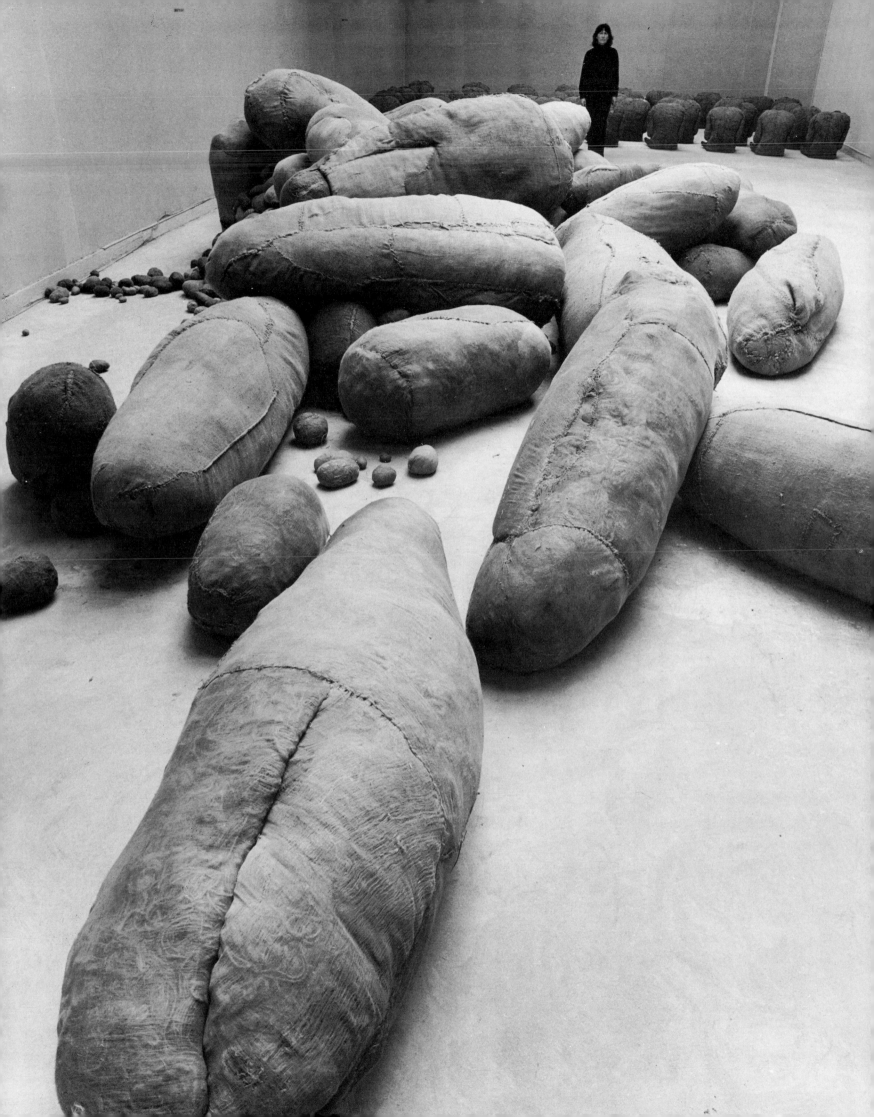

One of the most recent cycles of works, started in 1980, consists of bunches of birch twigs of different sizes bound together with wire and presented as a group (figs. 100, 101). Some are bulbous, some spindly, and all include elements which are pointed and sharp. The cycle started its life with the name *Sintrom,* after the Swiss anticoagulant used in the cure of her husband's heart illness. Later it reappeared as *Pregnant.* This cycle, which looks hard to the touch, represents a formal antithesis to *Embryology,* which always appears soft although it may be very resistant to the touch. Like *Embryology, Pregnant* lies on the floor.

Magda's cycles are like the cycles of life, with a continual transition from growth to decay. The emergence is tentative and slow, followed by an irrational exuberant explosion, brilliant and ecstatic, and then a contraction to a few essential simplified forms. Then a new cycle begins.

Figs. 100, 101 *Pregnant* 1981–82 (cat. no. 84)

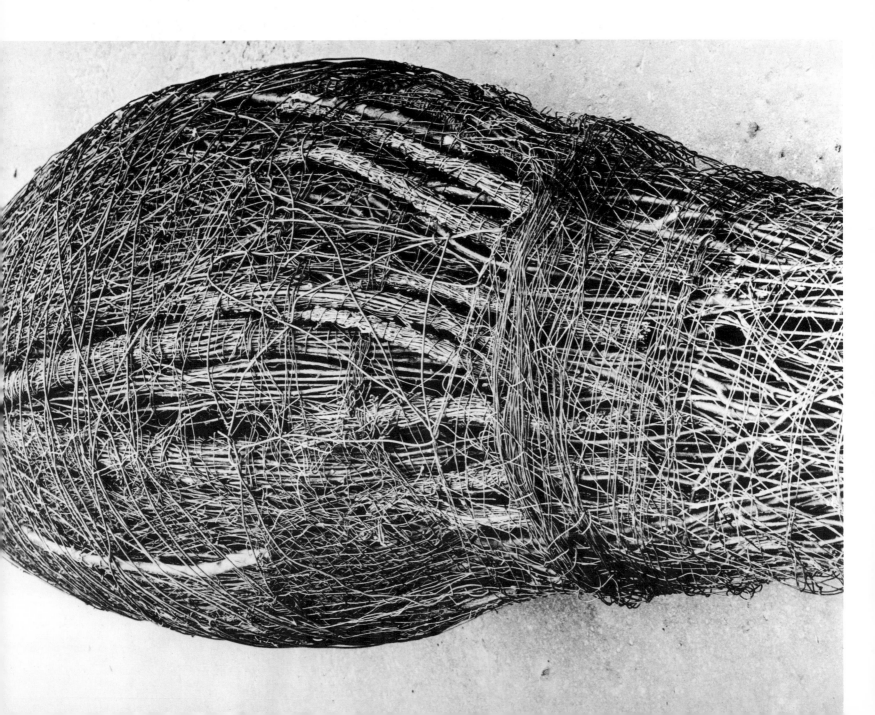

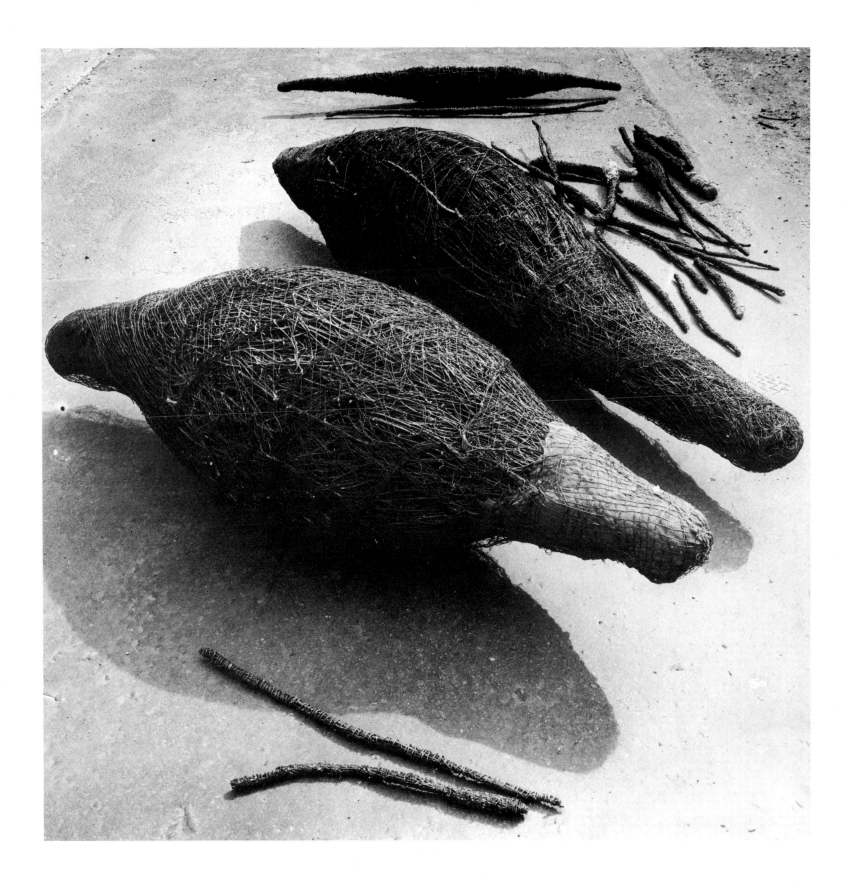

Burlap and Tarpaulins

Of her one-person exhibitions Magda has particularly liked the one in the Polish Pavilion at the Venice Biennale in 1980. Outside the Pavilion she installed two constructions which looked like sails (fig. 104) and which she called *Trzepaki* (large wooden frames for beating carpets). They provided a transition between the trees in the park and the white rectangular building in which the exhibition was held. Made of wood with hanging pieces of sacking sewn together, partly stuffed to produce bulges, and weighted down at the bottom with bags full of sawdust, they also provided a connection with the *Embryology* inside the Pavilion. "In both," said Magda, "everything depended on the full and the empty."[23] The difference between *Trzepaki* and the earlier *Abakans* was principally one of weight and texture: whereas the hermetic and dark *Abakans* created their own spaces and occupied floors, the burlap sacking became a part of the landscape and moved with the wind like everything else.

Figs. 102, 103 Construction of *Trzepaki* (cat. no. 77), 1980; from left to right: Magdalena Abakanowicz, Krysia Kiszkiel, and Stefa Zgudka

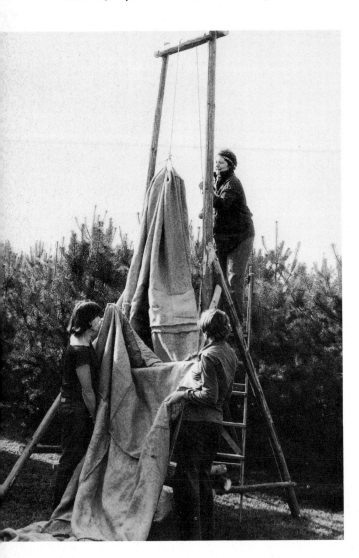
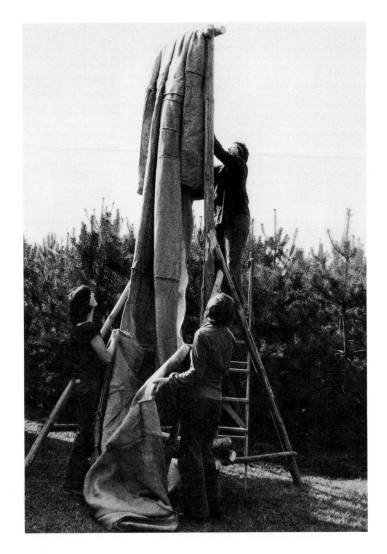

Fig. 104 *Trzepaki* 1980 (cat. no. 77) at the Polish
Pavilion, Venice Biennale, 1980 (cat. no. 78)

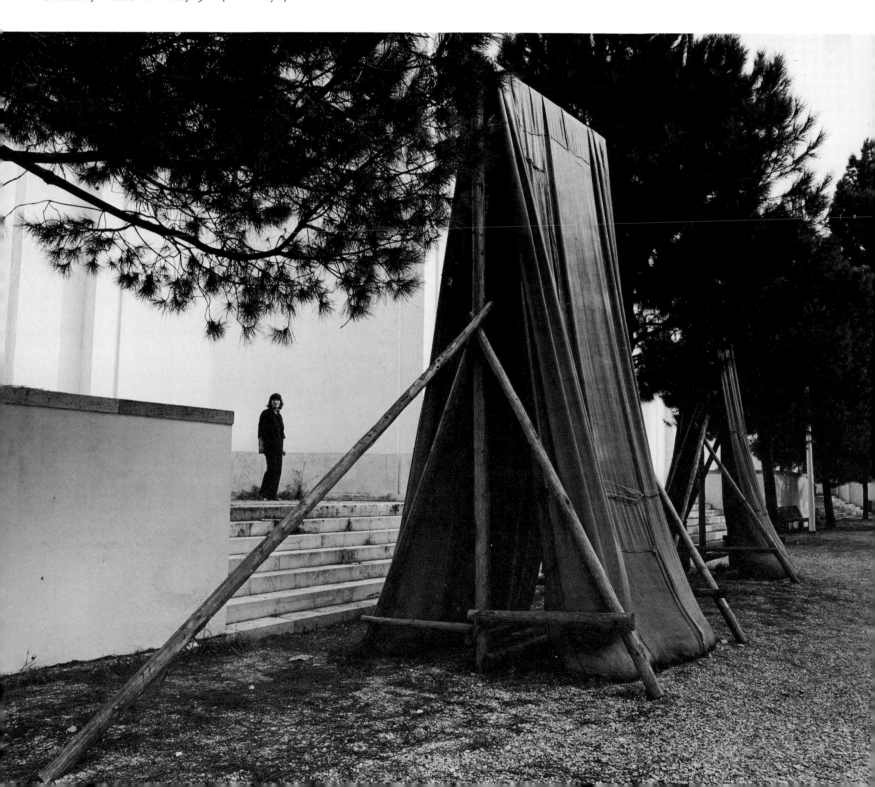

Trzepaki, with their loosely hanging, readymade cloth, anticipated the use of tarpaulins, for which Magda admits an interest of long standing. She used them for the first time in 1981 in the Malmö Konsthall. Each of the artists invited to participate was to make a work inspired by southern Sweden. Malmö itself, at one time a fortified seaport, is the country's second principal industrial center. A few months before the show, the artists were taken on a trip around the region to gain inspiration for creating relevant images. The port, sails, fishing poles, water, grays and greens, were the elements to which Magda reacted (see figs. 105, 106). On her return to Poland she decided to use tarpaulins: old, used, colored by rust, earth, and dust—their shapes and colors touched her imagination. She collected several old, dirty, green-gray tarpaulins measuring nine-by-six meters and took them with her to Malmö.

Several exhibition areas in the Konsthall have movable floors. Magda asked for such a space so that she could make use of the cavity under the floor. She got three old fishing poles from the port, each six meters long. One pole was used to divide the space of the cavity in half, the others were on either side, and to these the tarpaulins were attached, thus hanging from the level of the floor into the cavity. One tarpaulin hung separately in space (figs. 107-109). "It was dark," said Magda, "it could have been a bird, a fish, the bottom of a boat, or just a huge old rag."

She had intended to use water but in the end the idea was abandoned. The tarpaulins had their own character. "Water is again a material which I must discover very slowly while finding out what it has in common with me."[24] Even before she started work on the project, she stated in the catalogue that the result of her work would be her own story about all that she would have encountered in Malmö and all that she would have missed.[25]

Figs. 105, 106 Magdalena Abakanowicz in Malmö, Sweden, 1981

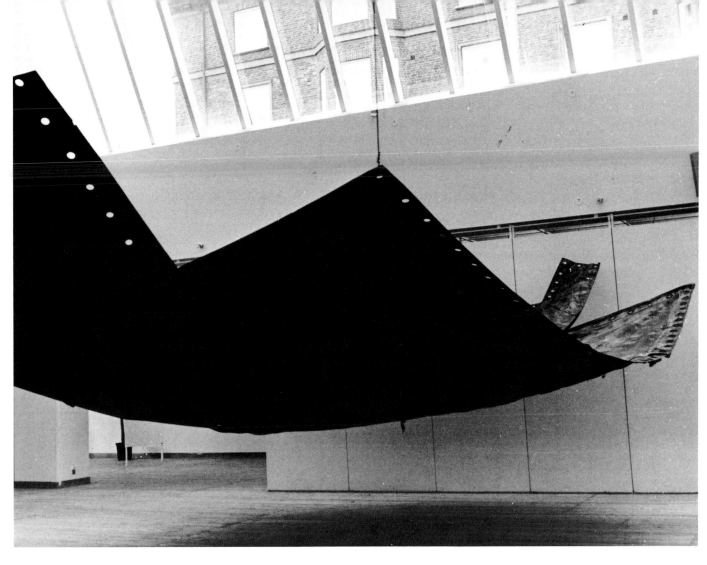

Figs. 107–109 Installation at the Malmö Konst-
hall, Sweden, 1981 (cat. no. 81)

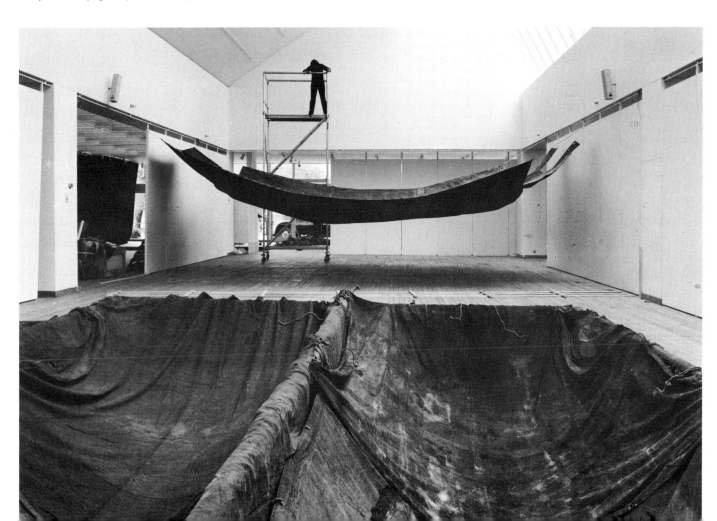

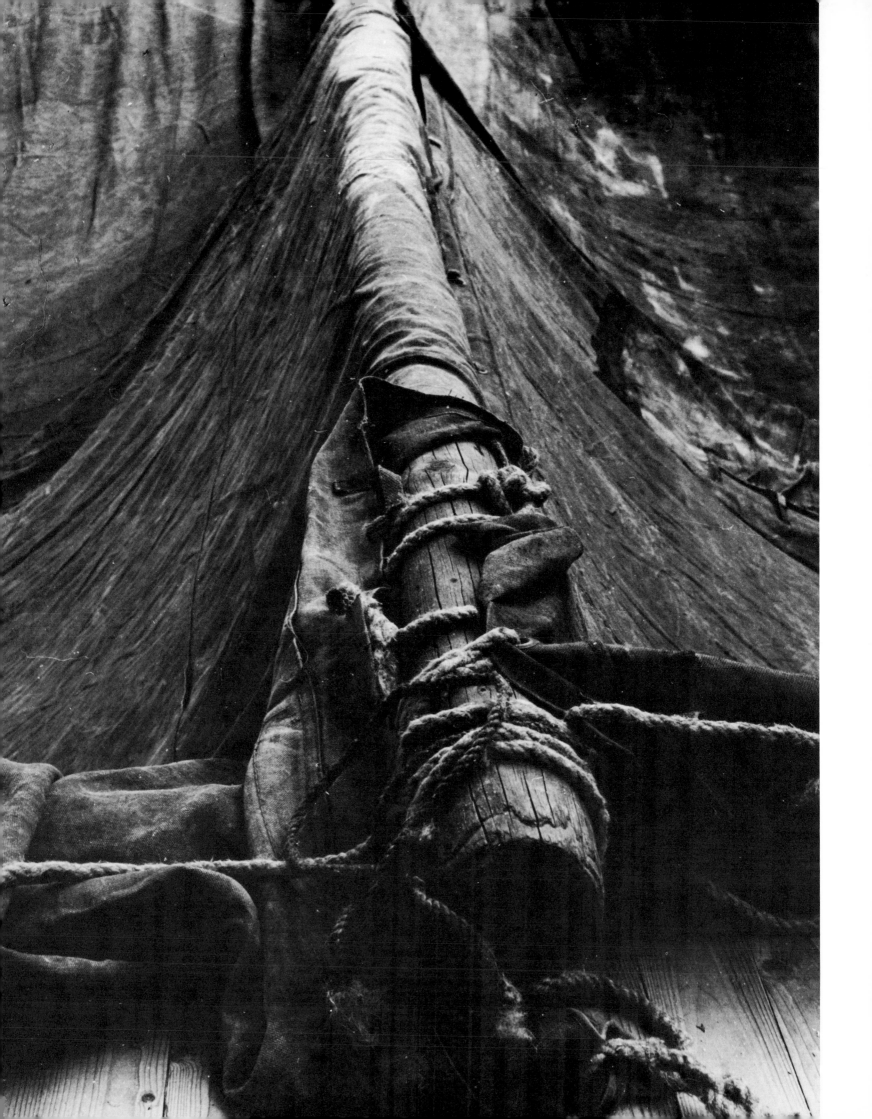

Drawings

In the course of the years Magda has made many different types of drawings. She has always drawn, although she abandoned drawing in pencil for some time after her experiences at the Academy when the professor rubbed out all those lines which he thought unnecessary.

The early drawings of the 1950s are colorful; later they tend towards monochrome. There are additions of collage, indications of textures, and sometimes pieces of paper attached with pins. In the 1960s there were more gouaches and collages. These drawings served for sorting out ideas, experimenting with juxtapositions, and as notes. On the basis of these Magda, along with Stefa and Krysia in the early days of their association, did the weaving. Magda continues to make drawings consisting of a few simple lines with measurement notations (figs. 110-114).

Magda says she does not make preparatory drawings for her works—for *Abakans,* for *Alterations,* for the meanderings of her rope through galleries, or for the layout of her exhibitions. Rather, she works directly with her materials, whether these be string and horsehair or completed sculptures, without benefit of sketches, diagrams, or studies. For instance, it was only after having created the *Heads* that Magda made a series of related gouaches (figs. 115, 116). And indeed, in all her work up to 1980, the drawings assume the role of an accompaniment to a choir.

Fig. 110 Working notes c. 1978–81 (ink on paper; collection of the artist)

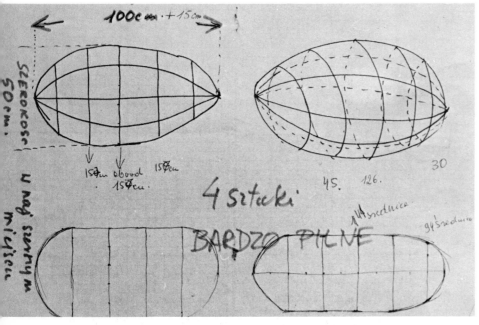

Figs. 111–114 Working notes c. 1978–81 (ink on
paper; collection of the artist)

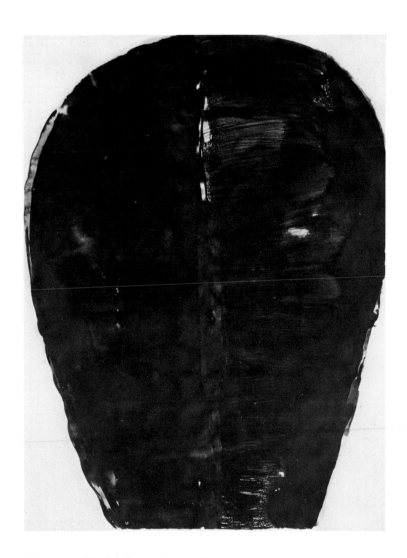

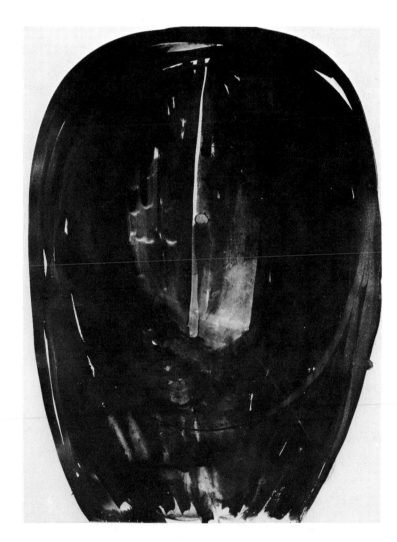

Fig. 115 *Untitled* 1976 (gouache on paper; 50 x 38
cm [19⅝ x 15 in.]; collection of the artist)

Fig. 116 *Untitled* 1976 (gouache on paper; 50 x 38
cm [19⅝ x 15 in.]; collection of the artist)

Fig. 117 *Untitled* (from the cycle *Bodies*) 1981
(cat. no. 82)

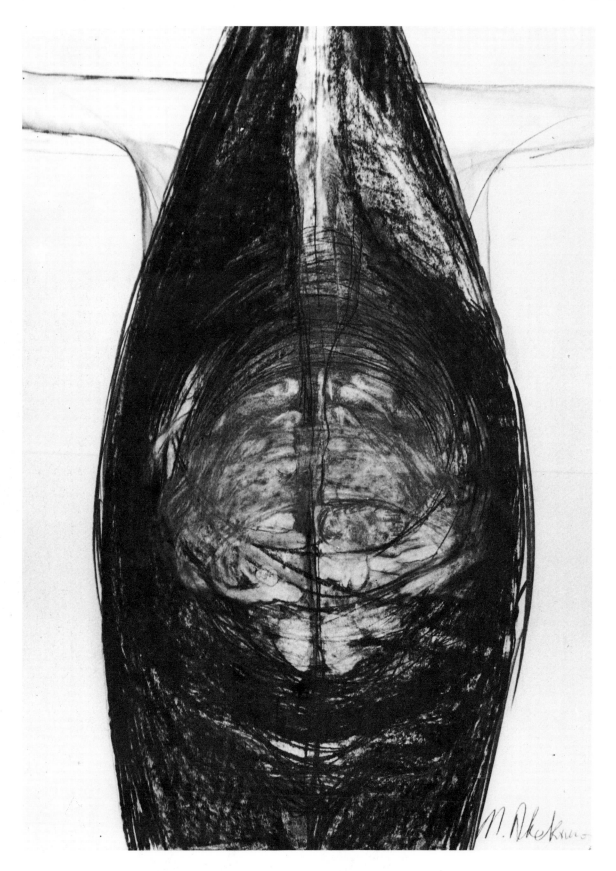

I did not yet know how to write. I drew in the earth with a stick. The marks were deeply etched. Then the rain erased them until they disappeared.

I loved to look at the lines scratched in the clay as they dried in the sun, splitting into cracks with irregular edges. The sand closed behind the finger as it drew—fine, quick—until only a wrinkle remained on the surface.

I no longer remember when I received my first paper. I drew kneeling on the floor. The lines escaped from the sheet, running along the floorboards, losing themselves in the shadows of the furniture. The drawing could be charged with secret power.

The village women inscribed on their doors signs and letters with consecrated chalk or charcoal. This warded off evil. I wished to know the spells but they were inaccessible to me. Only their presence could divide places into those which were safe and those open to all sorts of forces.

Now, when I draw, areas of those unguarded spaces appear on the sheet.

Magdalena Abakanowicz 1981

Fig. 118 Abakanowicz at work on the cycle
Bodies, 1981

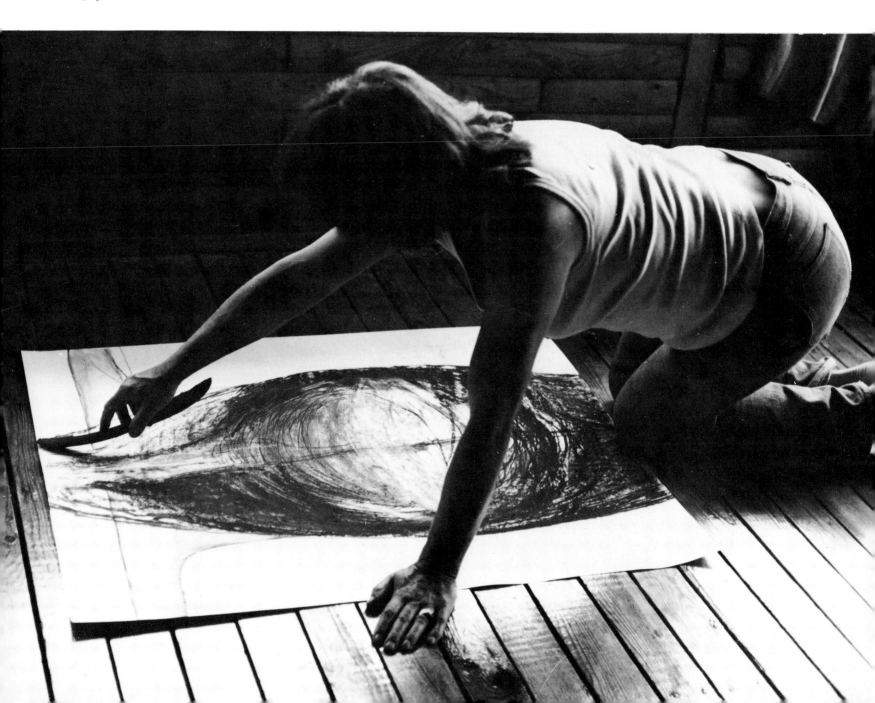

Recently Magda's drawings have taken on a more central role. Her new series are called *Faces* (figs. 122, 123) and *Bodies* (figs. 117-121). The latter is based on the figure which, as always, is severely truncated. There are only vestiges of neck, arms, and legs. The body, whose belly dominates almost everything else, is encased in a clearly delineated rectangular cruciform shape. The bellies are rounded and animated: their charcoal textures are reminiscent of *Abakans*, full of matted hair and embryonic forms seen as if in an X ray. These interiors of pulsating organic life are like teeming ponds. Magda has achieved the intensity of her *Alterations* in two dimensions on paper and because of this two-dimensional quality, these figures are even more disturbing and tragic.

The emotional charge of Magda's works has always been recognized and people have never failed to give them apt descriptions, attributes, titles, and associations when talking about them. They have run through the whole gamut of metaphors and invented words. They have talked of enchanted woods, primeval forests, dimly lit caves, mass graves, and the theater. In response to the new drawings, they will also invoke the church.

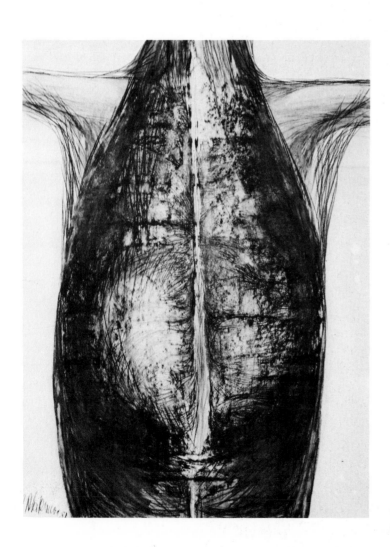

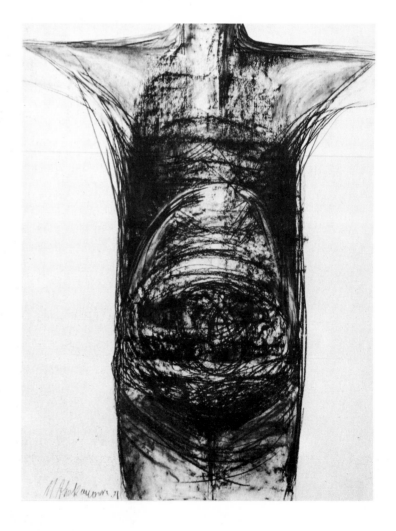

Fig. 119 *Untitled* (from the cycle *Bodies*) 1981

Fig. 120 *Untitled* (from the cycle *Bodies*) 1981

Fig. 121 *Untitled* (from the cycle *Bodies*) 1981

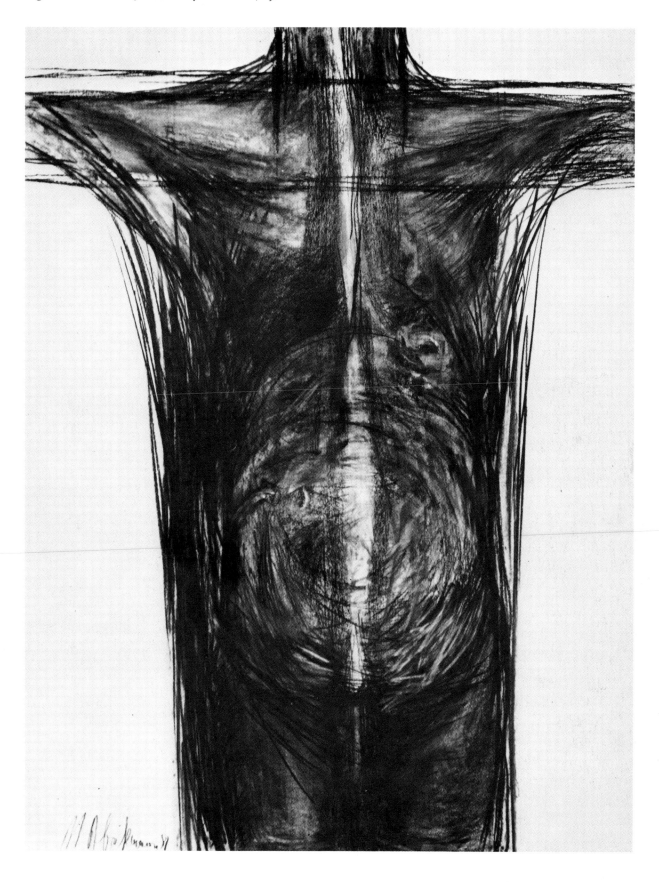

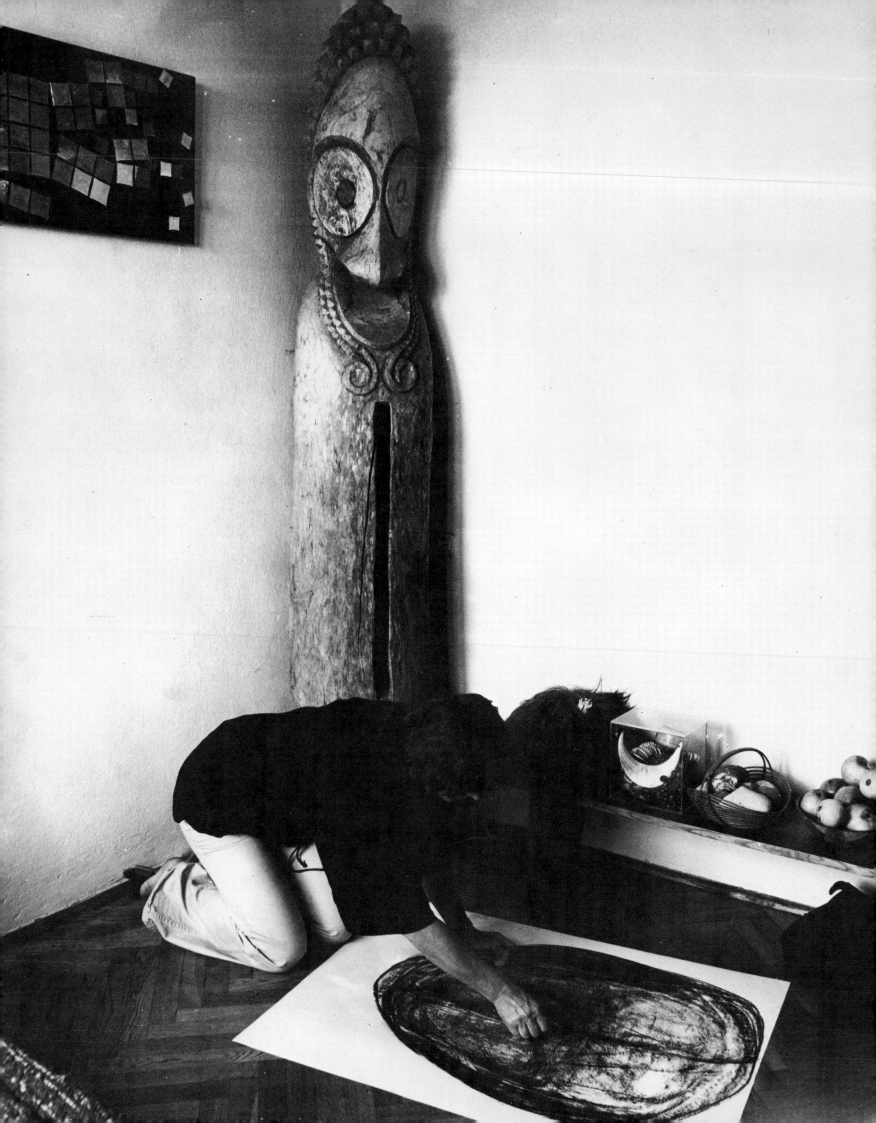

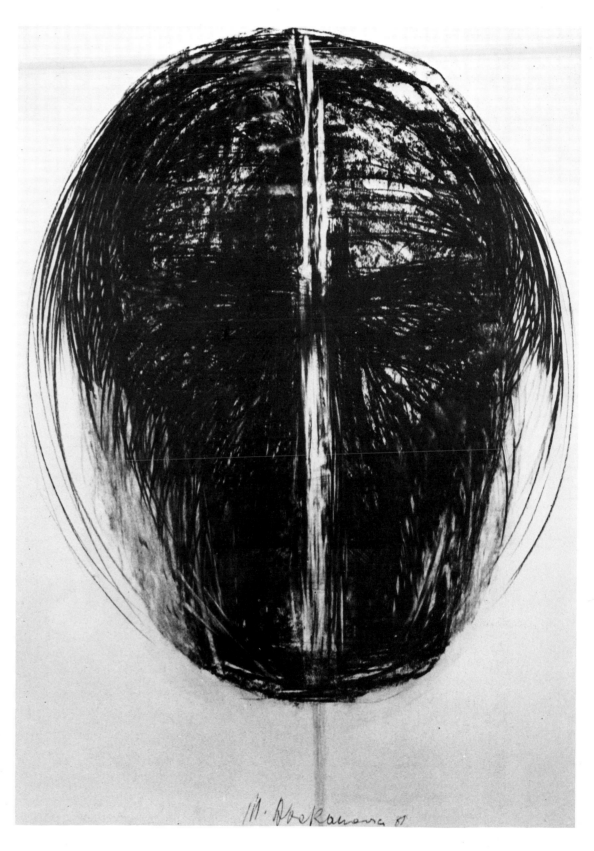

Fig. 122 Abakanowicz at work on the cycle *Faces*
(cat. no. 83) 1981; in the background: Henryk
Stazewski, *Composition* 1964, and a New Hebrides
drum

Fig. 123 *Untitled* (from the cycle *Faces;* collection
of Mr. and Mrs. Sicard, Paris) 1981

THE MAKING
OF AN AMBIENCE

<

Fig. 124 Magdalena Abakanowicz with *Black Garment with Sack* 1971 (cat. no. 46) and *Black Garment Rounded* 1974 (cat. no. 60) at Zachęta, Warsaw, 1975 (cat. no. 65)

Figs. 125–128 Installation of *Abakans* and ropes in the sand dunes along the Polish coast known as Łeba (cat. no. 36), 1969; included are *Brown Coat* 1968 (cat. no. 30); *Abakan 100* 1966/67 (cat. no. 18); *Red Abakan* 1967 (cat. no. 26); *Brown Abakan* 1968 (cat. no. 29); and *Yellow Abakan* 1969 (cat. no. 35)

In "Portrait x 20: Secrets" (p. 21), Magda talks about the things she collected in the country as a child. She used to bring them home when all was quiet, when night was falling, the shadows were long and rooms grew larger, and nobody was about. She emphasizes two points: one, that the things demanded to be taken home; and two, that they were alive and gradually engaged in a dance in which she joined. These were the first of her exhibitions—orchestrated in a specific place under conditions which had to be appropriate.

In real life her environmental exhibitions—or, as she refers to them, "works in space"—date from 1970 when Eje Högestätt invited her to Sweden to exhibit at the Södertälje Konsthall. Instead of asking for a number of works, he gave her a room with which to do something. Magda still thinks of her acceptance of the invitation as an act of courage. It would have been even more awesome if it had not been for a remarkable architect and exhibition designer, Stanisław Zamecznik, with whom Magda used to travel to the University in Poznan where they were both teaching. He had a very positive influence on Magda, and his ideas and example gave her the courage to create exhibitions herself as opposed to sending works to be arranged by others.

The exhibition in Södertälje was the first of a series of Magda's works to be shown in different centers in Europe. Thereafter, it became her aim to create environments into which the viewer is introduced. She feels that the best analogy for her exhibitions is music. She talks about the arrangements of works as spaces for contemplation into which the viewer can enter a different world, away from that of the noisy streets and brash technology. As she says, although man created for himself an artificial world, he belongs to an organic one. The viewer is confronted with the possibilities of finding himself inside the object, facing it, under it, or, at any rate, within a space surrounded by Magda's massive works.

Magda has said that she wants the contact between the spectator and her work to become as intimate as that between man and his clothes.[26] By this she means that she is seeking the feeling of recognition and familiarity which develops through a prolonged acquaintance. She is also talking about the importance of the sense of touch in her exhibitions: the sensibility of her own touch with which she creates her works and which they in turn communicate to the visitor.

Magda stages all her exhibitions using a repertory of objects that she owns and that travel with her. The works are like personages who arrive at a given destination, arrange themselves, and acquire a particular sense of place. They are also like actors who create different effects on different stages.

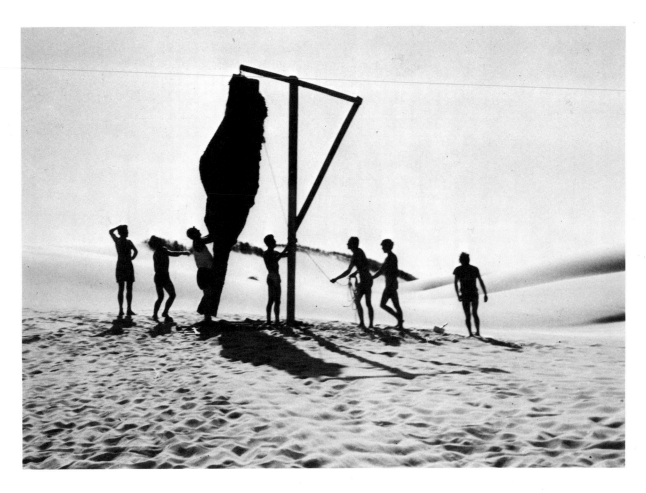

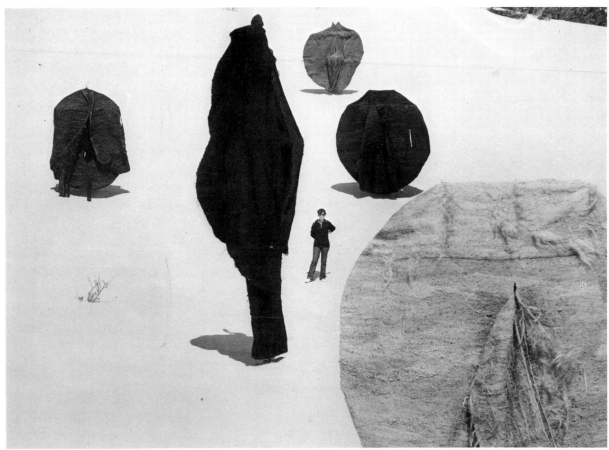

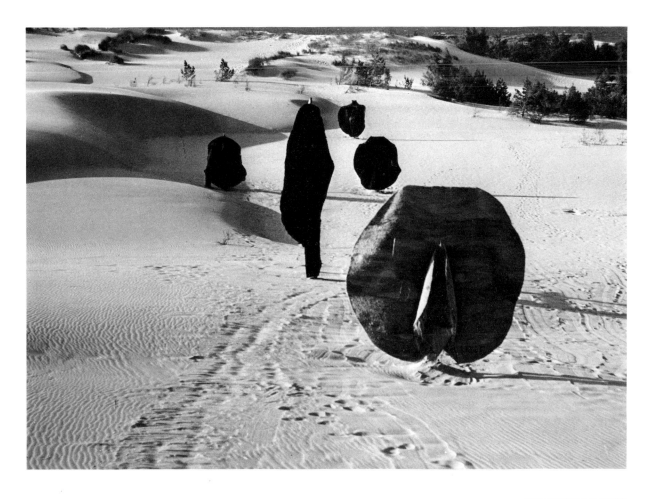

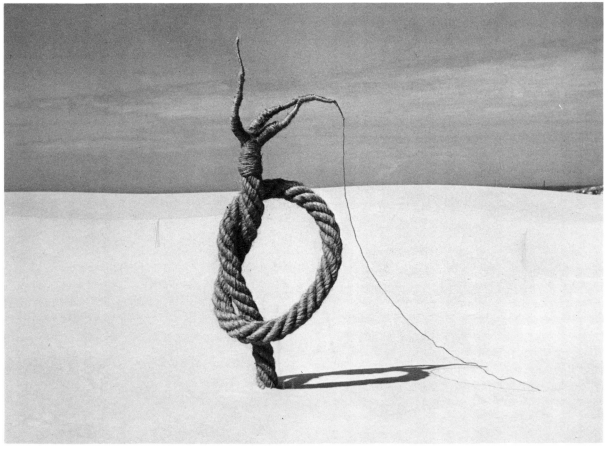

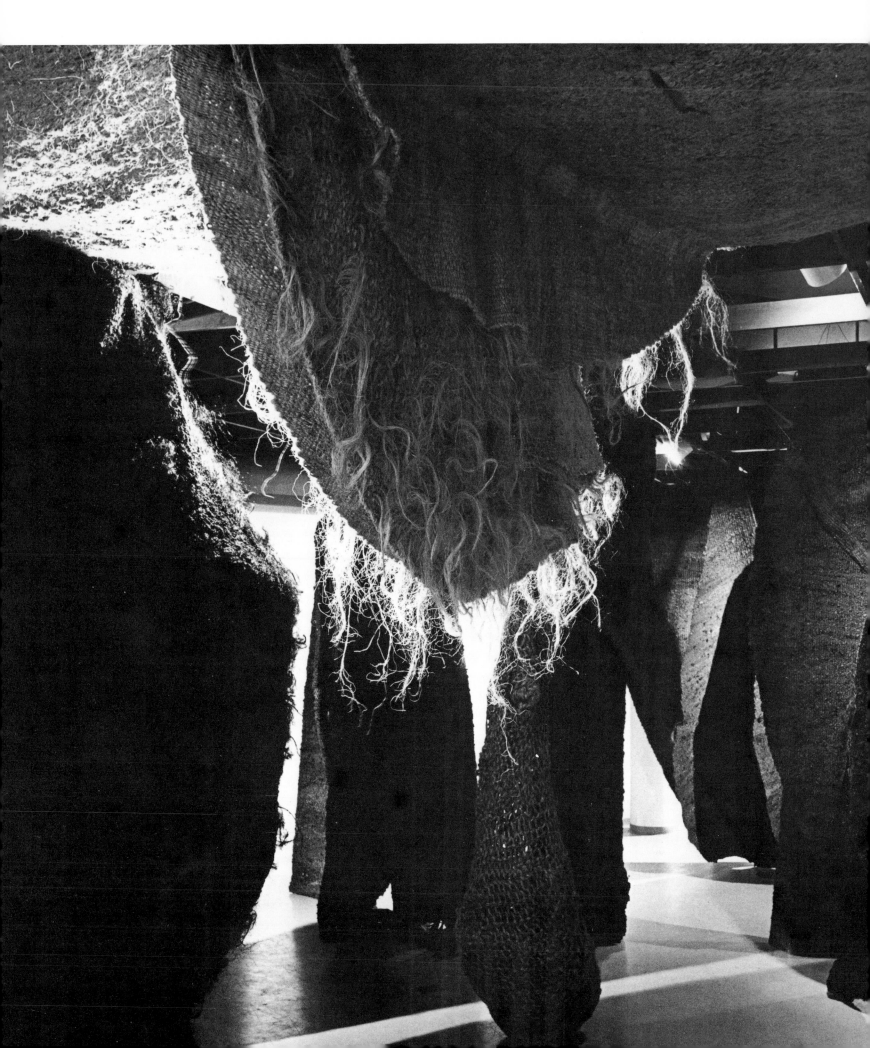

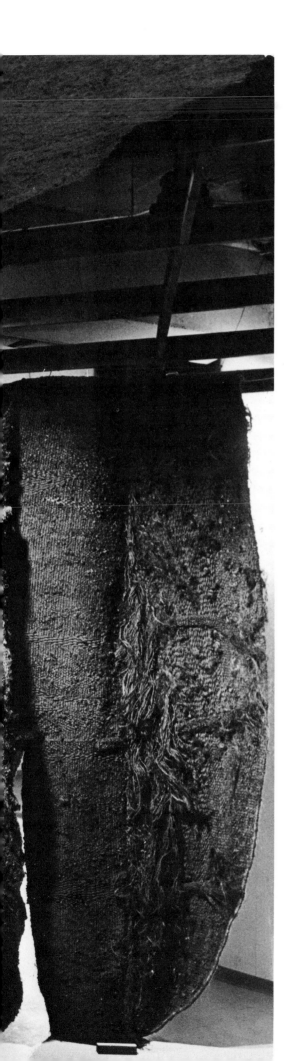

Creating, I am using woven materials and strings. These components allow me to construct different forms.

I like the surface of threads that I make, every square inch differs from the others, as in the creations of nature.

I want the viewer to penetrate the inside of my forms.

For I want him to have the most intimate contact with them, the same contact one can have with clothes, animal skins, or grass.

I am interested in constructing from my forms an environment for man.

I am interested in the scale of tensions that arises among the various shapes which I place in space.

I am interested in the feeling of man confronted by the woven object.

I am interested in the motion and waving of the woven surfaces.

I am interested in every tangle of thread and rope and every possibility of transformation.

I am interested in the path of a single thread.

I am not interested in the practical usefulness of my work.

Magdalena Abakanowicz 1971

Fig. 129 Installation of *Abakans* at the Södertälje Konsthall, Sweden, 1970 (cat. no. 39)

Fig. 131 Installation of ropes at the Södertälje
Konsthall

Fig. 130 Installation at the Södertälje Konsthall;
included is *Baroque Dress* 1969 (cat. no. 31)
mounted on the ceiling

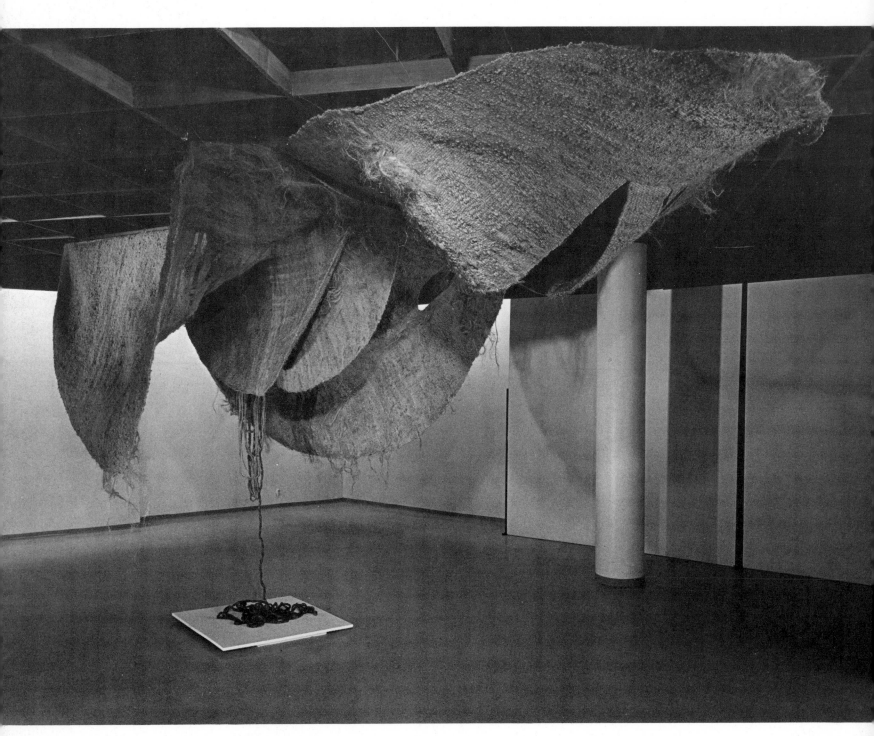

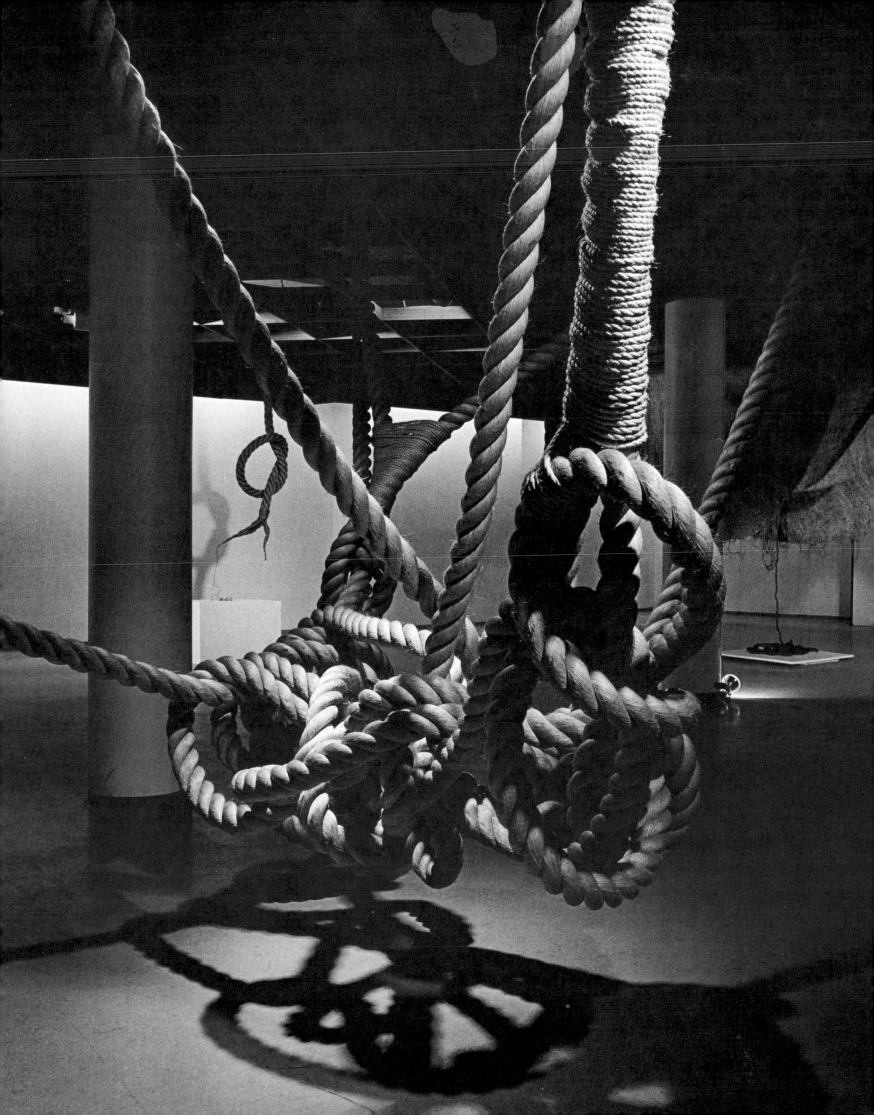

Fig. 133 Installation at Zachęta, Warsaw, 1975
(cat. no. 65); included are *Abakan* (destroyed);
Abakan Round 1967 (cat. no. 21); and *Abakan
Open* 1967 (cat. no. 20)

Fig. 132 *Abakans* at the Galeria Współczesna,
Warsaw, 1971

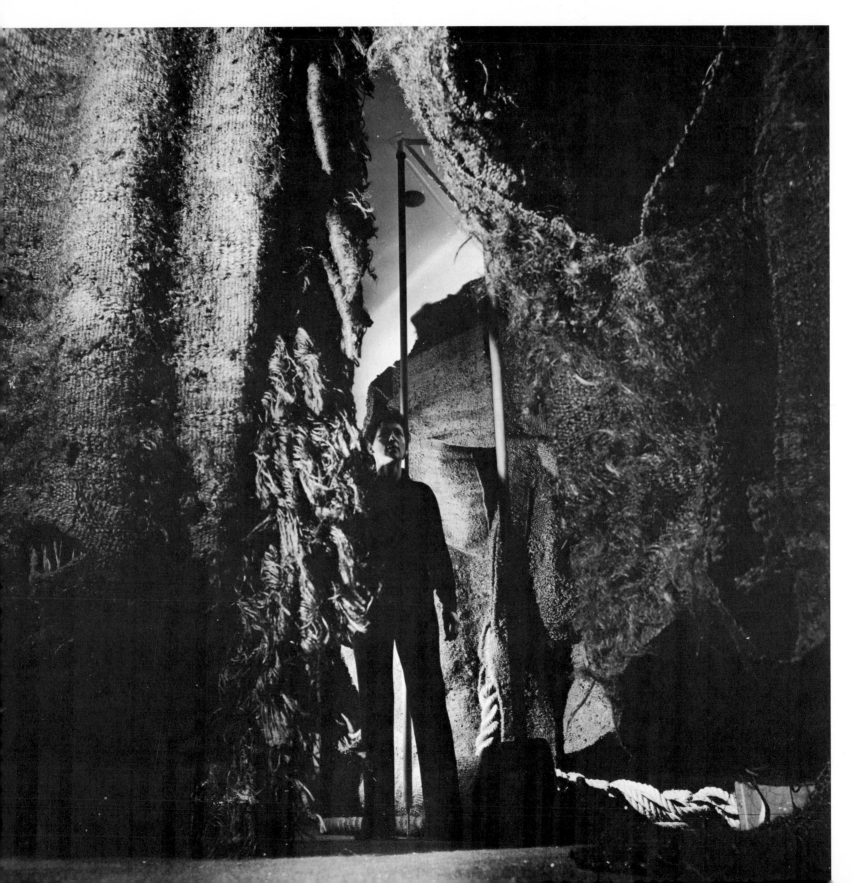

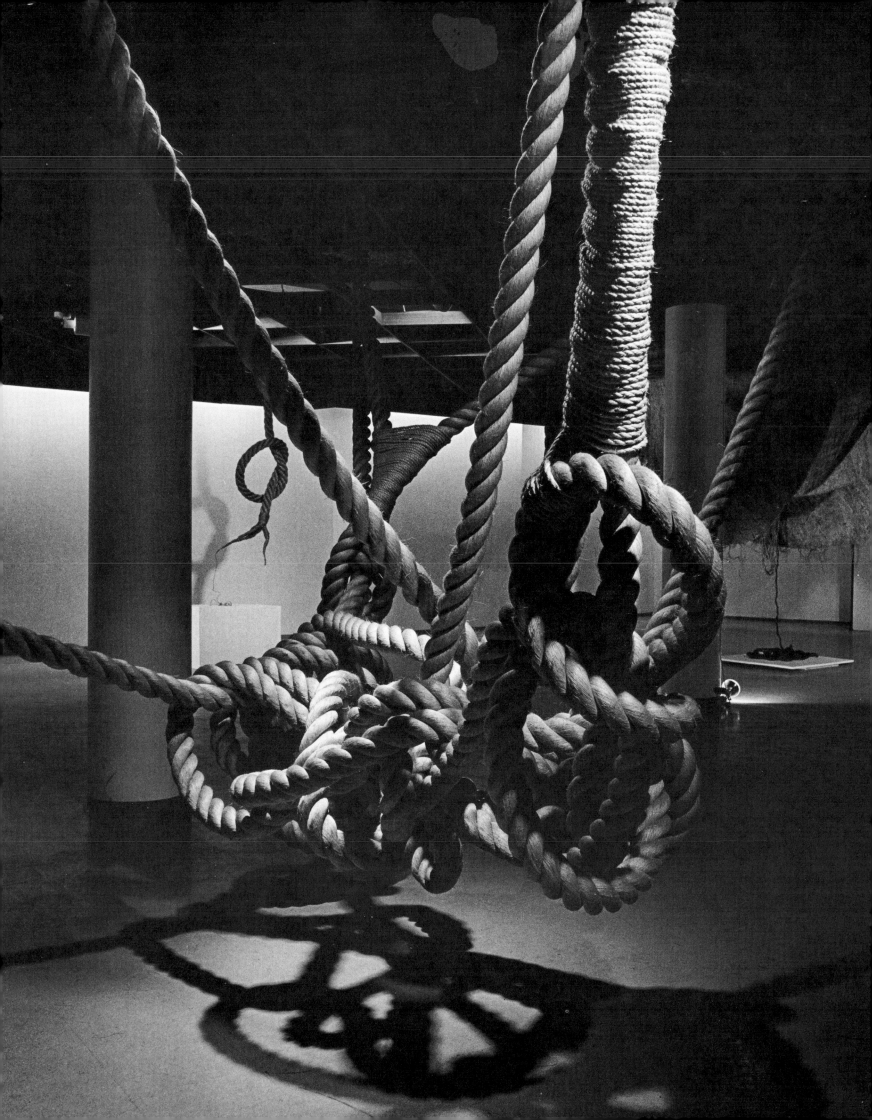

Fig. 132 *Abakans* at the Galeria Współczesna, Warsaw, 1971

Fig. 133 Installation at Zachęta, Warsaw, 1975 (cat. no. 65); included are *Abakan* (destroyed); *Abakan Round* 1967 (cat. no. 21); and *Abakan Open* 1967 (cat. no. 20)

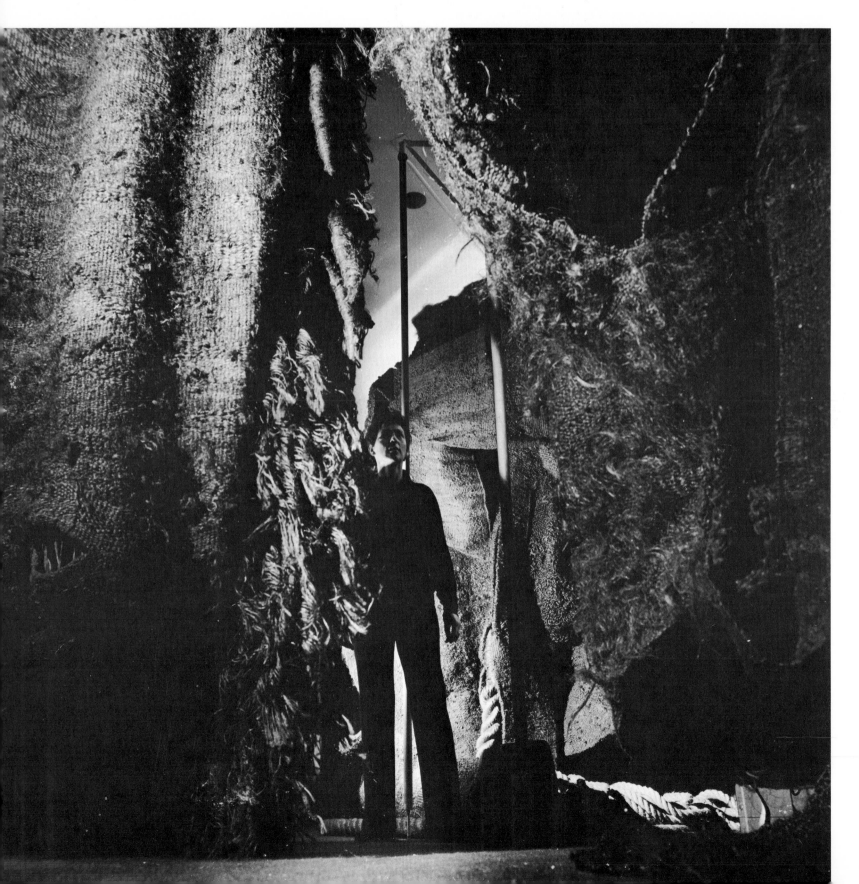

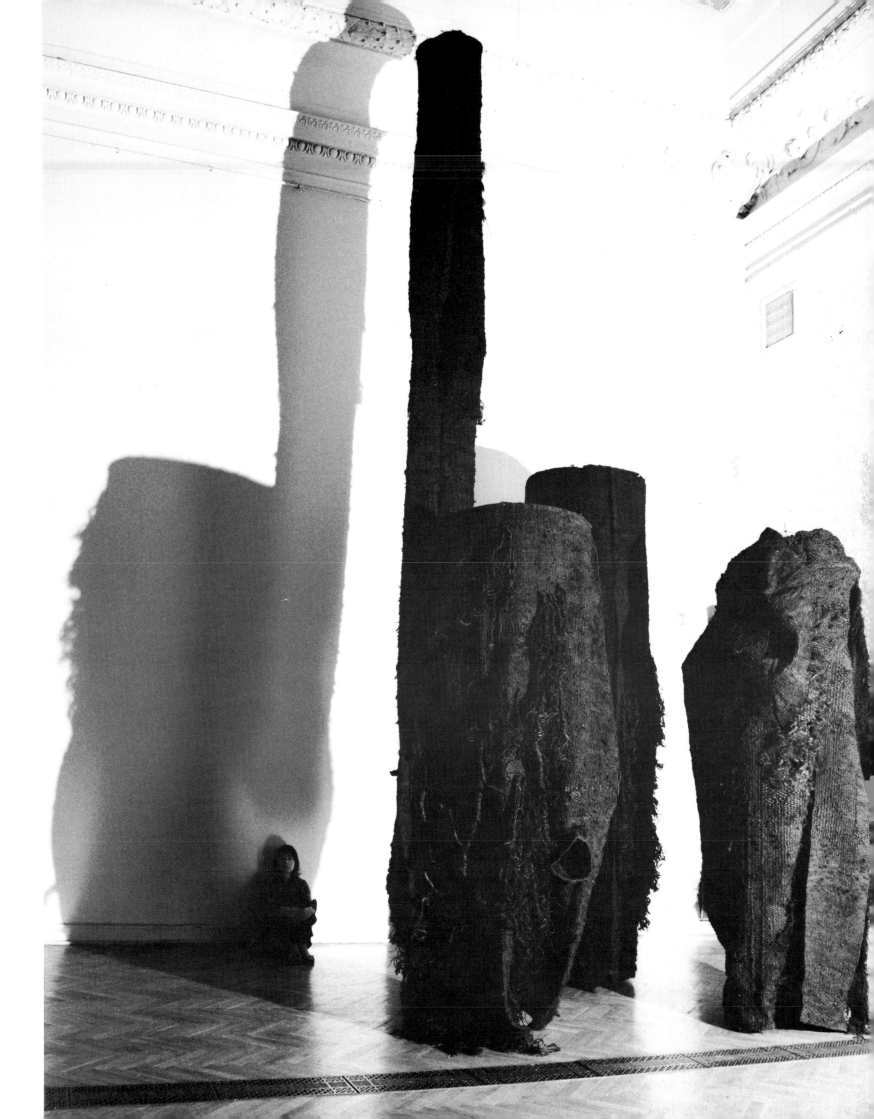

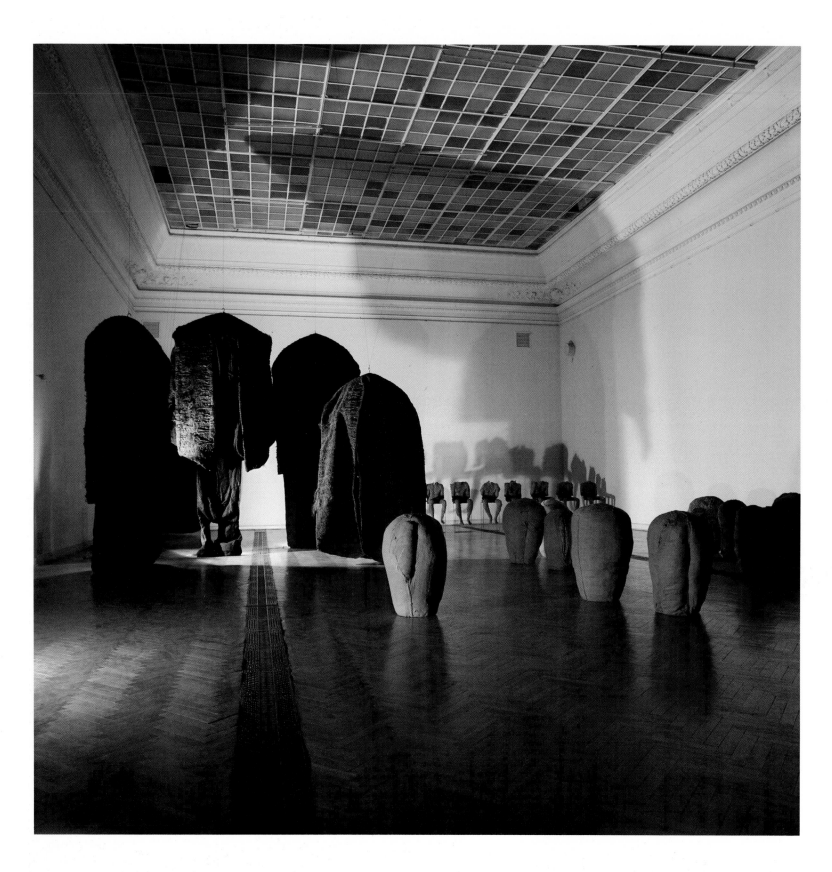

Fig. 134 Installation at Zachęta; included are *Black Garment Rounded* 1974 (cat. no. 60); *Black Garment with Sack* 1971 (cat. no. 46); *Black Garment* (Rectangle) 1974 (cat. no. 58); *Brown Coat* 1968 (cat. no. 30); *Seated Figures* 1974–75 (cat. no. 64); and *Heads* 1973–75 (cat. no. 57)

Fig. 135 Installation at Zachęta; included are *Black Environment* 1970–75 (cat. no. 43) and *Orange Abakan* 1971 (cat. no. 47)

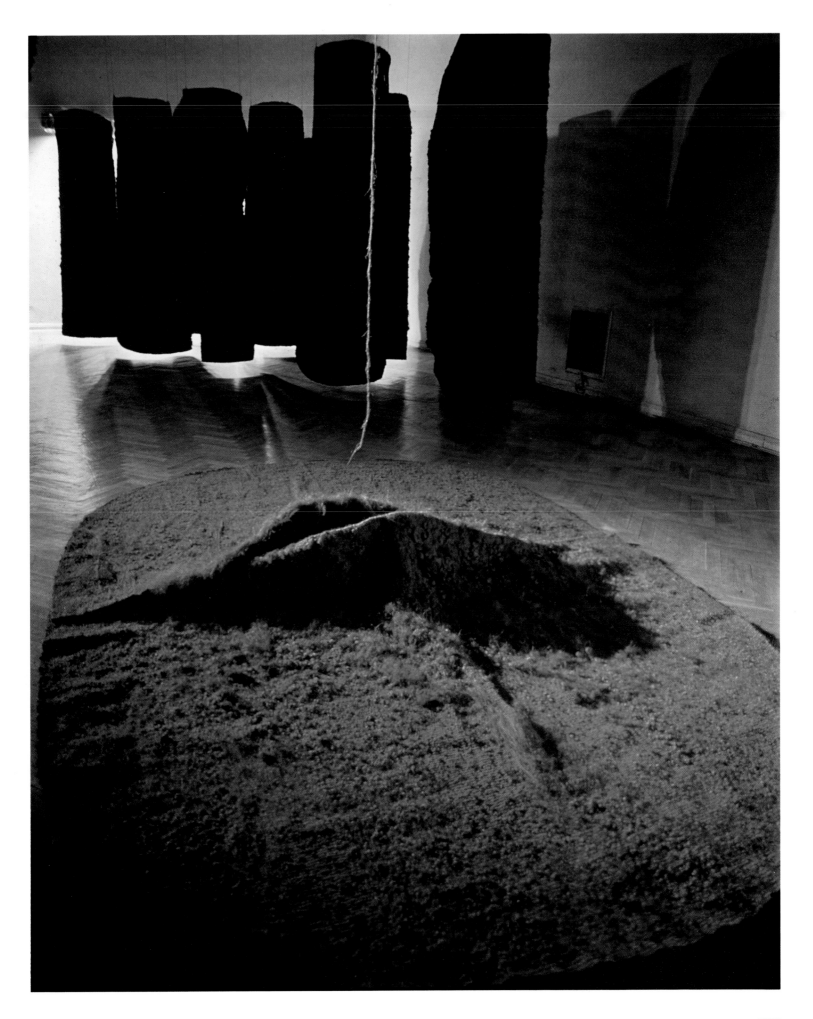

Fig. 136 Installation at the Malmö Konsthall, Sweden, 1977 (cat. no. 72); included are *Black Environment* 1970–77 (cat. no. 43); *Heads* 1973–75 (cat. no. 57); *Wheel and Rope* 1973 (cat. no. 56); and *Backs* 1976–77 (cat. no. 71)

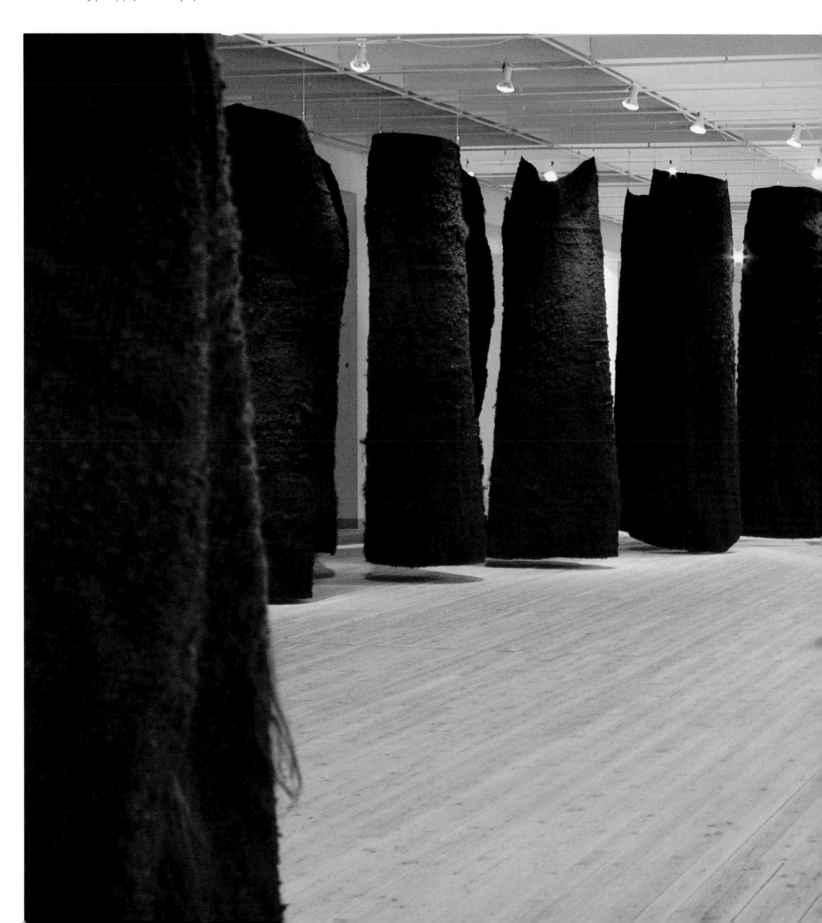

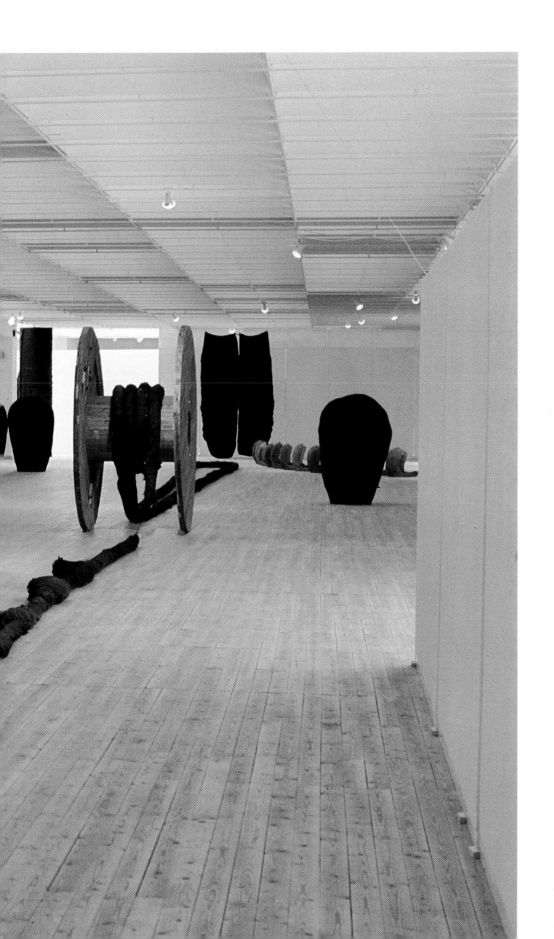

My exhibitions always give me new occasions for additional creative search. I always design and arrange them myself.

I sense the space of exhibition halls as a void with a given shape. I build different objects into it so as to achieve the highest scale of tensions between themselves and between them and emptiness and light.

Such arranged space can become a self-governing object of art—close to music—which one can sense when moving inside and registering feelings in given time intervals.

I am sure that as in the case of a sensitivity for music, there exists a common predisposition to sense the space.

Magdalena Abakanowicz 1975

Fig. 137 *Abakans* at the Malmö Konsthall

Fig. 138 Installation at the Sonja Henies og Niels Onstadts Stiftelser, Kunstsenter, Høvikodden, Norway, 1977 (cat. no. 73); included are *Black Garment* (Rectangle) 1974 (cat. no. 58); *Black Garment with Sack* 1971 (cat. no. 46); *Orange Abakan* 1971 (cat. no. 47); *Red Abakan* 1969 (cat. no. 34); *Wheel and Rope* 1973 (cat. no. 56); *Heads* 1973–75 (cat. no. 57) and *Back* 1976/77 (cat. no. 71)

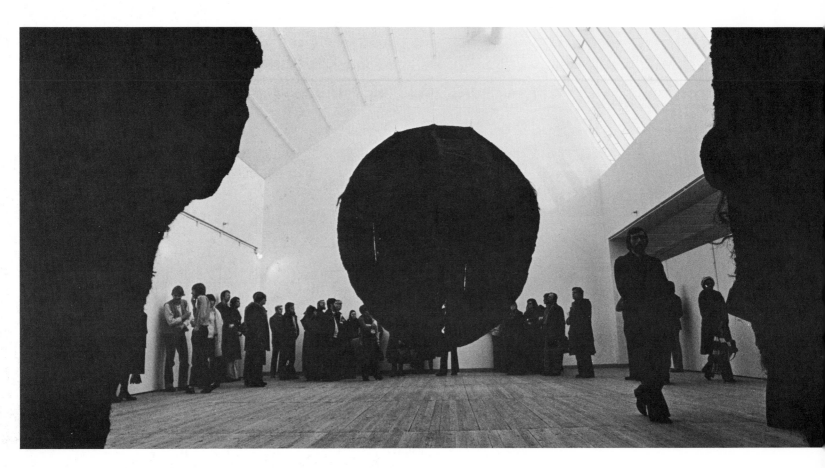

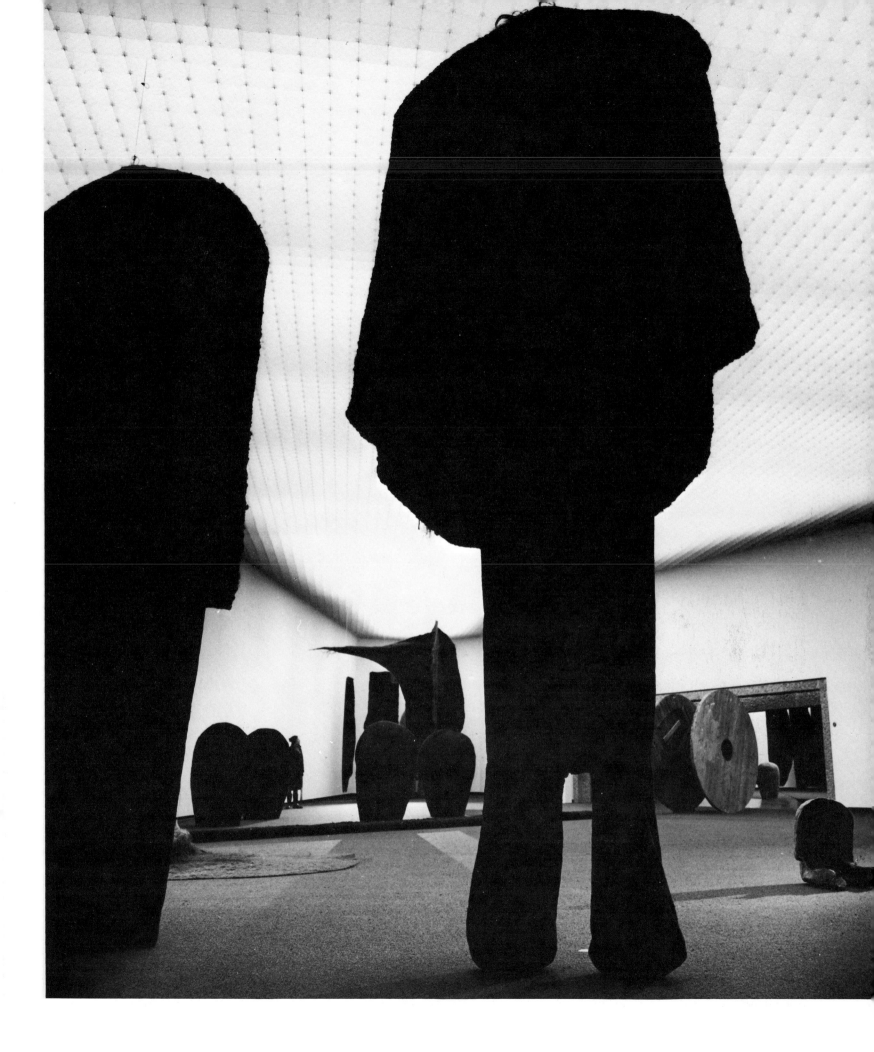

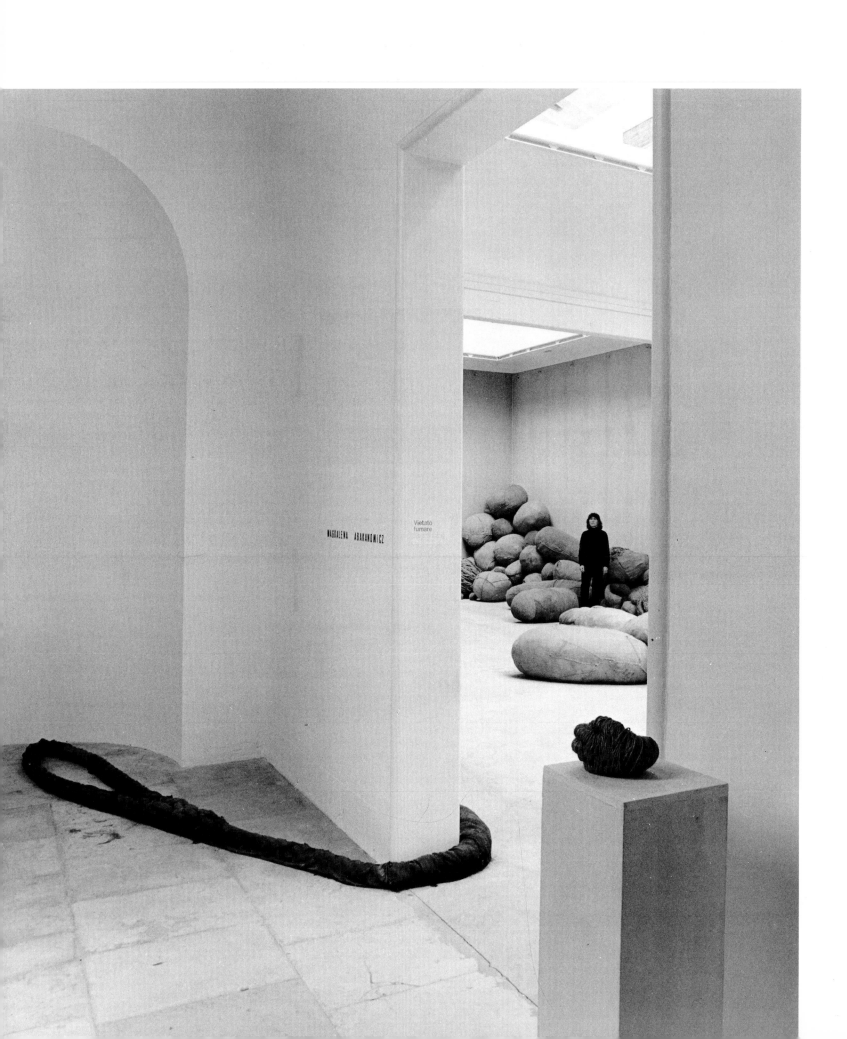

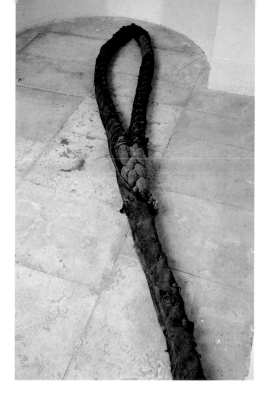

< >

Figs. 139–143 Installation at the Polish Pavilion,
Venice Biennale, 1980 (cat. no. 78); included are
The Hand 1976 (cat. no. 67a); *Wheel and Rope*
1973 (cat. no. 56); *Embryology* 1978–80 (cat. no.
76); and 40 *Backs* 1976–80 (cat. no. 71)

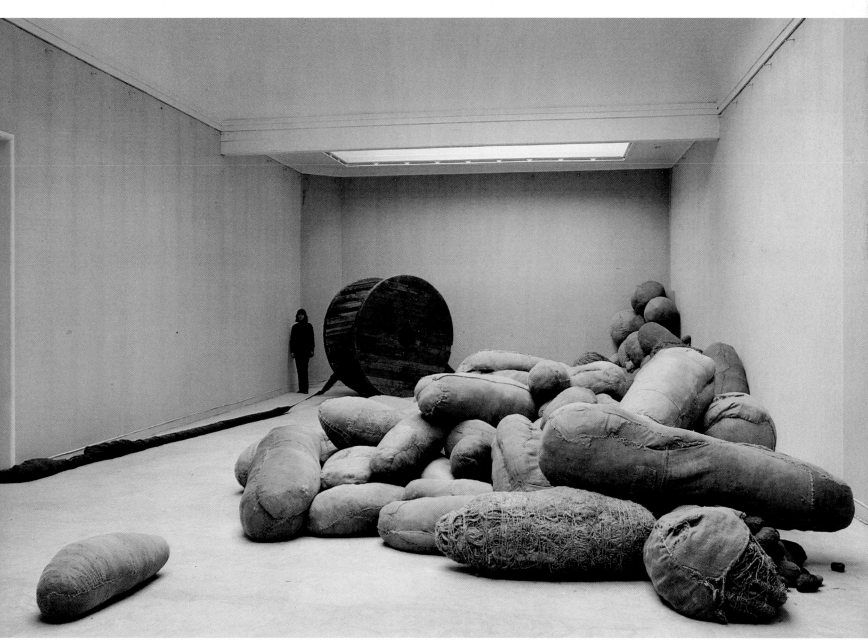

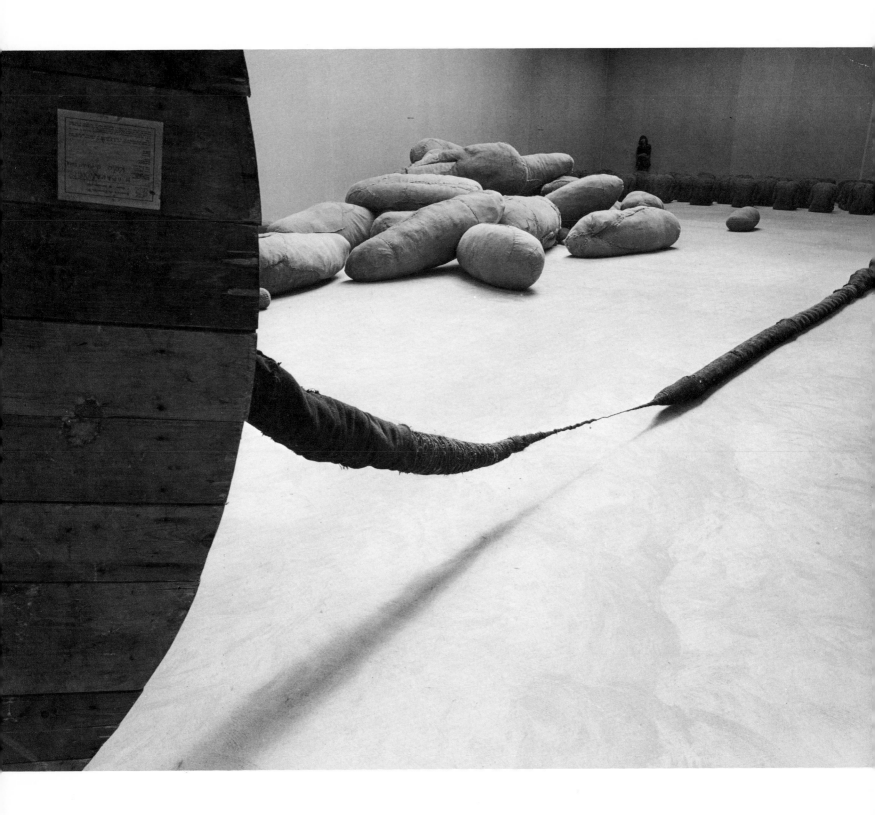

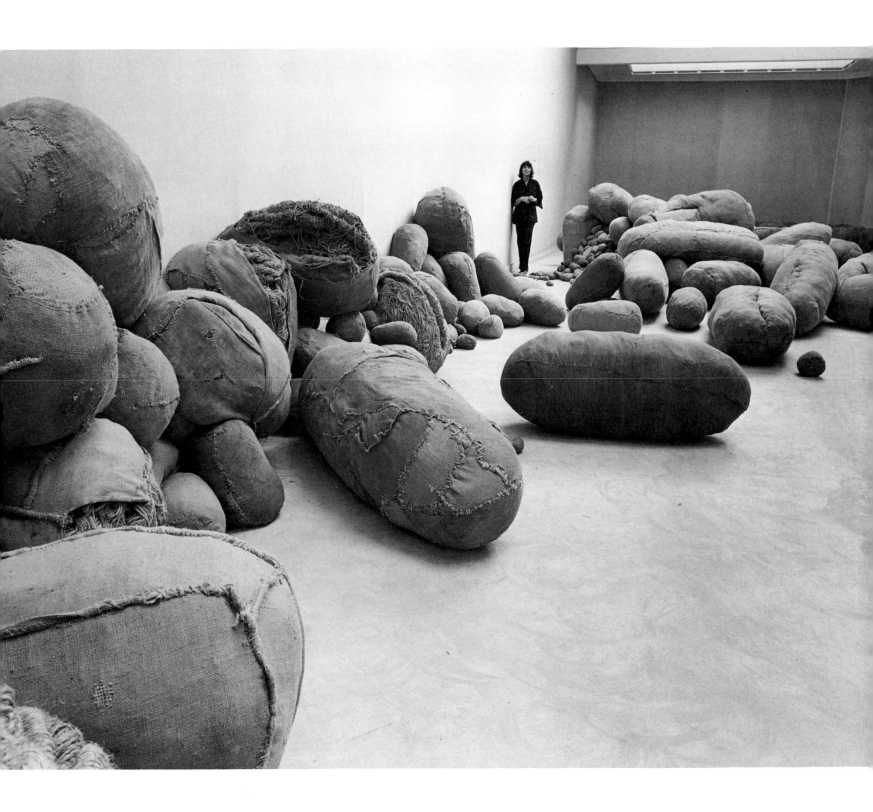

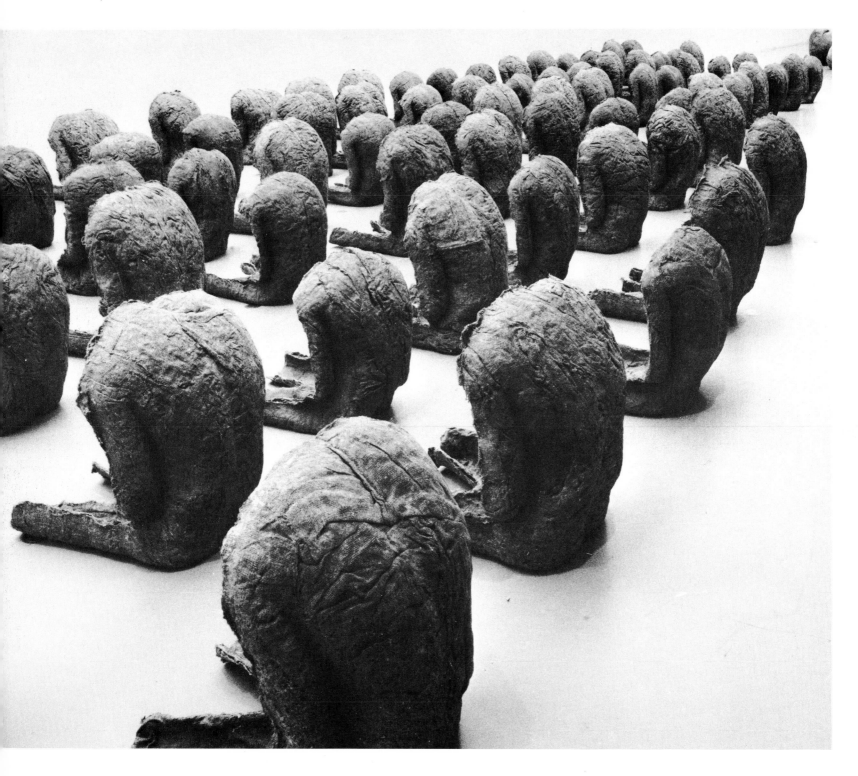

∨ >

Figs. 144–147 Installation at the Musée d'Art Moderne de la Ville de Paris, 1982 (cat. no. 85); included are 80 *Backs* 1976–81 (cat. no. 71); *Embryology* 1978–81 (cat. no. 76); and *Trunks* 1981 (cat. no. 80)

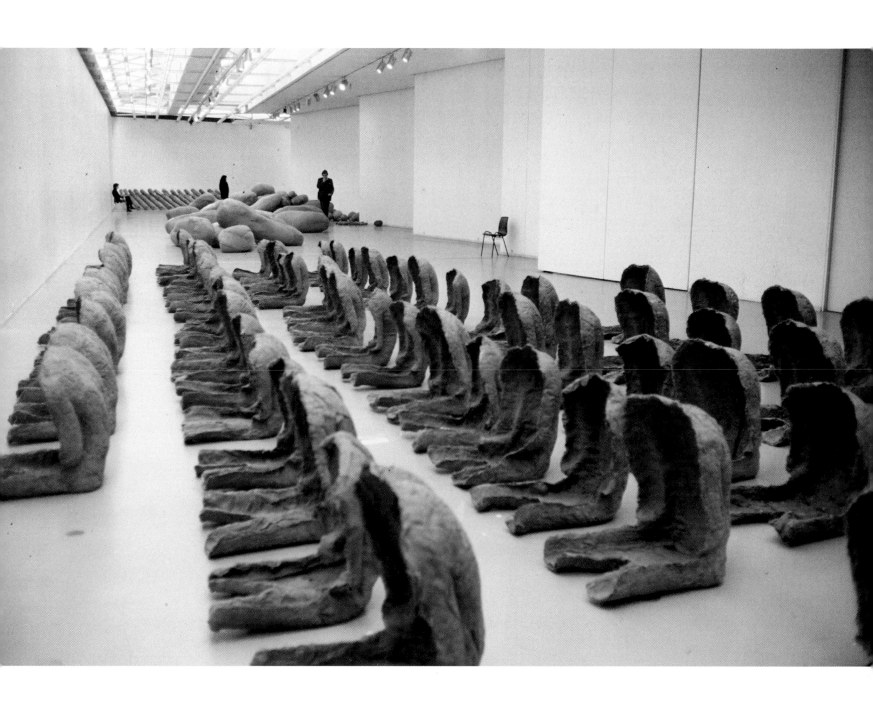

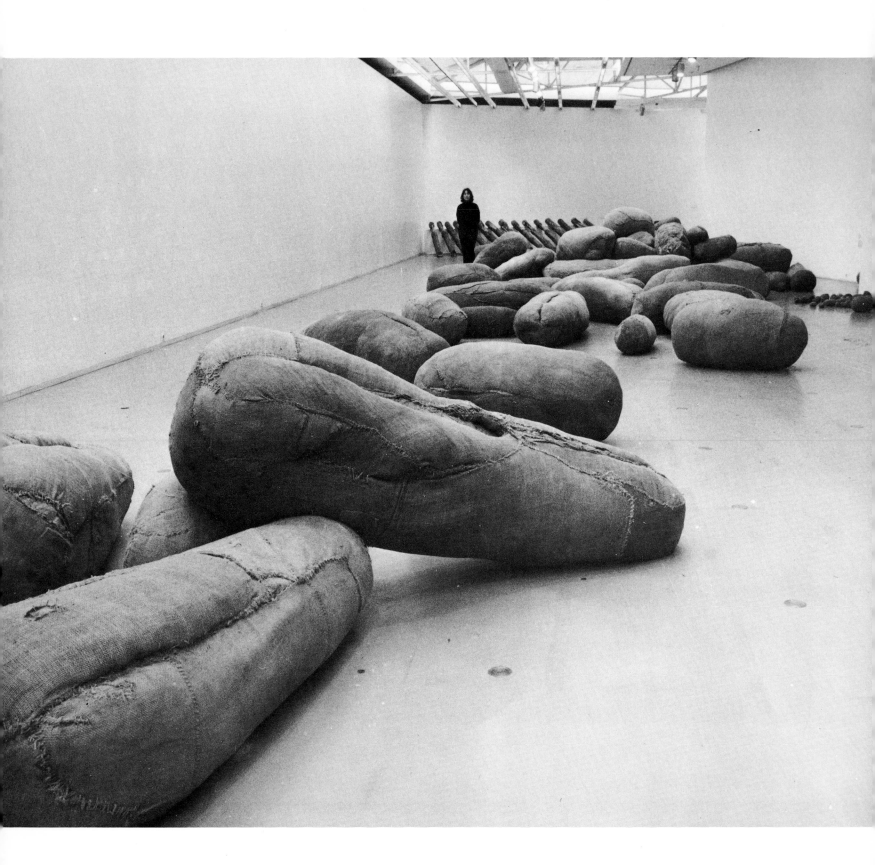

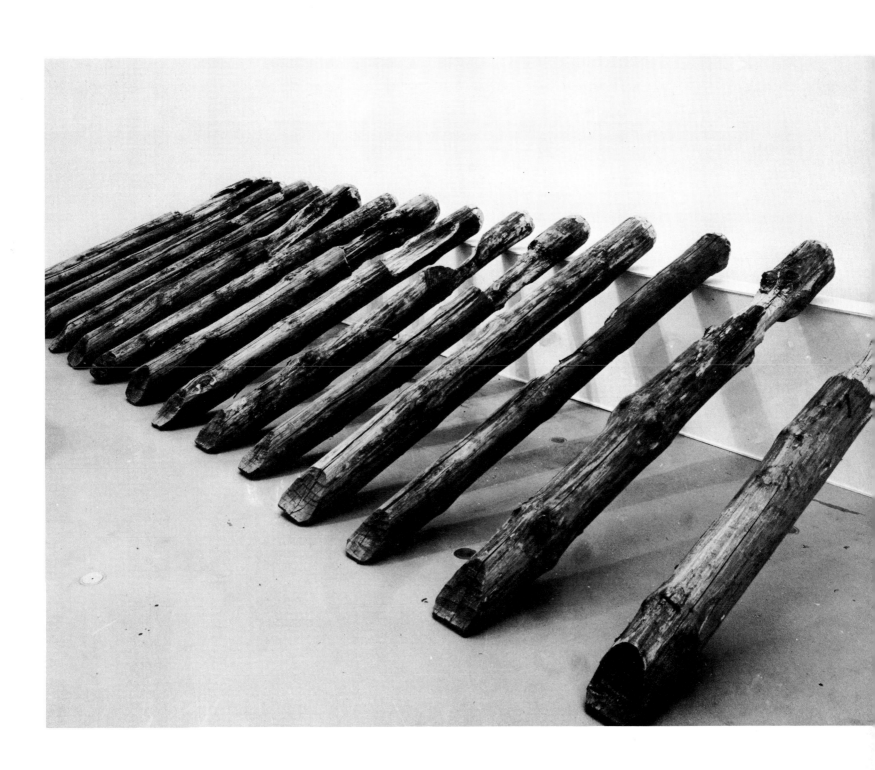

Creation is to observe nature and make something it has not made.
—LEONARDO DA VINCI

Nature comes first. It demonstrates the repertory of its forms, combinations, and tricks. To a few, it reveals its limitations—the copying of forms, extrapolating from one thing to another, repeating itself, and making errors. To most, it shows its abundant imagination in making new inventions and creating countless combinations of simple forms. It also plays some tricks, frequently in bad taste, and covers them up so that we may still believe it knows best and is incapable of lack of judgment.

For Magda, nature is neither calculating nor miraculous. It is somewhat like a large store of secrets to be marveled at and pondered. Each of nature's creations is something to be considered carefully for a long time, even years, before it is sufficiently familiar to be used. Nature, too, is Magda's preferred environment. What others think of nature, how it affects them and what they make of it, is of no concern whatever to Magda, but she does care about facts. She seeks out facts of biology, astronomy, physics, of the real world in all its manifestations, but she cares not at all for philosophies elaborated on the basis of those facts. Awareness of other people's thoughts can be a trap. Other people's interpretations of the world can lead her, she has said, "into false thinking" which is not hers.[27]

Facts are always interesting—although they may not affect Magda's intuitive understanding one way or another. Magda has written that her cycle *Alterations,* for instance, came about after talks with several scientists who were studying the physical changes in biological structures produced by abnormal stress—especially those in human beings. But more recently she has written that it was not so. Perhaps it was not exactly so. Her talks with the neurologist Professor Maria Dąbska in the early 1970s were fascinating, although she found them too technical. Later, in 1975 in London, she met and talked with another neurologist, Professor Patrick Wall of University College. She soon realized that this quest did not confirm or add anything to what she knew intuitively.

Magda's creations have often been talked about in terms of nature. *Abakans* were described as "huge, weighty, heavy-textured mats of sisal, hung in curves, like dark caves or hollow trees. Nature in the raw, tree barks, large rough animals . . . heavy encrustations and matted tangles of coarse shaggy hair . . . rusty black with scaly orifices and craters."[28] *Embryology* was described as a collection of "quasi-biological objects . . . newly dug from the earth."[29]

Magda has never tried to reproduce nature and, indeed, since nature changes constantly, this would be altogether impossible. These changes are slow and cyclical, rhythmic and indomitable, and these attributes Magda relates to her way of working. But her work itself is something else.

When we were together in the Polish countryside in the vicinity of her cottage, Magda looked at the unfinished construction of a water supply system for Warsaw and enthused about the pipes arrayed along the roadside and peeping out of the earth, and the iron rods sticking out of an uncompleted concrete section. This vast complex of machinery, sand, workers' colored huts, piles of wood, metal, and wire, is one of the many mysterious worlds in which one can find extraordinary things. A curious realm. Magda's interest in this miscellaneous array had a lot to do with the fact that one day these disconnected piles of rods, these irrational conglomerates of metal drums and concrete circles, will become something else. They, too, will undergo the inevitable process of change.

Fig. 148 Magdalena Abakanowicz outside Warsaw, 1981

My three-dimensional woven forms are about my opposition to the systematization of life and art. They grow with a leisurely rhythm like creations of nature and, like them, they are organic. Like other natural forms, they are also something to contemplate.

Magdalena Abakanowicz 1975

Magda saw César's expanded polyurethane sculptures at the Centre Georges Pompidou in Paris. She was fascinated with these things which were produced by mixing materials that hardened in 25 seconds and were so synthetic, so simple. But whatever temporary enthusiasm she might experience, nothing comes of it. In the end Magda cannot escape from herself and embrace alien influences, no matter how attractive they may be.

Magda finds my questions about external influences difficult. Yes, of course, the world does impinge on her, but to find the focus of that effect is difficult. Going to Kassel to see Documenta in 1964 was a good example. Seeing for the first time art of such monumentality and strength made an enormous impression on Magda. It confirmed her desire to work on a large scale and inspired her with greater confidence. The series of works which she then completed, a monumental cycle of *Abakans*, dominated the 1965 São Paulo Bienal.

On the whole, the outside world is an intrusion. The intrusion of which Magda is most aware, on a daily and even hourly basis, is the traffic noise of the highway audible from her studio on the tenth floor. Irregular and threatening, it is concealed only by the loud sound of a radio which is on constantly.

Magda is against many things; this gives her energy. The motor of her activity is always an activity against something. She has commented:

> To protest is to give importance to those things, situations, thoughts, against which one takes up a position. Protest is also the only possible active stance in the face of a threat, invasion; it is a defensive position. My life unfolded in such a way that in order to exist I had to accept this position. It was the constant act of confrontation, self-defense, which, although it could not be realized in the practical aspects of life, expressed itself in work.

> Discrimination at the beginning because of my parents' background, never being able to get a studio—these were allocated by the Artists' Union—conflict with my environment, envy of colleagues, my shyness—why list everything! The specific character of a country in which, after the war, peace never reigned.

Magda's disengagement from the art world is important to her freedom as an artist. And indeed, for an independent artist who works by herself and has an international reputation, living in Poland has some advantages. She arrives in the West without being expected to participate in the social gestures of the art world. Not to have to know who people are, not to have pressures which come from an understanding of hierarchies and being called upon to sit on committees, is important to an artist's freedom. Although, until such time as one is acknowledged and accepted, even voluntary isolation can be difficult. In Poland, where Magda feels she should make a contribution to the cultural life of the country, she participates in many group exhibitions, festivals, television discussions on art, but avoids panels and committees because they are so time-consuming, and she needs all the time she can get for her work, which is so very slow.

Magda does not need other artists. She admires several, speaks well of many, but feels close to none. She has expressed admiration and liking for Kantor, Grotowski, Szajna—three expressionist artists who work in the theater—and above all Henryk Stażewski (fig. 149), one of Poland's great Constructivists and a special old friend who has inspired her work for many years through his attitude toward life, inner discipline, and wisdom.

Fig. 149 Magdalena Abakanowicz with the philosopher Adam Mauersberger (left) and the Constructivist painter Henryk Stażewski, Warsaw, 1981

Magda spends little time at films or the theater, but she has talked with enthusiasm about Buñuel, Bergman, and some works of Wajda. For Magda, reading books is ultimately a distraction because every activity competes with her work. From time to time she reads the poetry of Bernard Noël because he sends her his books; otherwise she admits to not liking poetry. She read Czesław Miłosz in order to know what his poetry is like. She remembers Anatole France and Oscar Wilde. The poets who stand out in her memory are the two Russian lyric poets Aleksander Blok and Mayakovski; the Poles Krzysztof Baczyński (1921-1944), a lyric poet and soldier, and Konstanty Ildefons Gałczyński (1905-1953), a Warsaw satirist who worked in verse and prose, famous for his grotesque vision of the world. She has read Proust, Joyce, Borges. She acquired books by Mircea Eliade on the sacred and profane; Gunnar Myrdal on world poverty; Jonathan Miller and Marshall McLuhan. She has read the journals of Witold Gombrowicz. She also reads about science, nature, history, and geography, and gleans what she can of the imaginative aspect of higher mathematics.

So far as art is concerned, her own work is banished from her living room. Magda explains:

> My works are absent from the room in which I sleep, work, answer the telephone, and receive guests, because it is small and my works are large. Sometimes I think that if I had a hall, I would hang Abakan Round from 1967—the first three-dimensional work—which I like very much. In my small flat there is an awful congestion of objects. Every object becomes an enemy because my husband and I keep on colliding with it. To have a bit of space to breathe in the room where I sleep, I crowded all the wardrobes into the room which is also something of an office, because in it I keep all my catalogues, papers, books, documentation. One cupboard, for lack of space, stands on the desk. Half of the window is covered with shelves. There, between various objects such as dried plants from Australia and California, stones from Lanzarote, a dried frog and a clay statue from Mexico, a dried scorpion from Arizona, stones from fields in Poland, are a few pieces of Embryology.
>
> I am squeezed by it all as I try to get to the typewriter. It is a pity to throw it all out, but difficult to live with it. For a long time I resisted the temptation to collect objects during my travels, just to keep a little space in the confinement of this already crowded apartment. The first objects I brought back from Australia in 1976, today I know I should not have brought.[30]

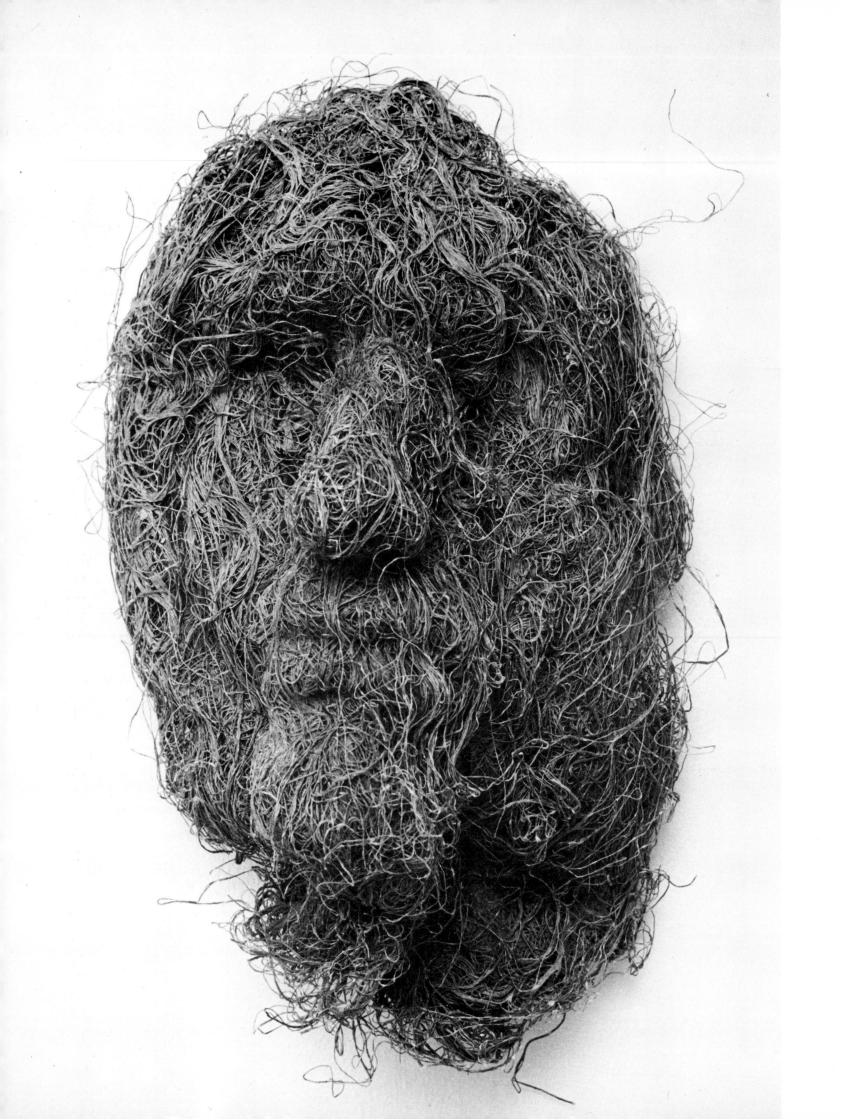

CODA – A THEATER OF IMAGINARY ANATOMY

The human body in its many manifestations is the essential core of Magda's works. She has treated this subject principally in two ways: either exposing its inside or representing its exterior.

When in 1975 she called her exhibition in London, "Organic Structures and Human Forms," she divided her works into those which evoke the intimate structure of organs (*Abakans*); and those which have associations with the archaeological remains of human bodies, dried and petrified husks (*Alterations*).

In their conception, feeling, and presentation, the *Organic Structures* are close to the anatomical drawings of the Renaissance: like those of Vesalius, for instance, who pinned back folds of loose skin to reveal the muscles, lungs, intestines, blood vessels. He, too, made up his compositions of petal-shaped hangings and textures, and presented dramatic points of communication between arteries and veins, muscles and tendons. For all their elegance, drama, and revelation, his anatomical studies do not touch on the brutal and gross existence of the human body. The most exact or the most imaginative of anatomic extravaganzas do not equal in their power Magda's metaphors for torn flesh, the viscera, and twisted ligaments. Her metaphors express the tragic inheritance of human beings, made as they are of meat. Magda feels that her imaginings and thoughts will turn to earth, as will the forms she creates. Since there is so little room, this is not a bad thing. She does not resist death.

Magda's human forms appear tragically affected not just by time, but also by the stripping away of their outer cover, the skin. It is the revelation of inner turmoil that characterizes the husks of the *Seated Figures,* the shells of the *Backs,* and even the two most delicate of her works, *Small Object* or *The Hand,* and *The Face,* sometimes called *The Center* (figs. 150-152).

Magda has talked and written about her work for many years. She has talked about her methods and the slow tempo at which the works come into being. She has talked about her materials and their tactile character, her concern with nature and history, and her desire to make environments for contemplation. She has talked about impermanence, death, lack of space. She has dwelt on human needs and the future. She has not talked about her epic voyage in and out of the human body—probably because she is still in the middle of this extraordinary journey.

Fig. 150 *The Center* 1976 (cat. no. 66)

Figs. 151, 152 *The Hand* 1976 (cat. no. 67b)

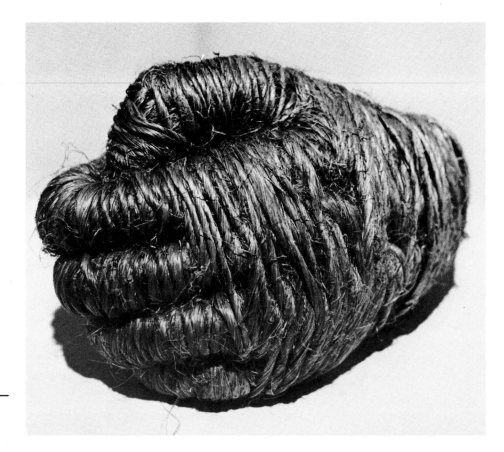

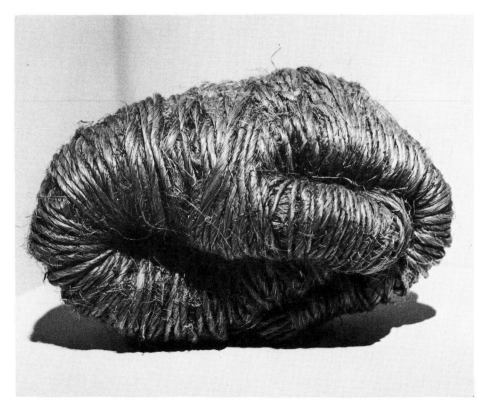

In the unconscious of contemporary man, mythology is still buoyant. It belongs to a higher spiritual plane than his conscious life. The most superficial being is crowded with symbols and the most logical person lives through images. Symbols never disappear from the field of reality; they can change their guise, but their role remains unchanged.

Music or smell, a thoughtful pause, a casual word, a landscape, can release nostalgic images and dreams. They always express much more than the person who experiences them can in turn convey in words.

Most people do not know how to verbalize such mental experiences, not from lack of intelligence, but because they cannot give sufficient weight to analytical language. It seems to me that these images can bring people closer more effectively and in a more fundamental way than analytical language.

Contemporary man may make light of these mental images, which does not alter the fact that he lives with them and through them. They are a real and undeniable part of human nature—they constitute the imagination.

To have imagination and to be aware of it is to benefit from possessing an inner richness and a spontaneous and endless flood of images. It means to see the world in its entirety, since the point of the images is to show all that which escapes conceptualization.

Magdalena Abakanowicz 1974

Notes

The preceding texts are based on conversations with Magdalena Abakanowicz over a period of some ten years, our correspondence, her own writings, and those of others about her. They are based on seeing her exhibitions in several countries and on time spent with her at her home, in her studio, and in the countryside in Poland.

These texts are about Magda's life, works, feelings, preoccupations, and contradictions. Such subjects clearly resist any pre-established order of presentation—be it alphabetical, chronological, or by any other rule—because they all coexist in an enormously complex relationship with one another. Taken together, they give an impression of Magda as artist and as individual.

1
Magda read my text and responded with a long and detailed commentary in Polish in a letter of August 31, 1981. Most of her comments, corrections, and explanations have been incorporated into the text, written September 1981. All of the following quotations by the artist, unless indicated otherwise, are from this letter.

2
J. K. Maciejewski, "Conversations with Artists: Magdalena Abakanowicz," *Chłopska Droga* (Warsaw), January 1, 1969, p. 11.

3
General conversations between the author and the artist, 1981.

4
"Cepelia" stands for Centrala Przemysłu Ludowego i Artystycznego or, in very approximate translation, Co-operative for the Promotion of the Popular Arts.

5
This was the third competition of the Artists' Co-operative for Design Projects, for furniture and fabrics. Magda presented three large gouaches which could be considered either purely decorative or utilitarian. Her contribution was thought to be the most emotional and done with the greatest panache. Her winning design, *Composition with Plants*, was a large, very brightly colored image of a centrally placed, explosive flower (fig. 1). The condition of winning the competition was that the work had to be executed as a tapestry in the Ład workshops.

6
Stefa Zgudka came to Warsaw to work with Magda in 1964; she has been her assistant ever since. Krysia Kiszkiel, who worked with Magda in Warsaw from 1970 to 1981, also graduated from the Zakopane weaving school. Both women are devoted to Magda and she considers them like family.

7
Le Corbusier, "Muralnomad," *1st International Biennial of Tapestry* (exh. cat., Musée Cantonal des Beaux-Arts, Lausanne, Switzerland), 1962, p. 9.

8
Michel Tourlière, *Tapisseries, Magdalena Abakanowicz, Pologne* (exh. cat., Galerie Dautzenberg, Paris), 1962.

9
Stanisława Grabska, "W Poszukiwaniu Rzeczy Pięknych," *Więź* 5, 25 (Warsaw) (May 1960), p. 96.

10
Jacek Sempoliński, "Wystawy i Problemy," *Przegląd Kulturalny* (Warsaw), April 28, 1960, p. 8.

11
Magdalena Abakanowicz, *Magdalena Abakanowicz: Organic Structures and Human Forms* (exh. cat., Whitechapel Art Gallery, London), 1975, p. [2].

12
Jeff Makin, "Magdalena Abakanowicz," *Quadrant* 6, 107 (Sydney) (May-June 1976), pp. 50-55.

13
Abakan is also incidentally the name of a river and a town in Siberia.

14
General conversations between the author and the artist, 1981.

15
John Russell, "Playing a Defensive Game," *The Sunday Times* (London), September 18, 1966.

16
Paul Overy, "The Art of Detachment," *The Listener* (London), September 29, 1966.

17
Abakans were celebrated in "Abakany," a film by Jarosľaw Brzozowski, who filmed the works in 1969 in the sand dunes on the coast of Poland known as Łeba.

18
Kirsten Dehlholm, "Taeppebiennalen i Lausanne 1967/The Carpet Biennale in Lausanne 1967," *Dansk Kunsthaandvaerk* 5-6, 39 (1966-67), pp. 161-162.

19
Tygodniak Polski (Warsaw), November 14, 1971.

20
Magdalena Abakanowicz and Judith Bumpus, "Rope Environments," *Art and Artists* 103, 9, 7 (London) (October 1974), pp. 36-41.

21
Ibid.

22
General conversations between the author and the artist, 1981.

23
Ibid.

24
Ibid.

25
Magdalena Abakanowicz in *"Malmoe"* (exh. cat., Malmö Konsthall, Sweden), 1981, p. 9.

26
A[ndré] K[uenzi], *Magdalena Abakanowicz* (exh. cat., Galerie Alice Pauli, Lausanne, Switzerland), 1971, p. [1].

27
General conversations between the author and the artist, 1981.

28
Cornelia Oliver, "Woven Structures at Aberdeen," *The Guardian* (Manchester), November 21, 1972.

29
Sr. Therese B. McGuire, "Magdalena Abakanowicz—Polish Pavilion," *Artery* 4, 2 (William Paterson College, Wayne, New Jersey) (November-December 1980), pp. 8-9.

30
General conversations between the author and the artist, 1981.

The forms of expression change.

Only they can tell the truth about themselves.

In everything I do, however, the constant factor and permanent necessity is to search for and reveal secrets inherent in structure, the structure being the phenomenon which all the organic world on our planet has in common. This mystery which can never fully be revealed.

Magdalena Abakanowicz 1976

Catalogue of Major Works

An asterisk (*) signifies works in the exhibition.
Height precedes width precedes depth. In addition
to individual works of art, a number of exhibitions
are important installation works, and thus appear in
this list.

1. *Composition with Plants* 1957
 Gouache on paper
 270 x 200 cm (106¼ x 78⅝ in.)
 Collection of the artist
 Fig. 1

2a. *Butterfly* 1957
 Gouache on paper
 270 x 200 cm (106¼ x 78⅝ in.)
 Collection of the artist

2b. *Butterfly* 1958
 Oil on canvas
 400 x 300 cm (157½ x 118 in.)
 Collection of the artist
 Fig. 2

3. *Relief* 1958
 Cork and wood
 161.3 x 96.5 x 96.5 cm (63½ x 38 x 38 in.)
 Destroyed
 Fig. 3

4. *Relief* 1958
 Cork and wood
 193.7 x 51.4 x 51.4 cm (76¼ x 20¼ x 20¼ in.)
 Collection of the artist
 Fig. 4

5. *Composition of White Forms* 1961-62
 Cotton and hemp ropes and wool weaving
 600 x 200 cm (236¼ x 78⅝ in.)
 Collection of the Muzeum Historii Włókien-
 nictwa, Łódź, Poland
 Figs. 16–18

6. *Andromeda* 1964
 Cotton rope, horsehair, and wool weaving in
 black and white
 250 x 350 cm (98⅜ x 137¾ in.)
 Collection of the artist

7. *Anna* 1964
 Cotton rope, horsehair, and wool weaving in
 black
 300 x 400 cm (118 x 157½ in.)
 Lost work

8. *Cleopatra* 1964
 Cotton rope, horsehair, and wool weaving in
 red and black
 300 x 420 cm (118 x 165⅜ in.)
 Collection of the Museu de Arte Contempo-
 ranea, São Paulo, Brazil

9. *Dorota* 1964
 Cotton rope, horsehair, and wool weaving in
 white and gray
 220 x 300 cm (86⅝ x 118 in.)
 Collection of the artist
 Fig. 21

10. *Helena* 1964
 Cotton rope, horsehair, and wool weaving in
 black, white, and gray
 300 x 500 cm (118 x 196⅞ in.)
 Collection of the Museu de Arte Contempo-
 ranea, São Paulo, Brazil

11. *Violet Abakan (Studium Faktur)* 1964
 Sisal weaving
 140 x 105 x 28 cm (55 x 41¼ x 11 in.)
 Collection of Claude Vermette and Mariette
 Rousseau-Vermette, Saint Adèle, Quebec
 Fig. 26

12. *Desdemona* 1965
 Cotton rope, horsehair, and wool weaving in
 red and black
 300 x 400 cm (118 x 157½ in.)
 Collection of the Muzeum Historii Włókien-
 nictwa, Łódź, Poland

13. *Untitled* 1965
 Steel
 700 x 250 x 220 cm (275⅝ x 98⅜ x 86⅝ in.)
 Collection of the City of Elbląg, Poland
 Fig. 19

14. *Black Relief* 1966
 Hemp and sisal ropes and horsehair weaving
 98 x 71 cm (38⅝ x 27⅝ in.)
 Collection of the artist

15. *Composition with Hands* 1966
Hemp and sisal ropes and horsehair weaving
in black with gypsum
100 x 157 cm (39⅜ x 61¾ in.)
Collection of the artist
Fig. 22

16. *White* 1966
Cotton rope, silk, and sisal weaving
150 x 200 cm (59 x 78⅜ in.)
Collection of the artist

17. *White Relief* 1966
Cotton rope, horsehair, and silk weaving
150 x 105 cm (59 x 41¼ in.)
Private Collection, London

18. *Abakan 100* 1966/67
Sisal weaving in black
500 x 200 x 100 cm (197 x 78⅝ x 39⅜ in.)
Destroyed
Figs. 125–127

19. *Abakan 27* 1967
Sisal weaving in brown
145.7 x 182.2 x 14.5 cm (57⅜ x 71¾ x 5¾ in.)
Collection of The Detroit Institute of Arts
(Gift of Jack Lenor Larsen)
Fig. 28

*20. *Abakan Open* 1967
Sisal weaving in black
300 x 100 x 100 cm (118 x 39⅜ x 39⅜ in.)
Collection of the artist
Figs. 32, 133

*21. *Abakan Round* 1967
Sisal weaving in black
300 x 100 x 100 cm (118 x 39⅜ x 39⅜ in.)
Collection of the artist
Figs. 34, 133

*22. *Abakan Winged* 1967
Sisal weaving in black and brown
300 x 350 x 100 cm (118 x 137¾ x 39⅜ in.)
Collection of the artist
Fig. 31

23. *Black Assemblage* 1967
Hemp and sisal ropes and horsehair weaving
300 x 270 cm (118 x 106¼ in.)
Collection of the artist

24. *Black Assemblage II* 1967
Hemp and sisal ropes and horsehair weaving
300 x 270 cm (118 x 106¼ in.)
Collection of the Kunstindustrimuseet, Oslo
Fig. 27

*25. *Great Black Abakan* 1967
Sisal weaving
300 x 150 x 100 cm (118 x 59 x 39⅜ in.)
Collection of the Centre Georges Pompidou,
Musée National d'Art Moderne, Paris
Fig. 32

26. *Red Abakan* 1967
Sisal weaving
300 x 300 x 100 cm (118 x 118 x 39⅜ in.)
Collection of the Museum Bellerive, Zurich
Figs. 35, 126, 127

27. *Abakan 29* 1967-68
Sisal weaving in black
200 x 160 x 40 cm (78¾ x 63 x 15¾ in.)
Private Collection, Switzerland
Fig. 30

28. *Yellow Abakan* 1967-68
Sisal weaving
315 x 333 x 150 cm (124 x 131 x 59 in.)
Collection of The Museum of Modern Art,
New York
Fig. 34

29. *Brown Abakan* 1968
Sisal weaving
300 x 200 x 50 cm (118 x 78¾ x 19⅝ in.)
Collection of the Röhsska Konstslöjmuseet,
Göteborg, Sweden
Figs. 36, 126, 127

30. *Brown Coat* 1968
Sisal weaving
300 x 180 x 60 cm (118 x 70⅞ x 23⅝ in.)
Collection of the Sonja Henies og Niels
Onstadts Stiftelser, Kunstsenter, Høvikodden,
Norway
Figs. 42, 43, 126, 127, 134

31. *Baroque Dress* 1969
Sisal weaving in orange
400 x 400 x 50 cm (157½ x 157½ x 19⅝ in.)
Collection of the Nationalmuseum, Stockholm
Figs. 38, 39, 129, 130

*32. *Black Garment* 1969
Sisal weaving
300 x 180 x 60 cm (118 x 70⅞ x 23⅝ in.)
Collection of the Stedelijk Museum,
Amsterdam
Fig. 44

33. *Red Abakan* 1969
Sisal weaving
300 x 300 x 50 cm (118 x 118 x 19⅝ in.)
Collection of Pierre and Marguerite Magnenat,
Lausanne, Switzerland

*34. *Red Abakan* 1969
Sisal weaving
400 x 400 x 350 cm (157½ x 157½ x 137¾ in.)
Collection of the artist
Figs. 41, 138

35. *Yellow Abakan* 1969
Sisal weaving
300 x 300 x 50 cm (118 x 118 x 19⅝ in.)
Collection of the Hyatt Regency O'Hare,
Chicago
Figs. 126, 127

36. Installation of *Abakans* and ropes in the sand
dunes on the Polish coast known as Łeba for
"Abakany," directed by Jarosław Brzozowski
1969
Figs. 125–128

37. *Abakan—Situation Variable* 1970
Sisal weaving in black
350 x 180 x 60 cm (137¾ x 70⅞ x 23⅝ in.)
Collection of the Palais des Congrès, Biel,
Switzerland
Figs. 45, 46

38. *Turquoise Abakan* 1970
Sisal weaving
350 x 500 x 500 cm (137¾ x 197 x 197 in.)
Collection of the Muzeum Narodowe w
Warszawie, Warsaw
Fig. 47

39. One-person exhibition of *Abakans* and ropes
at the Södertälje Konsthall, Sweden 1970
Figs. 45, 53-55, 129–131

40. One-person exhibition of *Abakans* and ropes
at the Nationalmuseum, Stockholm 1970
Figs. 56, 57

41. *Bois-le-Duc* 1970-71
Sisal and wool weaving in black and brown
800 x 2000 x 200 cm (315 x 787⅜ x 78⅝ in.)
Collection of the Provinciehuis, s'Hertogen-
bosch, the Netherlands
Figs. 49–52

*42. *Yellow Abakan* 1970-75
Sisal weaving
300 x 300 x 50 cm (118 x 118 x 19½ in.)
Collection of the artist
Fig. 37

*43. *Black Environment* 1970-78
Sisal weavings
Fifteen pieces, each: 350 x 80 x 80 cm (137¾ x
31½ x 31½ in.)
Collection of the artist
Figs. 33, 135, 136

*44. *Abakan Edinburgh* 1971
Sisal weaving in black
300 x 100 x 70 cm (118 x 39⅜ x 27⅝ in.)
Collection of the artist

*45. *Abakan Festival* 1971
Sisal weaving in black
350 x 100 x 100 cm (137¾ x 39⅜ x 39⅜ in.)
Collection of the artist

*46. *Black Garment with Sack* 1971
Sisal weaving
500 x 180 x 60 cm (197 x 71 x 23⅝ in.)
Collection of the artist
Figs. 42, 124, 134, 138

*47. *Orange Abakan* 1971
Sisal weaving
400 x 400 x 40 cm (157½ x 157½ x 15⅝ in.)
Collection of the artist
Figs. 135, 138

48. *Red Abakan II* 1971
Sisal weaving
300 x 300 x 50 cm (118 x 118 x 19⅝ in.)
Collection of Pierre and Marguerite Magnenat,
Lausanne, Switzerland

49. *Untitled* 1971
Group of sisal and wool weavings
Area: 3000 sq. cm (465 sq. in.)
Formerly the collection of the Huddinge
Sjukhus, Huddinge, Sweden
Destroyed
Fig. 48

50. One-person exhibition of *Abakans* and ropes
at the Pasadena Art Museum, California
1971
Figs. 32, 40, 47, 58, 59

*51. *Abakan January-February* 1972
Sisal weaving in black
300 x 200 x 100 cm (118 x 78⅝ x 39⅜ in.)
Collection of the artist

52. Rope installation in the "Edinburgh Inter-
national Festival: 'Atelier '72,'" Richard
Demarco Gallery 1972
Figs. 62–64

53. Rope installation in "Octobre à Bordeaux," Galerie des Beaux-Arts, Bordeaux, France 1973
Figs. 60, 61

54. Rope installation in one-person exhibition at the Arnolfini Gallery, Bristol, England 1973

55. Rope installation in the "6th International Biennial of Tapestry," Musée Cantonal des Beaux-Arts, Lausanne, Switzerland 1973

*56. *Wheel and Rope* 1973
Wood; burlap and hemp
Wheel: dia. 234 cm; d. 122 cm (92 in.; 48 in.)
Black and red ropes: lengths variable
Collection of the artist
Figs. 136, 138–142

*57. *Heads* 1973-75
Burlap and hemp rope
Sixteen pieces: from 84 x 51 x 66 cm to 109 x 76 x 71 cm (33 x 20 x 26 in. to 43 x 30 x 28 in.)
Fourteen in the collection of the artist; one in the collection of The Detroit Institute of Arts (Founders Society Purchase, Dr. and Mrs. George Kamperman and Anonymous Funds); and one in the collection of Pierre and Marguerite Magnenat, Lausanne, Switzerland
Figs. 73–76, 134, 136, 138

58. *Black Garment* (Rectangle) 1974
Sisal weaving and burlap
500 x 200 x 100 cm (197 x 78⅝ x 39⅜in.)
Destroyed
Figs. 42, 134, 138

59. *Black Garment V* 1974
Sisal weaving
300 x 170 x 70 cm (118 x 66⅞ x 27⅝ in.)
Collection of the Kyoto National Museum of Modern Art

*60. *Black Garment Rounded* 1974
Sisal weaving and burlap
500 x 200 x 100 cm (197 x 78⅝ x 39⅜ in.)
Collection of the artist
Figs. 42, 124, 134

*61. *Black Garment Triennale* 1974
Sisal weaving in black
350 x 200 x 100 cm (137¾ x 78⅝ x 39⅜ in.)
Collection of the artist

62. One-person exhibition of *Abakans, Heads,* and *Seated Figures* at the Muzeum Sztuki w Lodzi, Łódź, Poland 1974

*63. *Brown Abakan* 1974-76
Sisal weaving
300 x 300 x 100 cm (118 x 118 x 39⅜ in.)
Collection of the artist

*64. *Seated Figures* 1974-79
Figures: burlap and glue; stands: steel
Eighteen pieces: each figure approx. 104 x 51 x 66 cm (41 x 20 x 26 in.); each stand 76 x 46 x 22 cm (30 x 18 x 8½ in.)
Collection of the artist
Figs. 76–81, 134

65. One-person exhibition of *Abakans, Heads,* and *Seated Figures* at Zachęta, Warsaw 1975
Figs. 33, 42, 75, 76, 80, 81, 124, 133–135

*66. *The Center* 1976
Linen
26 x 15 x 10 cm (10¼ x 6⅞ x 3⅞ in.)
Private Collection, Switzerland
Fig. 152

*67a. *The Hand* 1976
Sisal
12 x 20 x 15 cm (4⅝ x 7⅞ x 6⅞ in.)
Collection of the artist
Fig. 139

67b. *The Hand* 1976
Sisal
12 x 20 x 15 cm (4⅝ x 7⅞ x 6⅞ in.)
Collection of John Melin, Malmö, Sweden
Figs. 153, 154

*68. *Landscape I-VI* 1976
Burlap and glue
Six pieces, each: 140 x 57 cm (55 x 22⅜ in.)
I-IV in the collection of Pierre and Marguerite Magnenat, Lausanne; *V* courtesy of Galerie Alice Pauli, Lausanne; and *VI* in the collection of the Musée Cantonal des Beaux-Arts, Lausanne, Switzerland
Figs. 87–90

69. One-person exhibition of *Abakans, Heads, Seated Figures,* and *Wheel and Rope* at the Art Gallery of New South Wales, Sydney, Australia 1976
Fig. 41

70. One-person exhibition of *Abakans, Heads, Seated Figures,* and *Wheel and Rope* at the National Gallery of Victoria, Melbourne, Australia 1976

*71. *Backs* 1976-82
Burlap and glue
Eighty pieces, three sizes: 61 x 50 x 55 cm
(24 x 19⅝ x 21⅞ in.); 69 x 56 x 66 cm
(27¼ x 22 x 26 in.); and 72 x 59 x 69 cm
(28¼ x 23¼ x 27¼ in.)
Collection of the artist
Figs. 82–86, 99, 136, 138, 142–145

72. One-person exhibition of *Abakans, Backs,
The Center, Disimetric Object, The Hand,
Heads, Landscapes, Seated Figures,* and *Wheel
and Rope* at the Malmö Konsthall, Sweden
1977
Figs. 65–68, 84, 136, 137

73. One-person exhibition of *Abakans, Backs,
The Center, Disimetric Object, The Hand,
Heads, Landscapes, Seated Figures,* and *Wheel
and Rope* at the Sonja Henies og Niels
Onstadts Stiftelser, Kunstsenter, Høvikodden,
Norway 1977
Fig. 138

74. One-person exhibition of *Abakans, Backs,
Heads,* and *Seated Figures* at the Biuro Wystaw
Artystycznych, Łódź, Poland 1978
Fig. 72

75. One-person exhibition of *Abakans, Backs,
Heads,* and *Seated Figures* at the Salon Sztuki
Współczesnej, Biuro Wystaw Artystycznych,
Bydgoszcz, Poland 1978

*76. *Embryology* 1978-81
Burlap, cotton gauze, hemp rope, nylon, and
sisal
Approximately 800 pieces: from 4
to 250 cm long (1⅝ to 98⅜ in.)
Collection of the artist
Figs. 91–99, 139, 141–143, 145, 146

*77. *Trzepaki* 1980
Burlap and wood
Two pieces: dimensions variable
Collection of the artist
Figs. 102–104

78. One-person exhibition of *Backs, Embryology,
The Hand, Trzepaki,* and *Wheel and Rope* at
the Polish Pavilion, Venice Biennale 1980
Figs. 97–99, 104, 139–143

*79. *Cage* 1981
Burlap and glue; wood
Two parts: *Back* 72 x 59 x 69 cm (28¼ x 23¼
x 27¼ in.); cage 167.6 x 116.8 x 155 cm (66 x
46 x 61 in.)

*80. *Trunks* 1981
Wood
Fifteen pieces, each: h. 224 cm; dia. 18 cm
(88¼ in.; 7 in.)
Collection of the artist
Figs. 20, 145–147

81. Installation of tarpaulins and wood at the
Malmö Konsthall, Sweden 1981
Two parts: 600 x 800 x 200 cm (236¼ x 315 x
78⅝ in.) and 150 x 700 x 500 cm (59 x 275⅝ x
197 in.)
Figs. 107–109

*82. *Bodies* 1981-82
Cycle of drawings
Charcoal on paper
Each 105 x 76 cm (41¼ x 29⅞ in.)
Various collections
Figs. 9, 117–121

*83. *Faces* 1981-82
Cycle of drawings
Charcoal on paper
Each 105 x 76 cm (41¼ x 29⅞ in.)
Various collections
Figs. 122, 123

*84. *Pregnant* 1981-82
Birch branches and wire
Twenty-three pieces: from 90 to 270 cm long
(35⅜ to 106¼ in.)
Collection of the artist
Figs. 100, 101

85. One-person exhibition of *Backs, Cage, Embry-
ology, Heads, Pregnant, Seated Figures,
Trunks,* and *Wheel and Rope* at the Musée
d'Art Moderne de la Ville de Paris 1982
Figs. 85, 144–147

One-Person Exhibitions

1960 Kordegarda, Ministerstwo Kultury i Sztuki, Warsaw, "Wystawa Prac Magdaleny Abakanowicz—Kosmowskiej" (exh. cat.)

1962 Galerie Dautzenberg, Paris, "Tapisseries, Magdalena Abakanowicz, Pologne" (exh. cat.)

1963 Galeria Sztuki Nowoczesnej, Warsaw, "Magdalena Abakanowicz, Gobelin" (exh. cat.)

1965 Zacheta, Centralne Biuro Wystaw Artystycznych, Warsaw, "Wystawa Gobelinów Magdaleny Abakanowicz" (exh. cat.)

1966 Biuro Wystaw Artystycznych, Zielona Góra, Poland, "Wystawa Gobelinów Magdaleny Abakanowicz" (exh. cat.)

1967 Galerie Alice Pauli, Lausanne, Switzerland, "Abakanowicz" (exh. cat.)

 Galeria Współczesna, Warsaw, "Magdalena Abakanowicz" (exh. cat.)

 Kunstindustrimuseet, Oslo, "Magdalena Abakanowicz, Arbeider i Vev" (exh. cat.) (also traveled in Norway to Stavanger Kunstforening; Trondheim Kunstforening; and Vestlandske Kunstindustrimuseum, Bergen)

1968 Stedelijk van Abbemuseum, Eindhoven, the Netherlands, "Abakanowicz: 2- en 3-dimensionale weefsels" (exh. cat.) (also traveled in the Netherlands to Frans Halsmuseum, Haarlem; Groninger Museum voor Stad en Lande, Groningen, 1969; and Stedelijk Museum, Schiedam, 1969)

 Züricher Kunstgesellschaft, Helmhaus, Zurich, "Abakanowicz, Eine Polnische Textilkünstlerin" (exh. cat.)

1969 Galerie Alice Pauli, Lausanne, Switzerland, "Abakanowicz, Jagoda Buic" (exh. cat.)

 Kunsthalle Mannheim, West Germany, "Magdalena Abakanowicz: Tapisserien und Räumliche Texturen" (exh. cat.)

 Stedelijk Museum, Arnhem, the Netherlands, "Magdalena Abakanowicz"

1970 Nationalmuseum, Stockholm, "Abakanowicz: en konfrontation" (exh. cat.)

 Södertälje Konsthall, Sweden, "Magdalena Abakanowicz/Textil Skulptur/Textile Environment" (exh. cat.)

1971 Galerie Alice Pauli, Lausanne, Switzerland, "Magdalena Abakanowicz" (exh. cat.)

 Galeria Pryzmat, Związek Polskich Artystów Plastyków, Cracow, Poland, "Magdalena Abakanowicz" (exh. cat.)

 Galeria Współczesna, Warsaw, "Magdalena Abakanowicz" (exh. cat.)

Pasadena Art Museum, California, "The Fabric Forms of Magdalena Abakanowicz" (exh. cat.)

1972 Aberdeen Art Gallery, Scotland, "Abakanowicz"

Kunstverein für die Rheinlande und Westfalen, Düsseldorf, "Magdalena Abakanowicz: Textile Strukturen und Konstruktionen, Environments" (exh. cat.)

1973 Arnolfini Gallery, Bristol, England, "Magdalena Abakanowicz, Rope Structures"

1974 Museum Sztuki w Łodzi, Łódź, Poland, "Doświadczenia i Poszukiwania"

1975 Galerie Alice Pauli, Lausanne, Switzerland, "Abakanowicz: Structures organiques et formes humaines" (exh. cat.)

Whitechapel Art Gallery, London, "Magdalena Abakanowicz: Organic Structures and Human Forms" (exh. cat.)

Zachęta, Centralne Biuro Wystaw Artystycznych, Warsaw, "Magdalena Abakanowicz" (exh. cat.)

1976 Art Gallery of New South Wales, Sydney, and National Gallery of Victoria, Melbourne, "Magdalena Abakanowicz: Organic Structures and Soft Forms" (exh. cat.)

1977 Galerie Alice Pauli, Lausanne, Switzerland, "Magdalena Abakanowicz" (exh. cat.)

Malmö Konsthall, Sweden, "Abakanowicz: Organic Structures" (exh. cat.)

Sonja Henies og Niels Onstadts Stiftelser, Kunstsenter, Høvikodden, Norway, "Magdalena Abakanowicz: Organiske Strukturer/Organic Structures" (exh. cat.)

1978 Biuro Wystaw Artystycznych, Łódź, Poland, "Magdalena Abakanowicz: Tkanina" (exh. cat.)

Salon Sztuki Współczesnej, Biuro Wystaw Artystycznych, Bydgoszcz, Poland, "Magdalena Abakanowicz" (exh. cat.)

1979 Galerie Alice Pauli, Lausanne, Switzerland, "Abakanowicz Rétrospective" (exh. cat.)

1980 Venice, La Biennale di Venezia, Polish Pavilion, "Biennale di Venezia '80: Magdalena Abakanowicz, Polonia" (general and Polish Pavilion exh. cats.)

1981 Galerie Alice Pauli, Lausanne, Switzerland, "Abakanowicz" (exh. cat.)

1982 ARC, Musée d'Art Moderne de la Ville de Paris, "Abakanowicz: 'Alterations'" (exh. cat.)

Galerie Jeanne Bucher, Paris, "Magdalena Abakanowicz: 21 dessins au fusain" (exh. cat.)

Walter Phillips Gallery, The Banff Centre, and Glenbow-Alberta Institute, Calgary, Alberta, Canada, "Magdalena Abakanowicz"

Selected Group Exhibitions

1956 Zachęta, Warsaw, "XXX-lecie Spółdzielni Artystów Plastyków 'ŁAD' " (exh. cat.)

Zachęta, Warsaw, "Ogólnopolska Wystawa Architektury Wnętrz" (exh. cat.)

1957 Biuro Wystaw Artystycznych, Warsaw, "Ogólnopolska Wystawa Architektury Wnętrz (exh. cat.)

Związek Polskich Artystów Plastyków, Warsaw, "Wystawa Zespołu Młodych Plastyków" (exh. cat.)

1958 Biuro Wystaw Artystycznych, Radom, Poland, "Ogólnopolski Salon Zimowy" (exh. cat.)

Cracow, Poland, "Ogólnopolska Wystawa Architektury Wnętrz i Sztuki Dekoracyjnej" (exh. cat.)

1959 Biuro Wystaw Artystycznych, Radom, Poland, "Ogólnopolski Salon Zimowy" (exh. cat.)

Biuro Wystaw Artystycznych, Sopot, Poland, "Wystawa Młodej Plastyki" (exh. cat.)

1960 Biuro Wystaw Artystycznych, Radom, Poland, Ogólnopolski Salon Zimowy" (exh. cat.)

Biuro Wystaw Artystycznych, Sopot, Poland, "Festiwal Sztuk Plastycznych" (exh. cat.)

Biuro Wystaw Artystycznych, Sopot and Gdańsk, Poland, "Tkaniny Milenijne" (exh. cat.)

Muzeum Narodowe w Warszawie, Warsaw, "Wystawa Malarstwa z Cyklu Polskie Dzieło Plastyczne w XV-lecie PRL" (exh. cat.)

1961 Biuro Wystaw Artystycznych, Radom, Poland, "Ogólnopolski Salon Zimowy" (exh. cat.)

Biuro Wystaw Artystycznych, Sopot, Poland, "Festiwal Sztuk Plastycznych" (exh. cat.)

Galeria Sztuki, Związek Polskich Artystów Plastyków, Warsaw, "Wystawa Doświadczalnej Pracowni Tkactwa" (exh. cat.)

1962 Biuro Wystaw Artystycznych, Radom, Poland, "Ogólnopolski Salon Zimowy" (exh. cat.)

Biuro Wystaw Artystycznych, Sopot, Poland, "Festiwal Sztuk Plastycznych" (exh. cat.)

Galeria Sztuki, Związek Polskich Artystów Plastyków, Warsaw, "Wystawa Tkanin Artystycznych i Rzeźb w Ceramice—Doświadczalna Pracownia Tkactwa" (exh. cat.)

Musée Cantonal des Beaux-Arts, Lausanne, Switzerland, "1st International Biennial of Tapestry" (exh. cat.)

1963 Château de Culan, Laon, France, "Exposition International de Tapisseries Contemporaines"

Muzeum Narodowe w Warszawie, Warsaw, "Wystawa Grupowa Gobelinów (Abakanowicz, Butrymowicz, Drouet, Kierzkowska, Łaszkiewicz, Sadley)" (exh. cat.)

Sala Wystawowa, Związek Polskich Artystów Plastyków, Warsaw, "Wystawa Doświadczalnej Pracowni Tkanin" (exh. cat.)

Warsaw, "Wystawa Rzeźb i Tkanin Okręgu Warszawskiego Z.P.A.P." (exh. cat.)

1964 Biuro Wystaw Artystycznych, Wrocław, Poland, "Wystawa Gobelinów" (exh. cat.)

Galeria Sztuki, Związek Polskich Artystów Plastyków, Warsaw, "Wystawa Tkanin Pracowni Doświadczalnej" (exh. cat.)

Museum am Ostwall, Dortmund, "Moderne Polnische Tapisserie" (exh. cat.) (also traveled in West Germany to Kunstgewerbemuseum der Stadt Köln, Cologne; Kunsthaus Hamburg; Städtische Kunsthalle Mannheim; Württembergischer Kunstverein, Kunstgebäude am Schlossplatz, Stuttgart)

Zachęta, Centralne Biuro Wystaw Artystycznych, Warsaw, "Ogólnopolska Wystawa: Tkanina, Ceramika, Szkło" (exh. cat.)

1965 Biuro Wystaw Artystycznych, Szczecin, Poland, "Grupowa Wystawa Tkanin" (exh. cat.)

Centralne Biuro Wystaw Artystycznych, Warsaw, "Ogólnopolska Wystawa: Tkanina, Ceramika, Szkło" (exh. cat.)

Elbląg, Poland, "I-e Biennale Form Przestrzennych" (exh. cat.)

Kunstindustrimuseet, Oslo, "Moderne Polsk Billedvev" (exh. cat.)

Stedelijk van Abbemuseum, Eindhoven, the Netherlands, "Poolse Wandtapijten" (exh. cat.) (also traveled to Frans Halsmuseum, Haarlem; Gemeentemuseum, Arnhem, the Netherlands; Kunstmuseum, St. Gallen, Switzerland; Museum des Kunsthandwerks, Leipzig, East Germany; and Neue Galerie der Stadt Linz, Wolfgang Gurlitt Museum, Linz, Austria)

Musée Cantonal des Beaux-Arts, Lausanne, Switzerland, "2nd International Biennial of Tapestry" (exh. cat.)

Sala Wystawowa, Zakopane, Poland, "Magdalena Abakanowicz—Tkanina, Stanisław Sikora—Rzeźba, Tadeusz Szymański—Szkło Artystyczne" (exh. cat.)

Sala Wystawowa, Związek Polskich Artystów Plastyków, Warsaw, "Wystawa Doświadczalnej Pracowni Tkanin Okręgu Warszawskiego" (exh. cat.)

São Paulo, Brazil, "VIII Bienal de São-Paolo" (general and Polish exh. cats.) (also traveled in South and Central America)

1966 Antibes, France, "Festival International d'Art" (exh. cat.)

Biuro Wystaw Artystycznych, Sopot, Poland, "Festiwal Sztuk Plastycznych: Nurty, Poszukiwania, Propozycje" (exh. cat.)

Grabowski Gallery, London, "Tapestries of Tomorrow from Polish Looms of Today" (exh. cat.)

Muzeum Sztuki w Łodzi, Łódź, Poland "Wystawa Malarstwa z Cyklu Polskie Dzieło Plastyczne w XXV-lecie PRL" (exh. cat.)

Santa Barbara Museum of Art, California, "Contemporary European Tapestries: The Collection of Mr. and Mrs. J. L. Hurschler" (exh. cat.) (also traveled in the United States to Colorado Springs Fine Arts Center; Joslyn Art Museum, Omaha; La Jolla Museum of Art, California; Municipal Art Gallery, Los Angeles; and Phoenix Art Museum, Arizona, 1967; Carnegie Institute, Pittsburgh; and Houston Museum of Fine Arts, Texas, 1968)

Związek Polskich Artystów Plastyków, Warsaw, "Festiwal Sztuk Plastycznych" (exh. cat.)

Związek Polskich Artystów Plastyków, Warsaw, "Wystawa Doświadczalnej Pracowni Tkactwa" (exh. cat.)

1967 Lunds Konsthall, Lund, Sweden, "Moderna Gobelanger och Aktuell Grafik Från Polen" (exh. cat.)

Musée des Beaux-Arts, La Chaux-de-Fonds, Switzerland, "Art Polonais" (exh. cat.)

Musée Cantonal des Beaux-Arts, Lausanne, Switzerland, "3rd International Biennial of Tapestry" (exh. cat.)

1968 Iran Bastan Museum, Teheran, "L'Art Polonais Contemporain"

Padiglione Centrale, Venice, "XXXIV Biennale Internazionale d'Arte; Linee della ricerca: dall' informale alle nuove strutture" (exh. cat.)

Zachęta and Związek Polskich Artystów Plastyków, Warsaw, "Festiwal Sztuk Plastycznych" (exh. cat.)

1969 Musée Cantonal des Beaux-Arts, Lausanne, Switzerland, "4th International Biennial of Tapestry" (exh. cat.)

Museo Español de Arte Contemporáneo, Madrid, "Experiencias Artisticas Textiles" (exh. cat.) (also traveled to Barcelona)

The Museum of Modern Art, New York, "Wall Hangings" (exh. cat.) (also traveled in the United States and Canada to Cascade Gallery, Seattle, Washington; Cummer Gallery of Art, Jacksonville, Florida; Flint Institute of Arts, Michigan; Mercer University, Macon, Georgia; Musée d'Art Contemporain, Montreal; Ringling Museum of Art, Sarasota, Florida; and University Art Museum, Austin, Texas, 1968;

Allentown Art Museum, Pennsylvania; Cedar Rapids Art Center, Iowa; Saint Cloud College, Minnesota; and University Art Gallery, State University of New York at Albany, 1969)

Stedelijk Museum, Amsterdam, "Perspectief in Textiel" (exh. cat.)

1970 Museum Folkwang, Essen, West Germany, "Moderne Polnische Teppiche" (exh. cat.)

Royal Academy of Arts, London, "A Thousand Years of Art in Poland"

1971 Białystok, Poland, "III-i Festiwal Muzyki i Poezji: Wystawa Współczesnej Tkaniny Polskiej" (exh. cat.)

Biuro Wystaw Artystycznych, Zielona Góra, "V Wystawa Plastyki Złotego Grona" (exh. cat.)

California College of Arts and Crafts, Oakland, "Dimension of Fiber"

Camden Art Centre, London, "Soft Sculptures"

Frederick S. Wight Art Gallery of the University of California, Los Angeles, "Deliberate Entanglements" (exh. cat.) (also traveled in the United States and Canada to the California Palace of the Legion of Honor, San Francisco; Museum of Contemporary Art, Chicago; Utah Museum of Fine Arts, Salt Lake City; and Vancouver Art Gallery, British Columbia)

Musée Cantonal des Beaux-Arts, Lausanne, Switzerland, "5th International Biennial of Tapestry" (exh. cat.)

Röhsska Konstslöjdmuseet, Göteborg, Sweden, "Moderna Polska Textilier" (exh. cat.)

1972 Centralne Muzeum Włókiennictwa, Łódź, Poland, "Ogólnopolskie Triennale Tkaniny Przemysłowej i Unikatowej" (exh. cat.)

The Denver Art Museum, Colorado, "Fiber Structures" (exh. cat.)

Haus am Waldsee, West Berlin, "Fetisch Jugend—Tabu Tod" (exh. cat.) (also traveled in West Germany to Frankfurter Kunstverein, Frankfurt; Kunsthalle zu Kiel; and Städtisches Museum Leverkusen)

Manufacture National des Gobelins, Paris, "L'Art du tissu en Pologne 1962-1972" (exh. cat.)

Richard Demarco Gallery, Edinburgh, "Edinburgh International Festival: 'Atelier '72,'" organized in collaboration with the Muzeum Sztuki w Łodzi, Łódź, Poland, and in association with the Edinburgh Festival Society (exh. cat.)

Związek Polskich Artystów Plastyków, Warsaw "IV-y Festiwal Sztuk Pięknych" (exh. cat.)

1973 Biuro Wystaw Artystycznych, Warsaw, "Warszawa w Sztuce" (exh. cat.)

Charlottenburg, Copenhagen, and Nordjyllands Kunstmuseum, Aalborg, Denmark, "Moderne Polsk Kunst," organized by the Muzeum Sztuki w Łodzi, Łódź, Poland

Emily Lowe Gallery, Hofstra University, Hempstead, New York, "Fibre Work—17" (exh. cat.)

Fine Arts Gallery of San Diego, California, "Contemporary Tapestries from the Hurschler Collection" (exh. cat.)

Galerie Alice Pauli, Lausanne, Switzerland, "Magdalena Abakanowicz, Jagoda Buic: textilreliefs" (exh. cat.)

Galerie des Beaux-Arts, Bordeaux, France, "Octobre à Bordeaux: 8 Artistes dans la ville" (exh. cat.)

Musée Cantonal des Beaux-Arts, Lausanne, Switzerland, "6th International Biennial of Tapestry" (exh. cat.)

1974 Bank of America, San Francisco, "Contemporary Tapestries from the Hurschler Collection"

Kunsthaus Zürich, "Kunst in Polen," organized by the Muzeum Sztuki w Łodzi, Łódź, Poland (exh. cat.)

Museum of Science and Industry, Chicago; Congress Center, Milwaukee, Wisconsin; University College, Buffalo, New York; and Cobo Hall, Detroit, "Poland Today"

Ontario Science Centre, Toronto, "In Praise of Hands," organized by the World Crafts Council (exh. cat.; Abakanowicz not in cat.)

Uméleckoprůmyslové Muzeum, Prague, "Polska Tapisserie"

1975 Abbaye de Fontevrault, Angers, France, "Festival d'Anjou: Textiles d'Aujourd'hui en Pologne"

Kunstgewerbemuseum, Staatliche Museen—Preussichër Kulturbesitz, West Berlin, "Textile Objekte" (exh. cat.) (also traveled in West Germany to the Badisches Landesmuseum, Karlsruhe; Kunstgewerbemuseum, Overstolzenhaus, Cologne; Museum für Kunst und Gewerbe, Hamburg; Museum für Kunsthandwerk, Frankfurt; and Stadtmuseum, Munich)

Musée Cantonal des Beaux-Arts, Lausanne, Switzerland, "7th International Biennial of Tapestry" (exh. cat.)

Museo de Arte Moderno, Mexico City, "Polonia en México Festival de las Formas/Pintura Contemporánea" (exh. cat.)

The National Gallery of Canada, Ottawa, "Tapestries from Poland: A Survey of Weaving from the Eighteenth Century to the Present Lent by the Polish People's Republic," organized by the Centralne Muzeum Włókiennictwa, Łódź, Poland (exh. cat.)

University Art Museum, Austin, Texas, "Contemporary Tapestries from the Hurschler Collection" (exh. cat.)

1976 Carnegie Institute, Pittsburgh, Pennsylvania, "Fiber Structures" (exh. cat.)

Kyoto National Museum of Modern Art, and National Museum of Modern Art, Tokyo, "Fiber Works Europe and Japan" (exh. cat.)

Zachęta and Związek Polskich Artystów Plastyków, Warsaw, "Festiwal Sztuk Plastycznych" (exh. cat.)

1977 Cleveland Museum of Art, "Fiberworks" (exh. cat.)

Galerie 100, Cracow, Poland, "Żyjnia" (exh. cat.)

Kölnischer Kunstverein, Cologne, West Germany, "22 Polnische Künstlers"

Musée Cantonal des Beaux-Arts, Lausanne, Switzerland, "8th International Biennial of Tapestry" (exh. cat.) (also traveled to Museu Calouste Gulbenkian, Lisbon)

Smithsonian Institution Traveling Exhibition Service, Washington, D.C., "22 Polish Textile Artists," organized in cooperation with the Ministerstwa Kultury i Sztuki, Centralne Biuro Wystaw Artystycznych, Warsaw (exh. cat.) (traveled to 14 museums in the United States)

1978 Biuro Wystaw Artystycznych, Koszalin, Poland, "W Kręgu Współczesnej Tkaniny Polskiej" (exh. cat.)

Biuro Wystaw Artystycznych, Warsaw, "Festiwal Sztuk Plastycznych" (exh. cat.)

Centralne Muzeum Włókiennictwa, Łódź, Poland, "3rd Textile Triennale—Art Fabric and Industrial Textile—Łódź-78," organized by Związek Polskich Artystów Plastyków—Okręg Łódź, Centralne Muzeum Włókiennictwa, and Biuro Wystaw Artystycznych w Łodzi (exh. cat.)

Galerie Jeanne Bucher, Paris, "L'Espace en demeure: Louise Nevelson, Marie-Hélène Vieira da Silva, Magdalena Abakanowicz" (exh. cat.)

Museum Bochum, West Germany, " 'Imagination' (Internationale Ausstellung Bildnerischer Poesie)" (exh. cat.)

1979 Galerie Alice Pauli, Lausanne, Switzerland, "Structures Murales, Tapisseries"

Galerie Asbaek, Copenhagen, "Modern Polish Art" (exh. cat.)

Kunsthaus Zürich, "Weich und Plastisch/Soft-Art" (exh. cat.)

Musée Cantonal des Beaux-Arts, Lausanne, Switzerland, "9th International Biennial of Tapestry" (exh. cat.) (also traveled to Nordjyllands Kunstmuseum, Aalborg, Denmark)

Fundación Joan Miró, Barcelona; Museo Provincial de Bellas Artes, Bilboa, Spain; Museu Calouste Gulbenkian, Lisbon; and Palacio de Velázquez, Madrid, "Escultura Polaca Contemporánea," organized by the Ministerstwa Kultury i Sztuki, Warsaw

São Paulo, Brazil, "XV Bienal de São-Paolo" (exh. cat.)

1980 Galeria "Awangarda," Wrocław, Poland, "Modern Polish Sculpture"

Musée d'Art Moderne de la Ville de Paris, "Sculptures Polonaises Contemporaines," organized by the Ministerstwo Kultury i Sztuki, Warsaw (exh. cat.)

Museum of Modern Art, Bucharest, "Warsaw—Bucharest"

National Gallery of Ireland and School of Architecture in University College, Dublin, "ROSC '80: The Poetry of Vision" (exh. cat.)

Pratt Manhattan Center Gallery, New York, "Contemporary Tapestry" (exh. cat.) (also traveled in the United States to Boston University Art Gallery; Gallery One, Montclair State College, New Jersey; Pratt Institute Gallery, New York; and University of Oklahoma Museum of Art, Norman)

1981 American Federation of the Arts, Washington, D.C., "The Art Fabric: Mainstream" (exh. cat.) (traveled in the United States and Canada to Brooks Memorial Art Gallery, Memphis, Tennessee; Minnesota Museum of Art at Landmark Center, St. Paul; and San Francisco Museum of Modern Art, 1981; Museum of Fine Arts, Springfield, Massachusetts; Philbrook Art Center, Tulsa, Oklahoma; and Portland Art Museum, Oregon, 1982; and Akron Art Institute, Ohio; Colorado Springs Fine Arts Center; Glenbow-Alberta Institute, Calgary, Alberta, Canada; and Memorial Art Gallery of the University of Rochester, New York, 1983)

Malmö Konsthall, Sweden, "Malmoe" (exh. cat.)

Muzeum Narodowe, Gdańsk, Poland, "Czas Widzenia"

1982 Nationalgalerie, West Berlin, "Kunst wird Material" (exh. cat.)

Awards

1956 First Prize at the "Spółdzielnia Artystów Plastyków, 'ŁAD,'" ŁAD, Warsaw

Prize at the "XXX-lecie Spółdzielnia Artystów Plastyków 'ŁAD,'" Zacheta, Warsaw

1965 Nagroda Ministra Kultury 1-go Stopnia (First Prize of the Minister of Culture), Poland

Gold Medal at the "VIII Bienal de São-Paolo," Brazil

1966 Złoty Medal Związku Polskich Artystów Plastyków (Gold Medal of the Polish Artists' Union) at the first "Festiwal Sztuk Plastycznych," Warsaw

1969 Srebrny Krzyz Zasługi (Silver Cross of Merit), Poland

1970 Nagroda Ministra Spraw Zagranicznych (Prize of the Minister of Foreign Affairs), Poland

1972 Nagroda Państwowa 2-go Stopnia (Second Prize of the State), Poland

1974 Złoty Krzyż Zasługi (Gold Cross of Merit), Poland

Degree of Doctor honoris causa, Royal College of Art, London

1978 Nagroda Ministra Oswiaty (Prize of the Minister of Education), Poland

1979 Gottfried von Herder Prize, Vienna, Austria

1980 Krzyż Kawalerski Orderu Odrodzenia Polski, "Polonia Restituta" (Cross of the Cavalier Order of the Renaissance of Poland)

Public Collections

The Art Institute of Chicago

Australian National Gallery of Art, Canberra

Centre Georges Pompidou, Musée National d'Art Moderne, Paris

City of Elbląg, Poland

The David and Alfred Smart Gallery, University of Chicago

The Detroit Institute of Arts

Frans Halsmuseum, Haarlem, the Netherlands

Kulturhistoriska Museet, Lund, Sweden

Kunstindustrimuseet, Oslo

Kyoto National Museum of Modern Art

Malmö Museum, Sweden

Musée des Beaux-Arts, La Chaux-de-Fonds, Switzerland

Museo Español de Arte Contemporáneo, Madrid

Museu de Arte Moderna, São Paulo, Brazil

Museum Bellerive, Zurich

Museum of Contemporary Crafts, New York

The Museum of Modern Art, New York

Museum am Ostwall, Dortmund, West Germany

Muzeum w Gnieznie, Gniezno, Poland

Muzeum Historii Włókiennictwa, Łódź, Poland

Muzeum Narodowe, Poznan, Poland

Muzeum Narodowe w Warszawie, Warsaw

Muzeum Pomorza Środkowego, Słupsk, Poland

Muzeum Sztuki w Łodzi, Łódź, Poland

Národni Galerie v Praze, Prague

Nationalmuseum, Stockholm

Palais des Congrès, Biel, Switzerland

Power Institute of Fine Arts, University of Sydney, Australia

Provinciehuis, s'Hertogenbosch, the Netherlands

Röhsska Konstslöjdmuseet, Göteborg, Sweden

Södertälje Kommun Kulturnämnden, Sweden

Sonja Henies og Niels Onstadts Stiftelser, Kunstsenter, Høvikodden, Norway

Städtische Kunsthalle Mannheim, West Germany

Stedelijk Museum, Amsterdam

University of Oslo

Bibliography

Editor's note: The bibliography is arranged chronologically with exhibition catalogues listed alphabetically at the end of each year. In order to make the bibliography as complete as possible, some references (especially from Poland) have been included which it has not been possible to confirm.

1956 A., K. "Pokłosie Ładowskiego Konkursu." *Stolica* (Warsaw), May 6, 1956, p. 4.

Dzikowski, Ryszard. "Konkurs 'Ładu.'" *Przemysł Ludowy i Artystyczny* 3 (Warsaw) (September 1956), pp. 64–68.

Warsaw. Zachęta. *XXX-lecie Spółdzielnia Artystów Plastyków "ŁAD."* Warsaw: 1956 (exh. cat.).

Warsaw. Zachęta. *Ogólnopolska Wystawa Architektury Wnętrz.* Warsaw: 1956 (exh. cat.).

1957 Warsaw. Biuro Wystaw Artystycznych. *Ogólnopolska Wystawa Architektury Wnętrz.* Warsaw: 1957 (exh. cat.).

Warsaw. Związek Polskich Artystów Plastyków. *Wystawa Zespołu Młodych Plastyków.* Warsaw: 1957 (exh. cat.).

1958 Cracow, Poland. *Ogólnopolska Wystawa Architektury Wnętrz i Sztuki Dekoracyjnej.* Cracow: 1958 (exh. cat.).

Radom, Poland. Biuro Wystaw Artystycznych. *Ogólnopolski Salon Zimowy.* Radom: 1958 (exh. cat.).

1959 Wróblewska, Danuta. "Tkaniny Malowane Magdaleny Abakanowicz-Kosmowskiej." *Przegląd Kulturalny* (Warsaw), April 16, 1959, p. 8.

Radom, Poland. Biuro Wystaw Artystycznych. *Ogólnopolski Salon Zimowy.* Radom: 1959 (exh. cat.).

Sopot, Poland. Biuro Wystaw Artystycznych. *Wystawa Młodej Plastyki.* Sopot: 1959 (exh. cat.).

1960 M., J. "Tkanina i Ciekawe Malarstwo." *Kurier Polski* (Warsaw), April 16, 1960.

Guze, Joanna. "Tkaniny i Ceramika." *Nowa Kultura* 17, 526 (Warsaw), April 24, 1960, p. 10.

Sempoliński, Jacek. "Wystawy i Problemy." *Przegląd Kulturalny* (Warsaw), April 28, 1960, p. 8.

Grabska, Stanisława. "W Poszukiwaniu Rzeczy Pięknych." *Więź* 5, 25 (Warsaw), May 1960, p. 96.

Lillejko, Nina. "Nowoczesne Tkaniny." *Zwierciadło* 5 (Warsaw) (May 1960).

Radom, Poland. Biuro Wystaw Artystycznych. *Ogólnopolski Salon Zimowy.* Radom: 1960 (exh. cat.).

Sopot, Poland. Biuro Wystaw Artystycznych. *Festiwal Sztuk Plastycznych.* Sopot: 1960 (exh. cat.).

Sopot and Gdańsk, Poland. Biuro Wystaw Artystycznych. *Tkaniny Milenijne.* Sopot and Gdańsk: 1960 (exh. cat.).

Warsaw. Kordegarda, Ministerstwo Kultury i Sztuki. *Wystawa Prac Magdaleny Abakanowicz-Kosmowskiej.* Warsaw: Związek Polskich Artystów, Plastyków, Centralne Biuro Wystaw Artystycznych, 1960 (exh. cat.).

Warsaw. Muzeum Narodowe w Warszawie. *Wystawa Malarstwa z Cyklu Polskie Dzieło Plastyczne w XV-lecie PRL.* Warsaw: 1960 (exh. cat.).

1961 Radom, Poland. Biuro Wystaw Artystycznych. *Ogólnopolski Salon Zimowy.* Radom: 1961 (exh. cat.).

Sopot, Poland. Biuro Wystaw Artystycznych. *Festiwal Sztuk Plastycznych.* Sopot: 1961 (exh. cat.).

Warsaw. Galeria Sztuki, Związek Polskich Artystów Plastyków. *Wystawa Doświadczalnej Pracowni Tkactwa.* Warsaw: 1961 (exh. cat.).

1962 Kuenzi, André. "Première Biennale de la Tapisserie à Lausanne, un sommet la Pologne." *Gazette de Lausanne,* June 16–17, 1962, p. 9.

"Trois Minutes avec trois polonaises." *Feuille d'Avis de Lausanne,* July 21–22, 1962, p. 25.

St. Pasierb, Ks. Janusz. "I Międzynarodowe Biennale Tkaniny Artystycznej." *Tygodniak Powszechny* (Warsaw), September 9, 1962.

Chevalier, Denys. "La Première Biennale de la tappisserie contemporaine." *Aujourd'hui / Art et Architecture* 38 (Paris) (September 1962), p. 64.

Grand, Paul-Marie. "Abakanowicz." *Le Monde,* November 29, 1962, p. 13.

U., R. M. "Magdalena Abakanowicz—Recherches de relief." *Arts* 892, 11 (Paris), November 30, 1962, p. 13.

Bøe, Alf. "Var Tids Billedtepper." *Bonytt* 11–12 (Oslo) (November-December 1962), pp. 267–270.

Lausanne, Switzerland. Musée Cantonal des Beaux-Arts. *1st International Biennial of Tapestry.* Lausanne: 1962 (exh. cat.).

Paris. Galerie Dautzenberg. *Tapisseries, Magdalena Abakanowicz, Pologne.* Text by Michel Tourlière. Paris: 1962 (exh. cat.).

Radom, Poland. Biuro Wystaw Artystycznych. *Ogólnopolski Salon Zimowy.* Radom: 1962 (exh. cat.).

Sopot, Poland. Biuro Wystaw Artystycznych. *Festiwal Sztuk Plastycznych.* Sopot: 1962 (exh. cat.).

Warsaw. Galeria Sztuki, Związek Polskich Artystów Plastyków. *Wystawa Tkanin Artystycznych i Rzeźb w Ceramice—Doświadczalna Pracownia Tkactwa.* Warsaw: 1962 (exh. cat.).

1963 Masteau, Pierre. "Recherches de Magdalena Abakanowicz." *Revue de l' Ameublement* 1 (January 1963).

Kuenzi, André. "La Tapisserie de demain est née en Pologne." *Gazette de Lausanne,* April 20–21, 1963, p. 19.

Huml, Irena. "Tkanina Monumentalna Magdaleny Abakanowicz." *Projekt* 4, 37 (Warsaw) (July–August 1963), pp. 16–21.

Garztecka, Ewa. "Wystawy." *Trybuna Ludu* (Warsaw), December 14, 1963.

Guze, Joanna. "Kilka Wystaw." *Świat* (Warsaw), December 15, 1963, pp. 10–11.

Witz, Ignacy. "Tkaniny-Tkaniny." *Życie Warszawy,* December 19, 1963.

Witz, Ignacy. "Doświadczalna Pracownia Tkacka." *Życie Warszawy* (1963).

Warsaw. Galeria Sztuki Nowoczesnej. *Magdalena Abakanowicz, Gobelin.* Text by Wiesław Borowski. Warsaw: 1963 (exh. cat.).

Warsaw. Muzeum Narodowe w Warszawie. *Wystawa Grupowa Gobelinów.* Warsaw: 1963 (exh. cat.).

Warsaw. Sala Wystawowa, Związek Polskich Artystów Plastyków. *Wystawa Doświadczalnej Pracowni Tkanin.* Warsaw: 1963 (exh. cat.).

Warsaw. *Wystawa Rzeźb i Tkanin Okręgu Warszawskiego Z.P.A.P.* Warsaw: 1963 (exh. cat.).

1964 Krieger, Margarethe. "Moderne Polnische Wandteppiche." *Mannheim Morgen,* January 27, 1964.

Dannecker, Hermann. "Moderne Polnische Bildteppiche." *Darmstädter Echo,* January 29, 1964.

Stein, Walter. "Moderne Polnische Tapisserie." *Südkurier-Konstanz,* February 6, 1964.

Żmudska, Elżbieta. "Magdalena Abakanowicz." *Zwierciadło* (Warsaw), February 9, 1964, pp. 7–8.

Ruether, Hanno. "Webkunst aus Warschau." *Frankfurter Rundschau,* February 18, 1964.

Baukloh, Friedhelm. "Wandteppiche für Morgen." *Echo der Zeit* (Dortmund), April 19, 1964.

Hofmann, Will. "Moderne Polnische Tapisserie." *Norddeutsche Nachrichten,* May 22, 1964.

Flemming, Hans Theodor. "Polnische Webkunst Wandteppiche im Kunsthaus Hamburg." *Die Welt* (Bonn), May 24, 1964.

Frenzel, Otto. "Moderne Polnische Tapisserie." *Hamburger Abendblatt,* May 27, 1964.

Kesselbach, F. "Polnische Webkunst." *Stuttgarter Zeitung,* June 17, 1964, p. 19.

"Wir trafen in der Stadt." *Stuttgarter Nachrichten,* July 18, 1964.

Diemer, Karl. "Farbwunder auf Bildteppichen." *Stuttgarter Nachrichten,* July 20, 1964.

Dortmund, West Germany. Museum am Ostwall. *Moderne Polnische Tapisserie.* Text by Ryszard Stanisławski. Dortmund: 1964 (exh. cat.).

Warsaw. Galeria Sztuki, Związek Polskich Artystów Plastyków. *Wystawa Tkanin Pracowni Doświadczalnej.* Warsaw: 1964 (exh. cat.).

Warsaw. Zachęta, Centralne Biuro Wystaw Artystycznych. *Ogólnopolska Wystawa: Tkanina, Ceramika, Szkło.* Warsaw: 1964 (exh. cat.).

Wrocław, Poland. Biuro Wystaw Artystycznych. *Wystawa Gobelinów.* Wrocław: 1964 (exh. cat.).

1965 Garztecka, Ewa. "Gobeliny Obrazy." *Trybuna Ludu* (Warsaw), March 29, 1965.

Rusocka, Janina. "Abakany." *Wiedza i Życie* 8 (Warsaw) (March 1965), pp. 354–355.

Ptaszkowska, Hanna. "Gobeliny Magdaleny Abakanowicz." *Kultura* (Warsaw), April 11, 1965, p. 9.

Huml, Irena. "Zagadnienia Współczesnej Tkaniny Monumentalnej." *Problemy* 4, 241 (Warsaw) (April 1966), pp. 237–247.

Czerwiński, Aleksy. "Gobeliny Obrazy." *Stolica* 16 (Warsaw) (May 1965), p. 13.

Kuenzi, André. "2e Biennale Internationale de la Tapisserie." *Gazette de Lausanne*, June 19–20, 1965.

Bøe, Alf. "Glimt fra Billeduen—Biennalen i Lausanne." *Dagbladet* (Oslo), July 6, 1965, p. 5.

"Outweaving the French." *Newsweek* 66, 8, August 23, 1965, p. 78.

Jezewska, Zofia. "Polskie Gobeliny Współczesne na II Międzynarodowym Biennale w Lozannie." *Świat* (Warsaw), October 10, 1965, p. 14.

Whittet, G. S. "The Dynamic of Brazil: The VIII Bienal of São Paulo." *Studio International* 170, 870 (October 1965), pp. 136–143.

Jobé, Joseph, ed. *Great Tapestries: The Web of History from the 12th to the 20th Century.* Texts by Michel Florisonne, Adolf Hoffmeister, François Tabard, and Pierre Verlat. Lausanne: Edita S.A. Lausanne, 1965.

Eindhoven, the Netherlands. Stedelijk van Abbemuseum. *Poolse Wandtapijten.* Eindhoven: 1965 (exh. cat.).

Lausanne, Switzerland. Musée Cantonal des Beaux-Arts. *2nd International Biennial of Tapestry.* Lausanne: 1965 (exh. cat.).

Oslo. Kunstindustrimuseet. *Moderne Polsk Billedev.* Oslo: 1965 (exh. cat.).

São Paulo, Brazil. Fundação Bienal de São-Paolo. *VIII Bienal de São-Paolo.* Text for Poland by Ryszard Stanisławski. São Paulo: 1965 (exh. cat.).

São Paulo, Brazil. Fundação Bienal de São-Paolo. *Pologne à la VIII Biennale de São-Paolo. 1965.* Texts by Wiesław Borowski and Ryszard Stanisławski. Warsaw: Ministry of Culture and Art of the People's Republic of Poland, Central Office of Art Exhibitions, 1965 (exh. cat.).

Szczecin, Poland. Biuro Wystaw Artystycznych. *Grupowa Wystawa Tkanin.* Szczecin: 1965 (exh. cat.).

Warsaw. Centralne Biuro Wystaw Artystycznych. *Ogólnopolska Wystawa: Tkanina, Ceramika, Szkło.* Warsaw: 1965 (exh. cat.).

Warsaw. Sala Wystawowa, Związek Polskich Artystów Plastyków. *Wystawa Doświadczalnej Pracowni Tkanin Okręgu Warszawskiego.* Warsaw: 1965 (exh. cat.).

Warsaw. Zachęta. Centralne Biuro Wystaw Artystycznych. *Wystawa Gobelinów Magdaleny Abakanowicz.* Text by Wiesław Borowski. Warsaw: Ministry of Culture and Art of The People's Republic of Poland, 1965 (exh. cat.).

Zakopane, Poland. Sala Wystawowa. *Magdalena Abakanowicz, Tkanina; Stanisław Sikora, Rzeźba; Tadeusz Szymański, Szkło Artystyczne.* Zakopane: Związek Polskich Artystów Plastyków, Biuro Wystaw Artystycznych w Krakowie Delegatura w Zakopanem, 1965 (exh. cat.).

1966 Twarowska, Maria. "Sous les Voies de l'art moderne: Abakanowicz, Sadley, Gostomski." *Projekt* 1, 51 (Warsaw) (January 1966), pp. 29–32.

Thévoz, Michel. "La IIe Biennale de la Tapisserie à Lausanne." *XXe Siècle* 26 (May 1966), supplement.

Groom, Susan. "Modern Polish Tapestries." *Arts Review* 18, 17 (London), September 3, 1966, p. 402.

Williams, Sheldon. "Polish Tapestries." *New York Herald Tribune*, September 6, 1966, p. 5.

Wilusz, Stefan. "Tkanina Jutra." *I.T.D.* (Warsaw), September 16, 1966, pp. 12–13.

Russell, John. "Playing a Defensive Game." *The Sunday Times* (London), September 18, 1966.

Overy, Paul. "The Art of Detachment." *The Listener* (London), September 29, 1966.

Collison, Judith. "From Polish Looms of Today." *Fotorama* 69 (September 1966), p. 8.

Mullaly, Terence. "Tapestries of Today." *The Daily Telegraph* (London), October 1, 1966, p. 13.

Spencer, Charles S. "Polish Tapestries." *The New York Times International*, October 4, 1966, p. 5.

Antibes, France. *Festival International d'Art.* Antibes: 1966 (exh. cat.).

Łódź, Poland. Muzeum Sztuki. *Wystawa Malarstwa z Cyklu Polskie Dzieło Plastyczne w XXV-lecie PRL.* Łódź: 1966 (exh. cat.).

London. Grabowski Gallery. *Tapestries of Tomorrow from Polish Looms of Today.* Text by Judith Collison. London: 1966 (exh. cat.).

Santa Barbara, California. Santa Barbara Museum of Art. *Contemporary European Tapestries: The Collection of Mr. and Mrs. J. L. Hurschler.* Texts by

J. L. and Flora Hurschler and Thomas W. Leavitt. Santa Barbara: 1966 (exh. cat.).

Sopot, Poland. Biuro Wystaw Artystycznych. *Festiwal Sztuk Plastycznych: Nurty Poszukiwania Propozycje.* Sopot: 1966 (exh. cat.).

Warsaw. Związek Polskich Artystów Plastyków. *Festiwal Sztuk Plastycznych.* Warsaw: 1966 (exh. cat.).

Warsaw. Związek Polskich Artystów Plastyków. *Wystawy Doświadczalnej Pracowni Tkactwa.* Warsaw: 1966 (exh. cat.)

Zielona Góra, Poland. Biuro Wystaw Artystycznych, Związek Polskich Artystów Plastyków. *Wystawa Gobelinów Magdalena Abakanowicz.* Text by Wiesław Rustecki. Zielona Góra: 1966 (exh. cat.).

1967 G., S. "Sculpture in Tapestry." *Sculpture International* 1, 4 (London) (January-March 1967), pp. 13–17.

Nilsson, Carin. "Polsk Textilkonstnärinna Brottas Med Materialet." *Sydsvenska Dagbladet Snällposten* (Malmö), February 14, 1967.

Stopczyk, Stanisław K. "Abakanowicz i Inni." *Kultura* 202 (Warsaw), April 23, 1967, p. 9.

Stensman, Mailis. "Polska Gobelanger." *Form* 4, 494 (Stockholm) (April 1967), pp. 260–264.

Kohler, Arnold. "La Tapisserie révolutionnaire." *Coopération* 26 (Geneva), July 1, 1967, p. 27.

Monnier, Jacques. "Les Tapisseries d'Abakanowicz." *Tribune de Lausanne*, August 10, 1967, p. 4.

Vaughan, Nicole. "Abakanowicz Seeks Tapestry in 3 Dimension." *Weekly Tribune* (Geneva), August 13, 1967, p. 13.

Kuenzi, André. "Magdalena Abakanowicz." *La Gazette Littéraire* (Lausanne), August 15–16, 1967, p. 25.

"Dramatiske Billedtepper Fra Polen." *Dagbladet* (Oslo), September 6–7, 1967.

C., W. "Eganartet Tekstilutstilling." *Nationen* (Oslo), September 9, 1967, p. 5.

Joansrud, Even Hobbe. "Kunst Og Kunstnere." *Aftenposten* (Oslo), September 16, 1967.

Schjodt, Liv. "Polsk Bildekunst i Vev." *Arbeiderbladet* (Oslo), September 16, 1967.

Øydvin, S. "Rask Runder i Oslos Kunstgallerier." *Gonsbergs Blad* (Norway), September 20, 1967, p. 12.

Bøe, Alf. "Magdalena Abakanowicz i Kunstindustrimuseet." *Dagbladet* (Oslo), September 23, 1967, p. 6.

"Magdalena Abakanowicz, tapisseries-assemblages à Lausanne." *Werk* 54, 10 (Winterthur) (October 1967), p. 675.

Remfeldt, Per. "Polsk Tappe Kunstner i Kunstforening." *Stavanger Aftenblad* (Norway), November 13, 1967.

Riis, Harald. "Polske Billedtepper i Kraft og Skjonnhet." *Rogalands Avis* (Stavanger, Norway), November 18, 1967.

"Dialog Med en Vevstol." *Rogalands Avis* (Stavanger, Norway), November 25, 1967.

Dehlholm, Kirsten. "Taeppebiennalen i Lausanne 1967 / The Carpet Biennale in Lausanne 1967." *Dansk Kunsthaandvaerk* 5–6, 39 (Copenhagen) (1966–67), pp. 157–166.

Elbląg, Poland. *II-e Biennale Form Przestrzennych.* Elbląg: 1967 (exh. cat. includes first and second biennials).

La Chaux-de-Fonds, Switzerland. Musée des Beaux-Arts. *Art Polonais.* La Chaux-de-Fonds: 1967 (exh. cat.).

Lausanne, Switzerland. Galerie Alice Pauli. *Abakanowicz.* Text by André Kuenzi. Lausanne: 1967 (exh. cat.).

Lausanne, Switzerland. Musée Cantonal des Beaux-Arts. *3rd International Biennial of Tapestry.* Lausanne: 1967 (exh. cat.).

Lund, Sweden. Lunds Konsthall. *Moderna Gobelanger och Aktuell Grafik Från Polen.* Lund: 1967 (exh. cat.).

Oslo. Kunstindustrimuseet. *Magdalena Abakanowicz, Arbeider i Vev.* Text by Alf Bøe. Oslo: 1967 (exh. cat.).

Warsaw. Galeria Współczesna. *Magdalena Abakanowicz.* Text by Janusz Bogucki. Warsaw: 1967 (exh. cat.).

1968 Huml, Irena. "Magdalena Abakanowicz Arbeider." *Kunsten Idag* 1, 83 (Oslo) (January 1968), pp. 30–41.

Lundahl, Gunilla. "De Polska Textilare." *Form* 4, 504 (Stockholm) (April 1968), pp. 266–267.

Wróblewska, Danuta. "Abakanowicz—Ou La Tapisserie structurale." *Opus International* 6 (Paris) (April 1968), pp. 42–43.

Billeter, Erika. "Am Webstuhl einer neuen Kunstform." *Neue Presse* (Coburg, West Germany), August 10, 1968.

"Abakanowicz Ausstellung in Helmhaus Zürich." *Neue Züricher Zeitung*, August 17, 1968, p. 39.

Bresser, P. "Magdalena Abakanowicz Revolutionaire Weefsels." *Eindhovens Helmonds Dagblad* (the Netherlands), September 28, 1968.

Redeker, Hans. "Abakanowicz." *Algemene Handelsblad* (the Netherlands), October 28, 1968.

—————————————————

Eindhoven, the Netherlands. Stedelijk van Abbemuseum. *Abakanowicz: 2- en 3-dimensionale weefsels*. Text by André Kuenzi. Eindhoven: 1968 (exh. cat.).

Venice. *Catalogo della XXXIV Esposizione Biennale Internazionale d'Arte Venezia*. Venice: 1968 (exh. cat.).

Warsaw. Zachęta and Zwiazek Polskich Artystów Plastyków. *Festiwal Sztuk Plastycznych*. Warsaw: 1968 (exh. cat.).

Zurich. Züricher Kunstgesellschaft, Helmhaus. *Abakanowicz, Eine Polnische Textilkünstlerin*. Texts by F. A. Baumann and Erika Billeter. Zurich: 1968 (exh. cat.).

1969 Billeter, Erika. "Die Revolution des Kunstgewerbes." *Ex Libris* (Zurich), January 1, 1969, pp. 16–18.

Maciejewski, J. K. "Conversations with Artists: Magdalena Abakanowicz." *Chłopska Droga* (Warsaw), January 1, 1969, p. 11.

F., T. "Perspectief in Textiel." *Eindhovens Helmonds Dagblad* (the Netherlands), January 5, 1969.

Billeter, Erika. "Revolution am Webstuhl." *Elle 5* (Paris), March 1, 1969, pp. 124–127.

Bourgeois, Louise. "The Fabric of Construction." *Craft Horizons* 29, 2 (March-April 1969), pp. 30–34.

Larsen, Jack Lenor. "The New Weaving." *Craft Horizons* 29, 2 (March-April 1969), pp. 22–29, 50–51.

Billeter, Erika. "Les Sculptures en matériaux de tissage." *Projekt* 2, 70 (Warsaw) (April 1969), pp. 33–37.

Fehsenbecker, Eva. "Magdalena Abakanowicz: Kunsthalle Mannheim." *Das Kunstwerk* 22, 7-8 (April 1969), p. 85.

Beks, Maarten. "Magdalena Abakanowicz Improviserend Aan't Getovw Weversopstand in de Beldende Kunst." *Limburgs Dagblad* (the Netherlands), June 7, 1969, p. 8.

Lahusen, Thomas. "Les Arts en Europe de l'Est—A Quelques Jours de la Biennale de Lausanne—La Tapisserie polonaise—Une Exploration de l'impossible—Ouvrage d'abeille ou de termite." *Tribune de Lausanne*, June 8, 1969, p. 31.

Kuenzi, André. "Lausanne IVe Biennale de la Tapisserie—Une Précurseur de la nouvelle tapisserie: Magdalena Abakanowicz." *La Gazette Littéraire* (Lausanne), June 14–15, 1969, pp. 5–6.

Grand, Paul-Marie. "A la Biennale de Lausanne—Quand la Tapisserie conteste le mur—La Tapisserie sculpture." *Le Monde*, June 26, 1969, p. 17.

Olkiewicz, Jerzy. "Magdalena Abakanowicz." *Kultura* (Warsaw), July 6, 1969.

Jarry, Madeleine. *World Tapestry*. New York: G. P. Putnam's Sons, 1969.

Łódź, Poland. Wytwórnia Filmów Oświatowych. "Abakany." Directed by Jarosław Brzozowski. Łódź: 1969.

—————————————————

Amsterdam. Stedelijk Museum. *Perspectief in Textiel*. Amsterdam: 1969 (exh. cat.).

Lausanne, Switzerland. Galerie Alice Pauli. *Abakanowicz, Jagoda Buic*. Texts by Magdalena Abakanowicz and Jagoda Buic. Lausanne: 1969 (exh. cat.).

Lausanne, Switzerland. Musée Cantonal des Beaux-Arts. *4th International Biennial of Tapestry*. Lausanne: 1969 (exh. cat.).

Madrid. Museo Español de Arte Contemporáneo. *Experiencias Artísticas Textiles*. Madrid: 1969 (exh. cat.).

Mannheim, West Germany. Kunsthalle Mannheim. *Magdalena Abakanowicz: Tapisserien und Räumliche Texturen*. Text by Heinz Fuchs. Mannheim: 1969 (exh. cat.).

New York. The Museum of Modern Art. *Wall Hangings*. Texts by Mildred Constantine and Jack Lenor Larsen. New York: 1969 (exh. cat.).

1970 Sydhoff, Beate. "Abakanowicz." *Form 3* (Stockholm) (March 1970), p. 140.

Kelk, Frank. "Een Weefster in Rol Van Acrobate." *Kunst* (Amsterdam), August 5, 1970, p. 11.

Wróblewska, Danuta. "Magdalena Abakanowicz: She Confronts the Viewer with Textile as Object and Environment." *Craft Horizons* 30, 5 (October 1970), pp. 18–23.

Johansson, Stig. "Skona Textila Attentat." *Svenska Dagbladet* (Stockholm), November 5, 1970.

—————————————————

Essen, West Germany. Museum Folkwang. *Moderne Polnische Teppiche.* Texts by Dieter Honisch and Hanna Kotkowska-Bareja. Essen: 1970 (exh. cat.).

Södertälje, Sweden. Södertälje Konsthall. *Magdalena Abakanowicz/Textil Skulptur/Textile Environment.* Texts by Magdalena Abakanowicz, Erika Billeter, Eje Högestätt, and Jack Lenor Larsen. Södertälje: 1970 (exh. cat.).

Stockholm. Nationalmuseum. *Abakanowicz: en konfrontation.* Texts by Magdalena Abakanowicz and Bengt Dahlbäck. Stockholm: 1970 (exh. cat.).

1971 "Magdalena Abakanowicz at the Kunsthalle in Södertälje." *Polish Art Review* 1 (Warsaw) (January 1971), pp. 24–27.

Ochnio, Włodzimierz. "Abakany Pani Magdaleny." *Kobieta i Życie* (Warsaw), April 25, 1971, p. 5.

Kuenzi, André. "5e Biennale de la Tapisserie—Magdalena Abakanowicz nous dit." *La Gazette Littéraire* (Lausanne), June 19–20, 1971.

Pierre, Marcel. "Magdalena Abakanowicz et Jolanta Owidzka—La Tapisserie polonaise à travers les artistes." *Feuille d'Avis de Lausanne*, July 8, 1971.

"Abakanowicz Bijna Klaar Met Grootste Wandtapijt Ter Wereld." *Provincie Noord Brabant* (the Netherlands), August 18, 1971, p. 136.

Kuenzi, André. "Oeuvres murales et spatiales récentes de Magdalena Abakanowicz." *Gazette de Lausanne*, September 26, 1971.

Daval, Jean-Luc. "La 5-ème Biennale de la Tapisserie." *Art International* 15, 8, October 20, 1971, pp. 41–47.

Larsen, Jack Lenor. "Two Views of the Fifth Tapestry Biennale, 'the Greatest Show on Earth.'" *Craft Horizons* 31, 5 (October 1971), pp. 23–30.

Tygodniak Polski (Warsaw), November 14, 1971.

Białystok, Poland. *III-i Festiwal Muzyki i Poezji: Wystawa Współczesnej Tkaniny Polskiej.* Białystok, 1971 (exh. cat.).

Cracow, Poland. Galeria Pryzmat, Związek Polskich Artystów Plastyków. *Magdalena Abakanowicz.* Cracow: 1971 (exh. cat.).

Göteborg, Sweden. Röhsska Konstslöjdmuseet. *Moderna Polska Textilier.* Texts by Göran Axel-Nilsson and Jan Brunius. Göteborg: 1971 (exh. cat.).

Lausanne, Switzerland. Galerie Alice Pauli. *Magdalena Abakanowicz.* Text by A[ndré] K[uenzi]. Lausanne: 1971 (exh. cat.).

Lausanne, Switzerland. Musée Cantonal des Beaux-Arts. *5th International Biennial of Tapestry.* Lausanne: 1971 (exh. cat.).

Los Angeles. Frederick S. Wight Art Gallery of the University of California. *Deliberate Entanglements.* Texts by Bernard Kester and Frederick S. Wight. Los Angeles: University of California Press, 1971 (exh. cat.).

Pasadena, California. Pasadena Art Museum. *The Fabric Forms of Magdalena Abakanowicz.* Texts by Magdalena Abakanowicz and Eudorah M. Moore. Pasadena: 1971 (exh. cat.).

Warsaw. Galeria Współczesna. *Magdalena Abakanowicz.* Texts by Erika Billeter, Paul-Marie Grand, and Jack Lenor Larsen. Warsaw: 1971 (exh. cat.).

Zielona Góra, Poland. Biuro Wystaw Artystycznych. *V Wystawa Plastyki Złotego Grona.* Zielona Góra: 1971 (exh. cat.).

1972 "Värlsberömd Polska Gör Textil Skulptur." *Lanstidningen* (Södertälje), January 20, 1972.

Leland, Mary Jane. "Entanglements." *Craft Horizons* 32, 1 (February 1972), pp. 14–21, 54–57.

Wall, Åsa. "Huddingepatient får Välja Bland Konstverk." *Svenska Dagbladet* (Stockholm) March 1, 1972, p. 8.

Romdahl, Margareta. "Drömskog i Sjukhusmiljö." *Svenska Dagbladet* (Stockholm) March 2, 1972.

Kaltwaser, Gerda. "Fabelwesen aus sisal und kokos—Magdalena Abakanowicz im Kunstverein." *Rheinische Post* (Düsseldorf), March 25, 1972.

Friedrichs, Yvonne. "Dunkle Innenwelt mit Wuchernden Säulen—Das Textil-Environment von Magdalena Abakanowicz in Düsseldorf." *Rheinische Post* (Düsseldorf), April 8, 1972.

"Anxiety and Exaggeration." *Poland* 5, 213 (May 1972), pp. 12–13.

Billeter, Erika. "Magdalena Abakanowicz—Besuch im Warschauer Atelier." *Artis—Das Aktuelle Kunstmagazine* 6 (Constance), June 6, 1972, pp. 25–29.

Oseka, Andrzej. "Abakany." *Tygodniak Kulturalny* (Warsaw), July 23, 1972.

Henkel, Barbara. "Kariera Abakanow Czyli Tkanina Wyzwolona." *Sztandar Młodych* (Warsaw), August 13, 1972, pp. 4–5.

Oliver, Cornelia. "Edinburgh Festival." *The Guardian* (Manchester), August 21, 1972, p. 8.

Wróblewska, Danuta. "Dans le Cadre hollandais." *Projekt* 4, 89 (Warsaw) (August 1972), pp. 56–59.

Garztecka, Ewa. "Nasze Sylwetki: Magdalena Abakanowicz." *Trybuna Ludu* (Warsaw), September 12, 1972.

Allen, Jane. "Soft Sculpture: Unraveling the Weavers." *Chicago Tribune*, October 25, 1972.

Oliver, Cornelia. "Woven Structures at Aberdeen." *The Guardian* (Manchester), November 21, 1972.

Lillejko, Nina. "Magdalena Abakanowicz." *Zwierciadło* (Warsaw), December 21, 1972, pp. 8–9.

Aliz, Torday. "Abakanowicz Terei." *Magyar Épitömüvészet* 3 (Budapest) (1972), pp. 58–59.

Constantine, Mildred, and Larsen, Jack Lenor. *Beyond Craft: The Art Fabric.* New York: Van Nostrand Reinhold Company, 1972.

Edinburgh. "Interwencja." Directed and produced by Magdalena Abakanowicz. Edinburgh: 1972.

———————————

Denver, Colorado. Denver Art Museum. *Fibre Structures.* Text by Imelda DeGraw. Denver: 1972 (exh. cat.).

Düsseldorf, West Germany. Kunstverein für die Rheinlande und Westfalen. *Magdalena Abakanowicz: Textile Strukturen und Konstruktionen, Environments.* Texts by Magdalena Abakanowicz, Karl-Heinz Hering, and Jasia Reichardt. Düsseldorf: 1972 (exh. cat.).

Edinburgh. Richard Demarco Gallery. *Edinburgh International Festival*: "Atelier '72." Edinburgh: (exh. cat.)

Łódź, Poland. Centralne Muzeum Włókiennictwa. *Ogólnopolskie Triennale Tkaniny Przemysłowej i Unikatowej.* Łódź: 1972 (exh. cat.).

Paris. Manufacture Nationale des Gobelins. *L'Art du tissu en Pologne 1962–1972.* Paris: 1972 (exh. cat.).

Warsaw. Związek Polskich Artystów Plastyków. *IV-y Festiwal Sztuk Pięknych.* Warsaw: 1972 (exh. cat.).

West Berlin. Haus am Waldsee. *Fetisch Jugend—Tabu Tod.* Texts by G. Ammon, Christian von Ferber, Thomas Kempas, Hans Georg Mierzwiak, and Rolf Wedewer. West Berlin: 1972 (exh. cat.).

1973 Restany, Pierre. "Da Varsovie, Zilina e Prague con Amore." *Domus* 518 (January 1973), pp. 49–57.

"Ropes at the Arnolfini." *Crafts* (London) (May–June 1973).

Daval, Jean-Luc. "Sixième Biennale de la Tapisserie: Entre l'Art et l'objet." *Journal de Genève*, June 23–24, 1973, p. 21.

Kuenzi, André. "Lausanne, Tapisseries en relief et environnement de Magdalena Abakanowicz et Jagoda Buic." *24 Heures* (Lausanne), June 28, 1973, p. 53.

Redeker, H. "Abakanowicz de Ariadne van Lausanne." *N.R.C. Handelsblad* (Rotterdam), July 13, 1973, supplement.

Daval, Jean-Luc. "De la Tapisserie au 'Textile-Relief.'" *Art International* 17, 6 (Lugano, Switzerland) (Summer 1973), pp. 20–21, 96–97.

Sydhoff, Beate. "Svezia: Gli Artisti a Risanare l'Ospedale." *Domus* 526 (September 1973), pp. 21–24.

K., M. "Uciec Wyobraźnią w Przyszłość." *Życie Warszawy*, October 28–29, 1973, pp. 1–2.

Anderson, Donald James. "Soft Walls." *Chicago Tribune,* November 26, 1973.

Artner, Alan G. "Some New Branches on Tapestry's Tree of Tradition." *Chicago Tribune*, December 16, 1973.

Kuenzi, André. *La Nouvelle Tapisserie.* Geneva: Les Editions de Bonvent, 1973.

———————————

Bordeaux, France. Galerie des Beaux-Arts. *Octobre à Bordeaux: 8 Artistes dans la ville.* Text by François Vehrlin. Bordeaux: 1973 (exh. cat.).

Hempstead, New York. Emily Lowe Gallery, Hofstra University. *Fibre Work—17.* Text by John Bernard Myers. Hempstead, New York: 1973 (exh. cat.).

Lausanne, Switzerland. Galerie Alice Pauli. *Magdalena Abakanowicz, Jagoda Buic: textilreliefs.* Texts by Magdalena Abakanowicz, Jagoda Buic, and Jean-Luc Daval. Lausanne: 1973 (exh. cat.).

Lausanne, Switzerland. Musée Cantonal des Beaux-Arts. *6th International Biennial of Tapestry.* Lausanne: 1973 (exh. cat.).

San Diego, California. Fine Arts Gallery of San Diego. *Contemporary Tapestries from the Hurschler Collection.* Text by Henry G. Gardiner. San Diego: 1973 (exh. cat.).

Warsaw. Biuro Wystaw Artystycznych. *Warszawa w Sztuce.* Warsaw: 1973 (exh. cat.).

1974 Abakanowicz, Magdalena, and Bumpus, Judith. "Rope Environments." *Art and Artists* 103, 9, 7 (London) (October 1974), pp. 36–41.

Artner, Alan G. "Poles Weave Motifs to Fabric Fore-front." *Chicago Tribune,* November 22, 1974.

Miller, Nory. "The Craft of Tapestry Becomes an Art." *Chicago Daily News,* November 23, 1974.

Osęka, Andrzej. "Textiles with a Difference." *Poland* 243, 11 (Warsaw) (December 1974), pp. 38–39.

Pieszak, D. "Reliefs in Fibre—Contemporary Tapestries." *New Art Examiner* 2, 3 (Chicago) (December 1974), p. 7.

Zurich. Kunsthaus Zürich. *Kunst in Polen.* Zurich, Kunsthaus and Łódź, Museum Sztuki: 1974 (exh. cat.).

1975 Sturaas, Reider. "Hun Adnet Venen Og Fant Veien Til Rommet." *Bergens Tidende* (Bergen, Norway), January 2, 1975.

Nastulanka, Krystyna. "O Abakanach—z Magdaleną Abakanowicz (Rozmawia Krystyna Nastulanka)." *Polityka* (Warsaw), January 4, 1975.

Buss, Anna. "O Magdalenie Abakanowicz—Abakany." *I.T.D. Tygodniak Studencki* (Warsaw), April 20, 1975, pp. 16–17.

Mullaly, Terence. "Tapestry behind a Curtain." *The Daily Telegraph* (London), May 31, 1975.

Moraes, Dom. "Tapestries for Our Time." *Horizon* 17, 2 (Spring 1975), pp. 22–31.

Grand, Paul-Marie. "La Tradition du changement. L'Apocalypse d'Abakanowicz et les tissus." *Le Monde,* June 3, 1975.

Vaizey, Marina. "Seductive Features." *The Sunday Times* (London), June 8, 1975, p. 35.

Kuenzi, André. "Nouvelles Tendences de la Tapisserie." *24 Heures* (Lausanne), June 13, 1975.

Gosling, Nigel. "Haunted by Ghosts." *The Observer* (London), June 15, 1975.

Daval, Jean-Luc. "Une Exposition triomphante de cohérence et de beauté." *Journal de Genève,* June 21, 1975, p. 21.

Lerrant, J. "Un Nouvel Art de l'espace et de l'environnement." *Le Progrès Lyon,* June 22, 1975.

Wróblewska, Danuta. "Lozanna, Rozdroże Tkaniny Współczesnej." *Literatura* (Warsaw), June 24, 1975.

Visser, Mathilde. "Biennale van de Tapisserie in Lausanne." *Het Financiele Dagblad* (Rotterdam), June 27, 1975.

Tisdall, Caroline. "Environments." *The Guardian* (Manchester), July 2, 1975.

Weale, Robert. "Art." *New Scientist* (London), July 3, 1975, p. 39.

Overy, Paul. "Very Flat, Sculpture." *The Times* (London), July 4, 1975, p. 12.

Romdahl, Margareta. "Rep Och Lurvigt Pa Sjunde Biennalen." *Dagens Nyheter* (Stockholm), July 7, 1975.

Marchand, Sabine. "Une Nouvelle Conception des arts de la laine." *Le Figaro,* July 8, 1975.

Reichardt, Jasia. "Individuality and Imagination." *Architectural Design* 45, 8 (August 1975), pp. 507–508.

Krzymuska, Joanna. "Magdalena Abakanowicz." *Plastyka w Szkole* 7–8, 141–142 (Warsaw) (September–October 1975), pp. 199–203.

Deroudille, René. "En Parlant avec Magdalena Abakanowicz...." *Dernières Heures Lyonnaises,* October 9, 1975.

Kuenzi, André. "Oeuvres récentes de Magdalena Abakanowicz." *24 Heures* (Lausanne), October 9, 1975.

Dale, Gloria. "London." *Craft Horizons* 35, 5 (October 1975), pp. 40–41.

Daval, Jean-Luc. "A Propos des 'Altérations' de Magdalena Abakanowicz." *Art International* 19, 8 (October 1975), pp. 30–34.

West, Virginia. "The Tapestry Biennial at Lausanne." *Craft Horizons* 35, 5 (October 1975), pp. 16–19.

Morawski, Stefan. "A Gloss on Magdalena Abakanowicz's Work." *Projekt* 4 (Warsaw) (1975).

Daval, Jean-Luc, ed. "Magdalena Abakanowicz" in *Skira Annuel No. 1.* Geneva: Editions Skira, 1975.

Austin, Texas. University Art Museum. *Contemporary Tapestries from the Hurschler Collection.* Texts by Marian B. Davis, Donald B. Goodall, and J. L. and Flora Hurschler. Austin: 1975 (exh. cat.).

Lausanne, Switzerland. Galerie Alice Pauli. *Abakanowicz: Structures organiques et formes humaines.* Texts by Magdalena Abakanowicz and Jean-Luc Daval. Lausanne: 1975 (exh. cat.).

Lausanne, Switzerland. Musée Cantonal des Beaux-Arts. *7th International Biennial of Tapestry.* Lausanne: 1975 (exh. cat.).

London. Whitechapel Art Gallery. *Magdalena Abakanowicz: Organic Structures and Human Forms.* Text by Magdalena Abakanowicz. London: 1975 (exh. cat.).

Mexico City. Museo de Arte Moderno. *Polonia en México, Festival de las Formas/Pintura Contemporánea.* Mexico City: 1975 (exh. cat.).

Ottawa. The National Gallery of Canada. "Tapestries from Poland," *Journal* 7 (October 1975), entire issue. Text by Krystyna Kondratiukowa. Ottawa: 1975 (exh. cat.).

Warsaw. Zachęta, Centralne Biuro Wystaw Artystycznych. *Magdalena Abakanowicz.* Text by Andrzej Osęka. Warsaw: Ministerstwo Kultury i Sztuki, 1975 (exh. cat.).

West Berlin. Kunstgewerbemuseum, Staatliche Museen—Preussischer Kulturbesitz. *Textile Objekte.* Texts by Franz-Adrian Dreier and Barbara Mundt. West Berlin: 1975 (exh. cat.).

1976 Borlase, Nancy. "It's Everybody's Year." *The Sydney Morning Herald,* January 8, 1976.

Wróblewska, Danuta. "Podjąć i Wytrzymać Ryzyko." *Literatura* (Cracow), January 15, 1976, p. 4.

"Magdalena Abakanowicz." *Craft Australia* 6, 1 (Sydney) (February–April 1976), pp. 25–27.

Heise, Marilyn. "Wrap, Tie or Weave—Statements in Fiber." *Chicago Sun-Times,* May 2, 1976.

Artner, Alan G. "Weavings at an Exhibition—the Magic Shines through." *Chicago Tribune,* May 9, 1976.

Makin, Jeff. "Magdalena Abakanowicz." *Quadrant* 6, 107 (Sydney) (May–June 1976), pp. 50–55.

Lynn, Elwyn. "The 1976 Adelaide Festival and Two Spectacular Women." *Art International* 20, 6 (Summer 1976), pp. 21–24, 52–53.

"Australia Exhibits." *Art Gallery of New South Wales* (Sydney) (1976).

Daval, Jean-Luc, ed. "Magdalena Abakanowicz" in *Skira Annuel No. 2.* Geneva: Editions Skira, 1976.

Krausmann, Rudi. "Magdalena Abakanowicz." *Aspect* 2, 1 (Sydney) (1976), pp. 1, 4–9.

Sydney. The Australian Film and Television School. "Abakanowicz." Sydney: 1976.

Sydney. Film Australia. "Abakanowicz in Australia." Sydney: 1976.

Sydney. Film Australia. "Division of Space." Sydney: 1976.

Emery, Irene. *Fiber Structures.* New York: Van Nostrand Reinhold, 1976 (exh. cat.). (Published in conjunction with the Handweaver's Guild of America, Inc. and the Weavers' Guild of Pittsburgh.)

Kyoto National Museum of Modern Art, and Tokyo National Museum of Modern Art. *Fiber Works Europe and Japan.* Kyoto and Tokyo: 1976 (exh. cat.).

Sydney, Art Gallery of New South Wales, and Melbourne, National Gallery of Victoria. *Magdalena Abakanowicz: Organic Structures and Soft Forms.* Text by Jasia Reichardt. Sponsored by the Crafts Board of the Australia Council in cooperation with The Polish People's Republic. Sydney: 1976 (exh. cat.).

Warsaw. Zachęta and Związek Polskich Artystów Plastyków. *Festiwal Sztuk Plastycznych.* Warsaw: 1976 (exh. cat.).

1977 Janstad, Hans. "Sitta Som en Hosäck, Visst är det Konst." *Arbetet Malmö,* February 26, 1977.

Mustelin, Ilse. "Flämt i Konsthallen." *Sydsvenska Dagbladet* (Malmö), February 26, 1977.

N., N. "En Rytm Olik Vardagens—Livets Snabba Reflexer." *Skånska Dagbladet* (Malmö), February 26, 1977.

Romdahl, Margareta. "Fiberkonst Kritik Mot Overbefolkningen. *Dagens Nyheter* (Stockholm), March 1, 1977.

Weimack, Torsten. "Här Växer Huvudena Fram Ur Säck Och Gamla Vanor." *Arbetet Malmö,* March 1, 1977.

Dwinger, Joanna. "Et Budskab Til Verden i Sissal Og Saekkelaerreo." *Politiken Köpenhamn* (Copenhagen), March 3, 1977.

Bråhammar, Gunnar. "Det Vacktraste Som Visats i Konsthallen." *Kvällsposten Malmö,* March 4, 1977.

Eliasson, Karl Erik. "Abakaner Och Mycket Annat." *Hälsingborgs Dagblad* (Helsingborg, Sweden), March 4, 1977.

Berntsson, Åsa. "En Bit Av Världen Räddar Från Förgängelse. *Sydsvenska Dagbladet* (Malmö), March 14, 1977.

H., E. "Konstleks Kurragömma Mellan Ljis Och Hörker." *Sydsvenska Dagbladet* (Malmö), March 20, 1977.

Bauer, Catharina. "Rep Konst." *Svenska Dagbladet* (Stockholm), March 26, 1977.

Kuenzi, André. "Huitième Biennale de la Tapisserie, Petit Coup d'oeil dans les coulisses." *24 Heures* (Lausanne), May 27, 1977.

Hugli, Pierre, "8e Biennale Internationale de la Tapisserie, Le Paysage varié présenté par neuf pays." *Gazette de Lausanne*, June 4–5, 1977.

Grand, Paul-Marie. "La VIIIe Biennale à Lausanne: Le Temps de la décantation." *Le Monde*, June 8, 1977.

Warnod, Jeanine. "Elle fait le mur." *Le Figaro*, June 10, 1977.

Daval, Jean-Luc. "La Biennale de la Tapisserie de Lausanne, pour conserver son rôle international, doit changer." *Gazette de Lausanne*, June 12, 1977.

Lerrant, Jean-Jacques. "La VIIIe Biennale Internationale." *Le Progrès Lyon*, June 12, 1977.

P., J. "Lausanne 1977. . . ." *La Libre Belgique, Gazette de Liège*, June 12, 1977.

Rederlechner, H. P. "Vom Wandteppich zum Textilen Objekt." *Berner Rundschau* (Bern), June 14, 1977.

Colberg, Claus. "Kunst zwischen Einfall und Gestaltung." *Nürnberger Zeitung*, June 15, 1977; *Oesterreich Rundfunk*, July 7, 1977; and *Deutschland Funk*, July 27, 1977.

Colberg, Claus. "Die 8 Internationale Biennale der Tapisserie." *Nürnberger Zeitung*, June 15, 1977.

Haimon, Paul. "Nederland Sterk Vertegenwoordigd Op Biennale." *Limburgs Dagblad* (the Netherlands), June 25, 1977

Redeker, Hans. "Het Wandkleed Los van de Muur." *N.R.C. Handelsblad* (Rotterdam), June 26, 1977.

Vadas, Jozsef. "Textilbörze." *Jrodalom* (Budapest), June 28, 1977.

Conroy, Sarah Booth. "Fiber Structures from Poland's New Wave of Textile Artists." *The Washington Post*, July 3, 1977.

N., N. "Achtste Biennale van Tappisserie in Lausanne." *Het Financieele Dagblad* (Amsterdam), July 8, 1977.

Deroudille, René. "La 8e Biennale de la Tapisserie de Lausanne." *Journal Français*, July 9, 1977.

"Międzynarodowe Biennale Tkanin Dekoracyjnnych." *Życie Warszawy*, July 13, 1977.

Ciachi, Arianna. "Die Blumenwiese ist da." *Frankfurter Algemeine Zeitung*, July 22, 1977.

"VIII Biennale w Lozannie." *Życie Literackie* (Cracow), July 24, 1977.

Wentinck, Charles. "Na de Revolutie Komen de Kleren." *Elseviers Magazine*, July 30, 1977, pp. 53–54.

Muntane, D. "VIII Bienal de la Tapiceria de Lausana." *Artes Plásticas*, August 7, 1977.

R., J.-L. "L'Eté de la tapisserie." *Feuille d' Avis de Vevey* (Switzerland), August 11, 1977.

Romdahl, Margareta. "Textilbiennal Vid Kritisk Skiljeväg." *Dagens Nyheter* (Stockholm), August 20, 1977.

Amaral, Cis. "What is Tapestry." *Arts and Artists* 8 (London) (August 1977).

Kato, Kuniko Lucy. "Fabric Art in Evolution." *Mainichi Daily News* (Japan), September 14, 1977.

Moser, Charlotte. "Weaving, Paper Fibers Gain Stature as Art Media." *Houston Chronicle*, October 8, 1977.

"Lausanne Tapestry Biennale." *Craft Horizons* 37, 5 (October 1977), pp. 22–27, 61.

Larsen, Turid. "Tekstil Som Gir en Sug i Magen." *Arbeiderbladet* (Oslo), November 3, 1977.

Lie, Job. "Storbesøk På Høvikodden." *Aftenposten* (Olso), November 3, 1977.

Haff, Thorstein. "Høvikodden Innvend i Stor-Skulpturer." *Verdens Gang* (Olso), November 4, 1977.

Hopstock, Kirsti. "Effekter i Grov Strie." *Morgenbladet* (Oslo), November 11, 1977.

Lie, Job. "Magdalenas Myke Mennesker." *Aftenposten* (Oslo), November 12, 1977, pp. 1, 25.

Durban, Arne. "Fra Fortidsrik Dom Til Nåtidstøv." *Norges Handels-og Sjøfartstidende* (Oslo), November 15, 1977.

Flor, Harald. "Polsk Angst Og Norsk Landskap." *Dagbladet* (Oslo), November 17, 1977.

Hougen, Pal. "En Jordskjelv i Billedkunsten." *Verdens Gang* (Oslo), November 23, 1977.

Andersen, Stig. "Store, Tunge Klesplagg Henger Ned Fra Taket." *Arbeider Bladet* (Oslo), November 24, 1977.

Andersen, Finn Aage. "Hun Viser Oss Det Som Ikke Lar Seg Formulere Med Ord." *Ostendingen*, November 26, 1977.

Lund, Bente Onsager. "Flaset Kunst Anmeldelse." *Arbeider Bladet* (Oslo), November 26, 1977.

Bjerke, Ø. "Abakanowicz På Høvikodden." *Vestfold* (Tonsberg, Norway), November 28, 1977.

Johnsrud, Even Hobbe. "Abakanowicz På Høvikodden." *Aftenposten* (Oslo), November 30, 1977.

Kato, Kuniko Lucy. "8th International Biennial of Tapestry." *A Bi-Monthly Review of Design* (Tokyo) (November 1977), pp. 78–82.

N., N. "Bienal de Lausana Esta na Gulbenkian-Tapecaria Abandona as Paredes." *Diario de Lisboa,* December 20, 1977.

"Wystawa Malarstwa Polskiego w Budapeszcie." *Nepszabadsag* (Budapest), December 21, 1977.

Oliveria, Mario de. "Na Fundação Gulbenkian 8 Bienal Internacional de Tapecaria de Lausana." *O Pais Lisboa,* December 30, 1977.

Gillemon, Daniel. "La Huitième Biennale de la Tapisserie: Un Art séculaire en vadrouille à Lausanne." *Le Soir Bruxelles* (1977).

Huml, Irena. "Lozańskie Obrachunki." *Sztuka* (Warsaw) (1977).

Łódź, Poland. Centralne Muzeum Włókiennictwa. *Centralne Muzeum Włókiennictwa.* Texts by Halina Jurga and Krystyna Kondratiukowa. Łódź: 1977.

Romdahl, Margareta. "Biennal i Kris." *Svensk Form* 6–7 (1977).

Schofield, Maria. *Decorative Art and Modern Interiors.* London: Studio Vista, 1977.

Styczyński, Jan. *The Artist and His Work.* Warsaw: Interpress Publishers, 1977.

Waller, Irene. *Textile Sculptures.* New York: Taplinger Publishing Company, 1977.

Warsaw, Centralne Biuro Wystaw Artystycznych, and Łódź, Centralne Muezum Włókiennictwa. *Artistes Polonais: Lausanne 1977.* Text by Dr. Adam Nahlik. Warsaw: 1977.

Cleveland Museum of Art. *Fiberworks.* Cleveland: 1977 (exh. cat.).

Cracow, Poland. Galerie 100. *Żyjnia.* Cracow: 1977 (exh. cat.).

Høvikodden, Norway. Sonja Henies og Niels Onstads Stiftelser, Kunstsenter. *Magdalena Abakanowicz: Organiske Strukturer/Organic Structures.* Texts by Magdalena Abakanowicz, Ole Henrik Moe, and Jasia Reichardt. Høvikodden: 1977 (exh. cat.).

Lausanne, Switzerland. Galerie Alice Pauli. *Magdalena Abakanowicz.* Text by Jasia Reichardt. Lausanne: 1977 (exh. cat.).

Lausanne, Switzerland. Musée Cantonal des Beaux-Arts. *8th International Biennial of Tapestry.* Lausanne: 1977 (exh. cat.).

Malmö Konsthall, Sweden. *Abakanowicz: Organic Structures.* Texts by Magdalena Abakanowicz, Eje Högestätt, and Jasia Reichardt. Malmö: 1977 (exh. cat.).

Washington, D.C. Smithsonian Institution Traveling Exhibition Service. *22 Polish Textile Artists.* Texts by Rita J. Adrosko and Krystyna Kondratiukowa. Washington, D.C.: Smithsonian Institution Press, 1977 (exh. cat.).

1978 Billeter, Erika. "Emanzipation vom Webstuhl." *Westermans Monatshefte* (Switzerland) (July 1978).

Park, Betty. "Fiberworks, Fireworks." *Crafts Horizons* 38, 4 (July 1978), p. 3.

Darkiewicz, Wiesław. "Chcę Tworzyć Obiekty Do Kontemplacji." *Za i Przeciw* (Warsaw), August 6, 1978, pp. 19–23.

Bacher, Ingrid. "Bilonerische Poesie im Bochumer Museum: 'Imaginatio Spur des Unbenannten.' " *Rheinische Post* (Bochum, West Germany), August 15, 1978.

Gentry, Barbara. "Fiberworks Symposium." *Interweave* 3, 4 (Loveland, California) (Summer 1978), pp. 26–27.

Krauze, Wojciech. "Laureaci i Dalszy Ciąg Pokazów." *Życie Warszawy,* September 8, 1978, p. 7.

Mazars, Pierre. "L'Espace en demeure." *Le Figaro,* October 17, 1978, p. 30.

Jastrzębska, Zuzanna. "Forma." *Filipinka* (Warsaw), October 22, 1978, p. 11.

Ramm, Janina. "VII Festiwal Sztuk Pięknych." *Stolica* (Warsaw), October 22, 1978, pp. 7–9.

Berkeley, California. Fiberworks. *Fiberworks: Symposium on Contemporary Textile Art.* Berkeley: 1978.

Florisonne, Michel; Hoffmeister, Adolf; Jobé, Joseph; Tabard, François; and Verlat, Pierre. *The Book of Tapestry: History and Technique.* Lausanne: Editor S.A. Lausanne with The Vendome Press, 1978.

Huml, Irena. *Polska Sztuka Stosowana XX Wieku.* Warsaw: Wydawnictwa Artystyczne i Filmowe, 1978.

Bochum, West Germany. Museum Bochum. *"Imagination" (Internationale Ausstellung Bildnerischer Poesie)*. Text by Milan Napravnik. Bochum: 1978 (exh. cat.).

Bydgoszcz, Poland. Salon Sztuki Współczesnej, Biuro Wystaw Artystycznych. *Magdalena Abakanowicz*. Texts by Magdalena Abakanowicz, Kuniko Lucy Kato, and Jasia Reichardt. Bydogszcz: 1978 (exh. cat.).

Koszalin, Poland. Biuro Wystaw Artystycznych. *W Kręgu Współczesnej Tkaniny Polskiej*. Koszalin: 1978 (exh. cat.).

Łódź, Poland. Biuro Wystaw Artystycznych. *Magdalena Abakanowicz: Tkanina*. Text by Magdalena Abakanowicz. Łódź: Biuro Wystaw Artystycznych, 1978 (exh. cat.).

Łódź, Poland. Centralne Muzeum Włókiennictwa. *3rd Textile Triennale—Art Fabric and Industrial Textile—Łódź 78*. Texts by Adam Nahlik and Danuta Wróblewska. Łódź: 1978 (exh. cat.).

Paris. Galerie Jeanne Bucher. *L'Espace en demeure: Louise Nevelson, Marie-Hélène Vieira da Silva, Magdalena Abakanowicz*. Text by Bernard Noël. Paris: 1978 (exh. cat.).

Warsaw. Biuro Wystaw Artystycznych. *Festiwal Sztuk Plastycznych*. Warsaw: 1978 (exh. cat.).

1979 N., N. "Rzeźba Polska w Madrycie." *ABC* (Barcelona), January 2, 1979.

"Exhibition e Palace Velázquez Sculpture." *Diario 16* (Madrid), January 4, 1979.

Kato, Kuniko Lucy; Reichardt, Jasia; and Osęka, Andrzej. "Trójgłos o Twórczosci Magdaleny Abakanowicz." *Dziennik Wieczorny* (Bydgoszcz, Poland), January 16, 1979, p. 1.

Nowicka, Zofia. "Requiem Magdaleny Abakanowicz." *Gazeta Pomorska* (Bydogszcz, Poland), January 16, 1979, p. 3.

Bacciarelli, Marceli. "Rzeźbienie Tkanina." *Fakty* (Warsaw) (January 1979), p. 10.

"G.-V. Herder-Preise." *Wiener Zeitung* (Vienna), February 7, 1979.

Kato, Kuniko Lucy. "Magdalena Abakanowicz: Art Is Eternity Made Tactile." *A Bi-Monthly Review of Design* 10 (Tokyo) (March 1979), pp. 35–70.

Kuenzi, André. "Biennale de la Tapisserie. Il y aurait de gros noeuds." *24 Heures* (Lausanne), April 26, 1979.

M., I. "Rendez-vous à ne pas manquer." *Journal de Genève*, June 17, 1979.

Daval, Jean-Luc. "La Biennale de la Tapisserie devient un salon." *Journal de Genève*, June 23, 1979.

Colberg, Klaus. "Plötzliche Rückbesinnung auf Fläche und Struktur." *Mannheimer Morgen*, June 24, 1979.

Lerrant, Jean-Jacques. "Une Neuvième Biennale de la Tapisserie un peu terne." *Le Progrès Lyon*, June 24, 1979.

Deroudille, René. "La IX Biennale de Tapisserie de Lausanne." *Le Tout Lyon*, June 25, 1979, p. 6.

Grand, Paul-Marie. "Un Biennale taille court." *Le Monde*, June 28, 1979.

Cruchet, B.-P. "Retrospective Magdalena Abakanowicz." *Gazette de Lausanne*, June 29, 1979, p. 2.

Daval, Jean-Luc. "La Création en crise. C'est bien plutôt l'organisation de la biennale qui est à revoir." *Journal de Genève*, June 30, 1979, p. 4.

Vallon, Claude. "Un Art à la découverte de l'espace." *Le Bouquet* (Bern), June 30, 1979.

Masciotta, M. "Una Mostra di Arazzi a Losanna." *La Nazione* (Florence), July 2, 1979.

Kuenzi, André. "Magdalena Abakanowicz à la Galerie Pauli." *24 Heures* (Lausanne), July 5, 1979, p. 41.

B., V. "Les Plus Grands Artistes textiles à Lausanne." *Femina Zürich*, July 11, 1979.

Monteil, Annemarie. "Ein Festival der Textilkunst." *Basler Zeitung* (Basel), July 24, 1979.

Zamocka, Hana. "Podnetna Lekcja." *Vecernik Bratislava* (Czechoslavakia), July 24, 1979.

Cabanne, P. "La IXe Biennale de la Tapisserie à Lausanne." *Le Matin*, July 27, 1979.

Welling, Dolf. "Tapijbiennale Te Lausanne Moet Nodig Op De Helling." *Rotterdamsch Nieuwsblad*, July 27, 1979.

Kato, Kuniko Lucy. "Tapestry Biennial." *Asahi* (Asahi, Japan), July 30, 1979.

"Nées de la fibre." *Connaissance des Arts* 329 (July 1979), p. 20.

Pulleyn, Rob. "9th International Biennial of Tapestry." *Fiberarts* 6, 4 (July–August 1979), pp. 62–64.

Colberg, Claus. "Die Rückkehr des Wandteppichs." *Der Tagesspiegel Berlin*, August 4, 1979.

Lehmann, Hans. "Gefragt war das technische Experiment." *Kieler Nachrichten* (Cologne), August 15, 1979.

Cruchet, B.-P. "Pour se Consoler de la Biennale, D'Autres Tapisseries." *Gazette de Lausanne,* August 22, 1979.

H., A. "La IX Internationale de la Tapisserie à Lausanne." *La Dernière Heure* (Brussels), August 23, 1979.

MacIntyre, Joyce. "The 9th Biennial of Tapestry Lausanne." *Arts Review* (London), August 31, 1979.

Botterbusch, Vera. "9. Internationale Biennale der Tapisserie." *Das Kunstwerk* 32, 4 (Stuttgart) (August 1979), p. 6.

Redeker, H. "Het Explorerend Wandtapijt." *Kunstbeeid* (August 1979).

Soest, Wil von. "De 9e Biennale in Lausanne." *Goed Handwerk La Haye* 78 (The Hague) (August 1979).

Abakanowicz, Magdalena, and Huml, Irena. 'Abakany—Nowy Gatunek Sztuki Tkackiej; Wszystko Co Tworzę Jest Dla Mnie Ważne." *Słowo Powszechne* (Warsaw), October 12, 1979, p. 3.

Pap. "Wczoraj Na Świecie." *Życie Warszawy,* October 15, 1979, p. 6.

Billeter, Erika. "Lausanne Biennial: An Endangered Tradition." *American Craft* 39, 5 (October–November 1979), pp. 20–25.

"Aalborg Vaert for Tekstillbiennale." *Morgenavisen-Jyllands Posten* (Viby, Denmark), November 2, 1979.

Dwinger, Jonna. "Traedene Samlet i Aalborg." *Politiken* (Copenhagen), November 2, 1979.

Schmidt, Doris. "Noch immer Angst vor grosen Formaten." *Süddeutsche Zeitung* (Munich), November 6, 1979.

Sinding, Ib. "Lausanne Biennalen i Aalborg." *Zyll Post* (Denmark), November 9, 1979.

Garde, C. F. "Fra Tekstil Kunstens Højborg." *Aarhuus Stiftstidende* (Denmark), November 11, 1979.

Wróblewska, Danuta. "Le Concours de Lausanne." *Projekt* (Warsaw), December 9, 1979.

Daval, Jean-Luc, ed. "Magdalena Abakanowicz" in *Skira Annuel No. 5.* Geneva: Editions Skira, 1979.

Schwaab, Catherine. "Lausanne Ville du fil." *Art* (Hamburg) (1979), p. 53.

Copenhagen. Galerie Asbaek. *Modern Polish Art.* Copenhagen: 1979 (exh. cat.).

Lausanne, Switzerland. Galerie Alice Pauli. *Abakanowicz Rétrospective.* Texts by Magdalena Abakanowicz and Andrzej Osęka. Lausanne: 1979 (exh. cat.).

Lausanne, Switzerland. Musée Cantonal des Beaux-Arts. *9th International Biennial of Tapestry.* Lausanne: 1979 (exh. cat.).

São Paulo, Brazil. *XV Bienal São Paulo.* São Paulo: 1979 (exh. cat.).

Zurich. Kunsthaus Zürich. *Weich und Plastisch/Soft-Art.* Texts by Magdalena Abakanowicz, Erika Billeter, Mildred Constantine, Richard Paul Lohse, Klaus Rinke, Willy Rotzler, and Andre Thomkins. Zürich: 1979 (exh. cat.).

1980 Banaszkiewicz, Grażyna. "Zejście Ze Ściany." *Tydzień* (Poznan, Poland), January 13, 1980, pp. 16–17.

Hermansdorfer, Mariusz. "Polska Sztuka w São Paulo." *Kultura* (Warsaw), January 13, 1980, p. 11.

Caurio, Rita. "Viagem Pelo Mundo da Tapecaria." *Arte Contemporânea Rio De Janeiro* (January 1980).

Magnaguagno, Guido. "Weichgebilde: Zur Ausstellung 'Weich und Plastisch—Soft Art.' " *Du* 1 (January–June 1980), pp. 70–72.

Gutowski, Maciej. "Paryska Wystawa Polskiej Rzeźby." *Kultura* (Warsaw), February 17, 1980.

Dugonja, Dubravka. "Lozanski Bijenale Tapiserije." *Naš Dom* 2 (Maribor, Yugoslavia) (February 1980), pp. 23–25.

Mikołajczyk, Maria. "Rozwinąć w Sobie Sztukę." *Gazeta Zachodnia* (Bydgoszcz, Poland), March 15–16, 1980.

"Biennale-Arte: Le Incognite." *Il Gazzettino* (Venice), May 28, 1980.

Jespersen, Gunnar. "Kunstens Oprør Mod Terroren (Venezia)." *Berlingske Tidende* (Copenhagen), June 5, 1980.

Vaizey, Marina. "This Way to the Eighties." *The Sunday Times* (London), June 8, 1980, p. 39.

Buschbeck, Malte. "Was ersetzt uns den Fortschriftsglauben." *Süddeutsche Zeitung* (Munich), June 14–15, 1980, p. 135.

Overy, Paul. "The Venice Biennale: More Baffling than Ever." *International Herald Tribune,* June 14–15, 1980, pp. 7, 10.

Breerette, Geneviève. "A la Biennale de Venise: Pardessus le marché." *Le Monde,* June 15–16, 1980, pp. 1, 11.

N., N. "39e Biennale in Venetie." *Nieuwsblad Van Het Noorden* (Groningen), June 20, 1980.

Florczak, Zbigniew. "Magdalena Abakanowicz w Wenecji." *Express Wieczorny* (Warsaw), July 2, 1980, p. 4.

Krauze, Wojciech. "Strefy Humanistycznej Kontemplacji." *Życie Warszawy*, July 19–20, 1980, p. 4.

Vaizey, Marina. "Dublin Opens the Window." *The Sunday Times* (London), August 3, 1980.

Overy, Paul. " 'ROSC '80'—A Melange of Modernism." *International Herald Tribune*, August 9–10, 1980, p. 11.

Nemeczek, Alfred. "Biennale 1980 oder das Debüt der neuen Milden." *Art* 8 (Hamburg) (August 1980).

"Contemporary Tapestries." *The Village Voice* (New York), September 10–16, 1980.

Gendel, Milton. "Ebb and Flood Tide in Venice." *Art News* 79, 7 (September 1980), pp. 118–120.

Müller, Hans-Joachim. "Biennale Venedig 1980." *Das Kunstwerk* 33, 4 (Fall 1980), pp. 58–69.

Malarcher, Patricia. "Crafts." *The New York Times*, November 23, 1980.

Overy, Paul. "Dublin: ROSC '80." *Flash Art* 100 (November 1980), p. 57.

McGuire, Sr. Therese B. "Magdalena Abakanowicz— Polish Pavilion." *Artery* 4, 2 (William Paterson College, Wayne, New Jersey) (November–December 1980), pp. 8–9.

Risatti, Howard. "Descending from Olympus. 1980 Venice Biennale: Art in the Seventies." *New Art Examiner* 8, 3 (December 1980) pp. 10–11.

Constantine, Mildred, and Larsen, Jack Lenor. *The Art Fabric: Mainstream*. New York: Van Nostrand Reinhold Company, 1980. (Published in conjunction with an exhibition circulated by the Smithsonian Institution Traveling Exhibition Service, Washington, D.C. [exh. cat.].)

Daval, Jean-Luc, ed. "Magdalena Abakanowicz" in *Skira Annuel No. 6*. Geneva: Editions Skira, 1980.

Editors of American Fabrics and Fashions Magazine, directed by William C. Segal. *The New Encyclopedia of Textiles*. Englewood Cliffs, New Jersey: Dorie Publishing Company, Prentice-Hall, 1980.

Warsaw. Cultural Program, Polish Television. "Pegaz Program: Magdalena Abakanowicz." Warsaw: 1980.

Dublin. National Gallery of Ireland and School of Architecture in University College. *ROSC '80: The Poetry of Vision*. Dublin: 1980 (exh. cat.).

New York. Pratt Manhattan Center Gallery. *Contemporary Tapestry*. New York: 1980 (exh. cat.).

Paris. Musée d'Art Moderne de la Ville de Paris. *Sculptures Polonaises Contemporaines*. Texts by Jean-Dominique Rey and Aleksander Wojciechowski. Paris: 1980 (exh. cat.).

Venice. La Biennale di Venezia. *La Biennale di Venezia: Section of Visual Arts, General Catalogue 1980*. Venice: 1980 (exh. cat.).

Venice. La Biennale di Venezia. *Biennale di Venezia '80: Magdalena Abakanowicz, Polonia*. Texts by Magdalena Abakanowicz and Aleksander Wojciechowski. Warsaw: Ministry of Culture and Art of The People's Republic of Poland, Central Office of Art Exhibitions, 1980 (exh. cat.).

1981 Abakanowicz, Magdalena. "Magdalena Abakanowicz." *Du-Die Kunstzeitschrift* 1 (Zurich) (January 1981), pp. 45–47.

Osęka, Andrzej. "Niepokojący Gwar." *Polska* 1, 317 (Warsaw) (January 1981), pp. 25, 36–37.

N., N ."16 Konstnärers Möte Med Malmoe." *Sydsvenskan Skane*, March 20, 1981, p. 29.

Wolf, René. "Eine Polin packt ihre Mythen in Jute." *Art* 3 (Hamburg) (March 1981).

Högestätt, Eje. "Malmoe—Sällsamt Mellanspel Eller." *Sydsvenska Dagbladet* (Malmö), April 14, 1981.

Sjöstedt, Sven. "16 Konstnärer i Malmoe Två På Snövandringar." *Sydsvenska Dagbladet* (Malmö), April 21, 1981.

Hennessey, W. J. "Reflections on the 39th Venice Biennale." *Art Journal* 41, 1 (Spring 1981), pp. 69–72.

Ballatore, Sandy. "The Art Fabric: Mainstream." *American Craft* 41, 4 (August–September 1981), pp. 34–39.

Paris. Société Française de Production et de Création Audiovisuelles. "L'Art et les hommes. Magdalena Abakanowicz." Directed by Jean-Marie Drot. Paris: 1981.

Lausanne, Switzerland. Galerie Alice Pauli. *Abakanowicz*. Text by Magdalena Abakanowicz. Lausanne: 1981 (exh. cat.).

Malmö, Sweden. Malmö Konsthall. "*Malmoe.*" Texts by Magdalena Abakanowicz, Eje Högestätt, and others. Malmö: 1981 (exh. cat.).

1982 Bouisset, Maïten. "Abakanowicz: la Pénélope de Varsovie." *Le Matin*, January 14, 1982.

N., N. "Magdalena Abakanowicz à l'ARC." *Le Monde*, January 14, 1982, p. 26.

Warnod, Jeanine, "Le Cri muet d'une artiste polonaise." *Le Figaro*, January 16, 1982, magazine section, p. 27.

Breerette, Geneviève. "Magdalena Abakanowicz à l'ARC: Altérations et métamorphoses." *Le Monde*, January 17–18, 1982, pp. 1, 9.

Faucher, Pierre. "Magdalena Abakanowicz." *Arts* (Paris), January 22, 1982.

Gibson, Michael. "Art beyond Mere Explanation." *International Herald Tribune*, January 23–24, 1982, p. 7.

Moulin, Raoul-Jean. "Archéologie du corps. La Sculpture textile de Magdalena Abakanowicz." *L'Humanité* (Paris), January 26, 1982.

Meleze, Josette. "Abakanowicz Pouvoir de la faiblesse." *Semaine De Paris–Pariscop*, January 27, 1982, p. 120.

Terzieff, Catherine. "A Corps et à cris." *7 A Paris*, January 27, 1982.

Hahn ,Otto. "Magdalena Abakanowicz à l'ARC." *L'Express* (Paris), January 29, 1982.

Huser, France. "Images pour l'imagination deux polonais et deux techniques pour alimenter nos rêves." *Le Nouvel Observateur* (Paris), January 30, 1982.

Daval, Jean-Luc. "Magdalena Abakanowicz l'homme devient le sujet et le support de nouvelles formes." *Textile/Art* 2 (Paris) (January 1982), pp. 20–25.

Macaire, Alain. "Abakanowicz. Les Mémoires de la matière." *Canal* 44 (Paris) (January 1982), p. 7.

Milliot, Anne-Marie. "Le Mystère de la naissance. Le Mythogramme de Magdalena Abakanowicz." *Textile/Art* 2 (Paris) (January 1982), pp. 20–25.

Thomas, M. "La Vérité du corps imaginaire." *Textile/Art* 2 (Paris) (January 1982), pp. 20–25.

Bisset, Pierre. "Magdalena Abakanowicz à l'ARC." *L'Oeil* 318–319 (Paris) (January–February 1982), p. 107.

Leveque, Jean-Jacques. "Magdalena Abakanowicz à l'ARC." *Les Nouvelles Littéraires* (Paris), February 4, 1982.

Hugonot, Marie-Christine. "Magdalena Abakanowicz." *Le Quotidien de Paris*, February 5, 1982.

Merckx, A. "Een Levend Museum." *Die Nieuwe Gazet* (Antwerp), February 9, 1982, p. 2.

"Magdalena Abakanowicz à l'ARC." *Bonnes Soirées Télé* (Paris), February 12, 1982.

Breerette, Geneviève. " 'Abakanowicz,' ARC, Musée d'Art Moderne de la Ville de Paris." *The Guardian* (Manchester), February 14, 1982.

Le Bot, Marc. "Les Ecorchés de Magdalena Abakanowicz." *Quinzaine Littéraire* (Paris), February 15, 1982.

Jaworski, Marek. "Polskie Imprezy we Francji." *Trybuna Ludu* (Warsaw), February 20–21, 1982, p. 4.

C., P. "Les Ventres féconds de Magdalena la polonaise." *Elle*, February 22, 1982, p. 25.

Selz, Peter. "Knox and Bolts." *Art in America* 70, 2 (February 1982), pp. 107–115.

Rose, Barbara. "Ugly? The Good, the Bad and the Ugly; Neo-Expressionism Challenges Abstract Art." *Vogue* 172, 3 (March 1982), pp. 370–375, 425.

Abakanowicz, Magdalena, and Jacob, Mary Jane. "Magdalena Abakanowicz." *Tri-Quarterly* 53 (Northwestern University, Evanston, Illinois) (Winter 1982), pp. 166–169 and cover.

Paris. ARC, Musée d'Art Moderne de la Ville de Paris. *Abakanowicz: "Alterations."* Texts by Magdalena Abakanowicz, Jean-Luc Daval, and Suzanne Pagé. Paris: 1982 (exh. cat.).

Paris. Galerie Jeanne Bucher. *Magdalena Abakanowicz: 21 dessins au fusain.* Text by Magdalena Abakanowicz. Paris: 1982 (exh. cat.).

West Berlin. Nationalgalerie. *Kunst wird Material.* West Berlin: 1982 (exh. cat.).

Reproduction Credits